EVE BITES BACK

'A smart, funny and highly readable journey through the lives of women writers and the challenges they and their works face. It's an informative, enthusiastic and rightly enraging tour de force.'

A.L. Kennedy

'A totally absorbing and enlightening tour through the work of eight significant women authors – with one of the funniest introductory chapters ever.'

Sarah Bakewell, author of *At the Existentialist Café*

'Writing with energy, wit and at times barely suppressed fury, Anna Beer brings to life the struggle to be heard of eight women writers over 500 years. Her subtle literary excavations are both informative and a gripping read.'

**David Goodhart, founder editor of *Prospect*
and author of *Head, Hand, Heart***

'Anna Beer is one of those very rare writers who are able to combine rigorous research with a gripping and thoroughly accessible style. This is an ambitious, authoritative, feisty book and a worthy successor to her inspirational *Sounds and Sweet Airs: The Forgotten Women of Classical Music.*'

Kate Kennedy, author of *Dweller in Shadows*

'Written with a clear and authoritative voice, this is both a very entertaining and very important book about the many obstacles that women have overcome to be writers, and the long struggles even the most gifted and well-connected women authors have encountered in order to be taken seriously.'

**Yasmin Khan, associate professor of history,
University of Oxford**

ANNA BEER

Eve Bites Back

AN ALTERNATIVE HISTORY OF ENGLISH LITERATURE

ONEWORLD

A Oneworld Book

First published by Oneworld Publications in 2022

Copyright © Anna Beer, 2022

The moral right of Anna Beer to be identified as the Author of this work has been
asserted by her in accordance with the Copyright, Designs, and Patents Act 1988

ISBN 978-0-86154-293-2
eISBN 978-0-86154-294-9

Typeset by Tetragon, London
Printed and bound in Great Britain by Clays Ltd, Elcograf S.p.A.

Oneworld Publications
10 Bloomsbury Street
London WC1B 3SR
England

MIX
Paper from
responsible sources
FSC® C018072

Contents

List of Illustrations

In the Beginning

I STARTED by seeking out a different Bible. I felt I knew more than enough about Eve bringing sin and death into the world ('she gave me of the tree and I did eat') and the more punitive bits of the Book of Genesis:

> I will greatly multiply thy sorrow and thy conception; in sorrow thou shalt bring forth children; and thy desire shall be to thy husband, and he shall rule over thee.

I was aware of Eve's successors, the bloodthirsty Old Testament women (think Artemisia Gentileschi's graphic, disturbing painting of Judith slaying Holofernes) or the sexy New Testament ones (think Dan Brown's *Da Vinci Code*'s portrayal of Mary Magdalene, sex worker turned Mrs Jesus). And I thought I knew the redemptive Second Eve, the Virgin Mary.

I was looking for something different, a biblical text written *by* a woman. So I seized on the Book of Esther, excised by the Church Fathers from the biblical canon. It was a mistake. No one has any idea who actually wrote the book, and, if we are being academic, the concepts of a single author or even a definitive text are both

pretty useless when considering the murky, complicated origins and transmission of the texts that make up the Jewish and Christian Scriptures. When an author *has* been suggested, it has been a man, Mordecai, the 'main' character. It might have saved me some time in the remoter corners of biblical scholarship if they had called it the Book of Mordecai.

Looking for Esther the author was a foolish mistake, but thinking about the erasure of women's lives and words in the far distant past was not. How that erasure was achieved, what was said, done and written then, matters now. When the patriarchs (literally, they *were* patriarchs) wrote their histories of the early Church, two archetypal women were left standing in the ruins. They would dominate literature in English for the next two millennia: Eve and the Virgin Mary. To be honest, if the two hadn't existed, then the patriarchy would have had to invent them. Do be Mary. Don't be Eve.

Eve whose God-given punishment for bringing sin and death into the world was to be placed under Adam's rule and to experience pain in childbirth. Eve who was responsible for Adam's sin as well as her own. Eve who gave authority to patriarchal commentators to tell women, over and over again, that their essential nature was vile and disgusting, that any attempt to conceal let alone challenge the fundamental truths of their bodies was fraudulent and blasphemous. Put bluntly, as Tertullian the early Christian Father did: women 'are Eve'.

Sometimes, though, Eve fights back. She does so in unexpected ways that don't necessarily fit with our modern ideas of what a woman, let alone a feminist, should do. But simply by putting words together on the page, she takes up battle. And she does so, knowing – in one form or another – every reason why she should not write, and certainly should not bite.

Here are some of them.

II

You are physically incapable of being an author.

Medicine and philosophy, astronomy and theology all combined for millennia to insist that the female body is intrinsically faulty, cold, wet, irrational, changeable and above all fallen: unfit for the task of authorship. You can see why people questioned whether Trota of Salerno, a female doctor in eleventh-century Italy, actually wrote a number of texts about diseases and health conditions affecting women. Surely a woman could not possess the intelligence and expertise to have written the works? The obvious first step was to ascribe the works to male authors and the follow-up was to suggest that she never existed at all. Job done.

It didn't help that, back in the day, although the word 'author' could and did suggest 'writer', it was more usually a synonym for authority (*auctorite* in Middle English). Greek and Roman writers were authorities. So were the patriarchs of the Church. All of the latter, and almost all of the former, were male. Even when the word 'author' becomes separated from 'authority', that older sense lingers as a ghost reminding women of their place.

The underlying paradigm of women and words goes back, as so many things do, to the Book of Genesis. Adam is not only the first man, but he is the first namer of things. Eve is the first woman – and thus named. Women are created by, not creators of, words. Since God is, obviously, the ultimate author/authority, and men are made in the image of God, it is equally obvious that women should not usurp the powers of either God or Man. While we are on the subject, don't get any ideas about being a genius. A simple Google search will demonstrate that almost all humans with exceptional abilities happened to be born male. Beliefs about women's innate abilities, and, in particular, a woman's capacity for 'genius', are impressively enduring. The philosopher Christine Battersby argued back in 1989 that the word itself is 'utterly contaminated by past usage, and by the way

that the male (still) provides the paradigm for both the normal and supernormal personality-types, consciousness-types, and energy-types'. We still like our geniuses male, with a side order of women.

Thank you for taking that on board. If you are very good, we might allow you to write, but only about certain things and in certain ways and for certain people.

The successful novelist Fanny Trollope, mother to the more famous Anthony, picked up on a line from (male) French writer Beaumarchais to comment, wryly, on the ways in which her writing was circumscribed:

> It is said that providing I don't speak about authority, culture, politics, morality, people, the opera or other entertainments, nor about anyone who believes anything, then I can print freely.

Like all good irony, it works because it reveals a universally understood truth about women and writing. Most topics are off-limits, but not all. A conventional take on religion is usually a safe bet. Perhaps instructing other women as to how to be a good woman.

Because, as a woman, if you are given the gift of education, your literacy is not a means of opening doors to different ways of being, but designed to prepare you better for your decreed role in life. Your task is to provide moral guidance, not to entertain, since for you to provide pleasure to your reader would make you little more than a courtesan. If you do have to write about sex and desire, then bear in mind that religious and literary traditions link women's sexuality to subjection rather than authority.

A question from the back? The Guerrilla Girls are asking, having noticed the absence of female artists on the walls of the Metropolitan Museum of Art in New York, whether a woman needs to be naked to be displayed. The simple answer is yes, ladies, you do. Do not represent your *own* bodies and desires: leave that to the men who

will disclose and gaze upon the dark secrets of your sex. Do not write about the messy, sometimes painful, bodily experiences of periods, pregnancy, miscarriage, birth – let alone bad sex or the menopause. In other words, steer well clear of Genesis and the apple incident. Head for the Virgin Mary, a good, sexless, immaculate mother devoted to her son.

I see you've gone ahead and written something according to this guidance. That's great.

Of course, precisely because you have created in the genres we told you that you *could* work in, we are going to exclude you from the history of Literature with a capital L. Because, sorry, we don't value letters or diaries, translations or advice manuals, devotional verses or lullabies, your memoirs or your prayers.

Then again, if you do have the temerity to ignore our guidelines and stray into men's territory, we will always and ever find a way to understand your work on the basis of your gender, regardless of the quality or nature of your writing. Remember the words of composer Elisabeth Lutyens: when her male contemporary Benjamin Britten 'wrote a bad score, they'd say, "He's had a bad day". If I'd written one it was because I was a woman.' If you are productive, then you will be condemned as facile and prolix. Loose writing: loose woman. If you write in a wide variety of genres, your poly-authorship will reveal your desperation rather than your remarkable range. If a man challenges the status quo, he is excitingly political. As a woman, you are bitter and angry and, of course, writing from your own narrow, personal agenda. And if you write novels, they will be 'chick lit'.

It is not enough to rigorously uphold a literary double standard for men and women; you will be attacked personally if you challenge that double standard. Yes, we note that a female rapper can win a whole load of Grammys by taking a traditionally male, masculine genre and doing it bigger, better and bolder, placing her female body

front and centre, but – not for the first or last time – we will shame her for it. We will conflate your sexuality with your creativity, and condemn both as improper. It's worked for centuries: why stop now?

And finally, if you are still determined to write, the survival of your work will be a small miracle. Most women's words are necessarily occasional, ephemeral, insignificant to what we call History. Someone may destroy your work. Maybe you will do it yourself, because you are fearful of a hostile response. If you expect your family and friends to respect your literary legacy after your death, then think again. Your words will, most likely, be simply discarded or forgotten for want of a family member or friend to keep them alive. Johnson had his Boswell. Shakespeare had his mates. It helps.

You've taken all this on board, but have decided to write using a male pseudonym. It's a strategy, admittedly.

You think it is going to help you be taken seriously. You're pretty sure it's the only way you will get published. You might even have read that famous study which demonstrates that if employers are given identical CVs with merely the information that the candidate is a rising star, but that one is called James, the other Andrea, then not only is James chosen more often, but Andrea is described as abrasive, pushy and untrustworthy. You know, as Madeline Heilman (one of the authors of that study) knows, that 'in any kind of field or occupation or role that men have traditionally dominated, there's a perception that what's required to do the job are things that are typically associated with men, whether it's assertiveness, competitiveness, or taking risks'.

It's not going to work. Women who attempt to take their sex out of the equation (we are looking at you George Eliot, Acton Bell and J. K. Rowling) often face backlash from the literary establishment they fooled. They also, and for this we are truly grateful for their help, sometimes and with the best of motives diminish their fellow lady authors. Currer Bell (better known as Charlotte

Brontë), according to biographer Juliet Barker, worked to consign her sister Acton (Anne) Bell's *The Tenant of Wildfell Hall* 'to oblivion because she considered its subject at odds with her own perception of what Anne's character was and ought to have been'. George Eliot (aka Mary Ann Evans), when fighting to be taken seriously as an intellectual, sought to put as much distance as possible between herself and 'silly lady novelists', and then refused to engage with discussions of 'the Woman Question' because the debate 'seems to me to overhang abysses of which even prostitution is not the worst'. Who needs men when women can enforce the rules of patriarchy?

Ah, you've gone ahead and written something exceptionally good. Well, this is awkward.

Fortunately, we've been practising ways of denigrating or excluding you and your work for thousands of years. Take the most brilliant poet of her time, the sixth century BCE: Sappho. Admittedly, we can't do much with Plato's admiration of her, since he thought Sappho was Homer's equal and called her the Tenth Muse. Aristotle, however, gives us something to go on, when he offers up grudging praise that 'the Mytilineans honoured Sappho although she was a woman'. Thank goodness he has reminded us that she was a female of the species, kicking open the door to centuries of, at best, scurrilous anecdotes, and at worst, demonisation.

There are other ways we will distract people from your work. The medieval poet Gwerful Mechain made the rookie error of winning a literary competition against her Welsh male contemporaries with a poem in praise of the cunt (*gont* in the original). There was no way, of course, we could contemplate publishing such obscenity in our ground-breaking twentieth-century collection of Welsh medieval poetry, but we might just take another look at its author, reading from the text to the life. If she wrote those words, then she must have been a prostitute. (Mechain wasn't, but truth is the first casualty of gender war.)

We will find more subtle ways to mask or appropriate your achievements. We will publish your work but re-ascribe it to a male author, as happened with Christine de Pisan's *Book of the City of Ladies* when it was translated into English. Someone you trust, even love, will take your work and use it for his own literary ends, consciously or unconsciously. Alexander Pope published one of his friend's, later enemy's, poems as his own. When that friend, Lady Mary Wortley Montagu, saw, by chance, her work passed off as his in print, she scrawled 'mine' in the margin. It probably made her feel better for a moment, but face facts: you may have heard of Pope, but have you heard of Montagu? William Wordsworth apparently nicked his host of golden daffodils from the diary of his sister, Dorothy. She didn't mind, of course, because she loved her brother.

This kind of thing has been given a name in the sciences: the Matilda effect. Historian of science Margaret Rossiter looked at the 'Matthew effect', whereby already prominent people are more likely to get credit than non-prominent people, and applied it to women. But as even an (obviously angry) feminist, Lara Rutherford-Morrison, considering the Matilda effect has to acknowledge, it can happen unintentionally or with the best intentions. Men who:

> ultimately received acclaim for major achievements that should have at least partially been attributed to women didn't necessarily do so purposefully or with the intention of taking credit where it wasn't due. In many cases, men were given credit because that's just how things were done; in fields like the sciences, there wasn't an extensive history of eminent female scholarship, so people simply couldn't imagine it happening – and therefore assumed that major breakthroughs must somehow be attributable to dudes.

Exactly! It's nobody's fault – it's just how things were done back then. And maybe a little bit now. Dudes.

III

No wonder that many women authors, past and present, feel alone. Fifty years ago, Adrienne Rich wrote powerfully of the moment when she noticed the absence of female experience in the books she was reading. She urged the reclamation and recovery of the voices of women of the past – to make the literary world for writers and readers a little less lonely for women.

Reclamation and recovery are not always simple tasks, however, especially when we go back in time hundreds, thousands, of years. In the words of Anna Fisk, writing specifically about the Bible, there are very 'few whole and untarnished objects' for scholars to find amidst fundamentally male-centred traditions. Men's exclusion of women from literary production over the centuries means that there were, statistically, fewer women writing, fewer women published, fewer women read.

Should our task be, therefore, to explore the *representation* of women in literature? Perhaps, indeed, that is all that is possible, because if you go back five hundred, a thousand, three thousand years, there is (almost) no writing by women, only writing about women by men. In the following chapters, I will be writing a lot about how women are represented, but not because it is all we can do. For me, that parenthetical 'almost' is important. Thanks to the text detectives who have been out in force for decades, we now know of many, many more literary works by women. I am dependent upon that recuperative scholarship, I am deeply grateful for it, I've even done a bit of it myself, but it is the beginning not the end of literary history. It is not enough simply to refresh the stock of English Literature with works by women.

We need, in addition, to question many of the stories we tell about the lives of women and their work, and some of the ways we think about Authorship and Literature. Take for example the re-discovery of the medieval *Book of Margery Kempe* over five hundred years after its creation. It is a great story, newsworthy at the time, the 1930s, a

small step in the repopulation of English Literature with women authors, a rallying cry to inspire the seeking out of other hidden gems. The *Book* was hailed and is still hailed as the earliest autobiography in English, making Kempe herself one of the first English women authors. She has been called a voice across the centuries. She is the kind of writer to make Adrienne Rich feel less lonely.

Being first is a wonderful hook on which to hang an author and it gets *The Book of Margery Kempe* into our literary histories. Great, you might say. Good for you, Aemilia Lanyer, to write a country house poem several years before your contemporary Ben Jonson got around to composing *To Penshurst*. Even more kudos to Phyllis Wheatley, who gained her first name from the ship that brought her as a slave from Gambia to Boston, USA, and her family name from the man who bought her when the ship landed. Wheatley was the first African American woman to have a volume of poetry published. But as the life and work of those two women demonstrate (Lanyer's poem sank without trace, Wheatley failed to get another volume published and died in poverty), to be 'first' can be an empty accolade. It makes it all too easy to dismiss the writer: she was first, but was she any good? As Charlotte Gordon, biographer of Anne Bradstreet, writes of her earliest encounters with the author, she thought the poet's 'only claim to recognition was good timing'. Gordon changed her opinion, but only after taking the time and effort to engage with Bradstreet's work.

This first-past-the-post approach to literary history is not 'job done', particularly for women. Mere claims of precedence allow critics to dismiss writers such as Bradstreet, Lanyer and Wheatley as being of 'literary historical importance' but then to move swiftly on to the proper writers. Smacking of tokenism, the move conceals the important questions: what enabled a woman to be first and how can the first become the second, and then reach a critical mass – something we are nowhere near. It distracts our attention from what that writer does with words, and what others do with her words and, in particular, how those words have come to us.

Understanding the ways in which transmission and circulation work for women's words is one of the keys to understanding why women authors still don't get the recognition they deserve. When women do get into the canon, a complex body of writing is often reduced to one, emblematic piece of work. Honorée Fanonne Jeffers, for example, has spoken about her initial response to Phyllis Wheatley's most frequently anthologised poem. For Jeffers, as a young African American woman author, that single poem seemed alien to her experience. But when that one poem was joined by its fellows, when Jeffers began to explore Wheatley's life and times, when other histories were included – black histories, slaving histories, white women's histories – then Wheatley's work began to resonate with her.

Something related happens when individual women are represented (and represent themselves) as special cases. The brilliant woman becomes the exception who proves the male rule. The argument has been around a long time, a favourite of men who don't have a high view of the capabilities of females. They will flatter an individual, as John Donne did his patron, Lucy Countess of Bedford, that she stands 'alone' in her 'worthiness'. It's also a take used by men who are celebrating *their* woman – wife, daughter, whatever – she is 'exceptional for her sex'. This functions most depressingly when women turn on women, scapegoating the rest of their sex in defence or justification of their own (exceptional) right to write.

There's a pattern here. A woman's oeuvre is reduced to one poem. A brilliant woman is seen as a one-off. The final step is to reduce women's lives to one kind of story, pivoting on romantic love or the absence of it. Those stories often remain in circulation long after they have been discredited by scholars and they stick around for a reason.

To make women's lives the sum of their salacious or sentimental moments not only does their work a disservice, but makes it all too easy for the guardians of morality to make their attacks. Take that explicitly sexual work I mentioned earlier. If 'To the Cunt' is considered, it becomes a window into its author's life. The poem's sexual banter shows that Gwerful Mechain wrote it before her marriage – it

would not have been appropriate otherwise. Or the banter is a sign that she is a confident *married* woman: she can only entertain this way *after* marriage. Or is she actually trapped in an abusive marriage, and writing the poem as a form of cathartic therapy? All these theories have been put forward. All focus our attention on the author's personal life and her relationship with a man. None fully attend to the poem as a successful piece of performance poetry. Sappho has had this treatment from earliest times. A fragment sneers at Lesbians a mere generation after the poet's death; the male writers of New Comedy lampoon her; a story circulates that she was rejected by a boatman, Phaon, which leads her to commit suicide; Christians critique the woman's immorality; well-meaning editors straighten out her writing.

Even when they don't read like the biographical equivalent of the tabloid sidebar of shame, women's lives are often seen as more interesting than their work. Above all, we want relationships and we want relationships to become books. We do this to men as well (think, if you want, of the film *Shakespeare in Love* in which Will's love for Viola explains – or put more accurately hetero-washes – his *Sonnets*) but when we read from the text to the life, and back again, we read particularly reductively, particularly literally and particularly punitively when it comes to women authors. It's all enough to push some feminists to argue that we shouldn't be talking about the lives of female authors in the first place.

They have a point. None of the authors in this book wished their work to be read, condescendingly, as 'women's writing'. Some sought actively to take their own sex out of the equation. The novelist Mary Elizabeth Braddon, whom you will meet in chapter 7, wanted her literary mentor Edward Bulwer-Lytton to see her as an author, not a woman, and so concealed her pregnancies, births and family life from him. Is it therefore a disservice to these women to try to explore how they lived? Does the biographical turn lead, inexorably, as some would argue, to sexism? It depends on what kind of life you come up with.

IV

It is futile (although it is often done) to attempt to write Julian of Norwich's life according to the template of the Great Male Authors of later centuries. It is racist (although it has been done) to write enslaved African American Phyllis Wheatley's life according to the template of the upper-class White Lady Author. In writing women's literary lives, we often need to ask different questions, explore different archives, look at familiar things from different perspectives. But I believe it is worth attempting, for it both honours women for writing despite and because they were born female and begins to answer the question: why so few?

This is not to say it isn't challenging. Often the documents are simply not there and what we want to know remains well hidden. But this is true for many men. The surprising fact is that there is often just as much information about female authors as there is about male authors – and equally, some of the most canonical writers in English Literature (Shakespeare and Milton) test the practices of the conventional biographical project almost to destruction. For Shakespeare, the archival cupboard is very, very bare, with almost no documents to tell us anything about William's personal life. In fact, there are no letters *at all*, even to the man let alone from him. We have to build a life from some references, made by others, to his professional career ('upstart crow'), from a few legal documents ('tax avoider') and the infamous bequest of his second-best bed to his wife in his will. We get an upstart crow tax avoider who hates his wife. For Milton, in contrast, the cupboard is full. But what looks like archival riches, five volumes and counting of *Life Records*, turns out to be a mirage. Milton, or people close to him, made very sure that only certain kinds of documents would survive, skewing the archive to create the picture of an exclusively public life. Not only are there no letters to his three wives, or to his three daughters. There are none to his brother or father. None of this has stopped life-writers and critics in their tracks.

Nature and biographers abhor a vacuum – so we fill it, reading from literary texts to the life and back again. It is how we do it that matters. Here's Harriette Andreadis writing about Sappho's reputation and the recovery of her poems. Both are:

> fraught with the complexities of informational lacunae and textual instability, so much so that the myths of Sappho soon overtook Sappho the poet and Sappho the person. In short, each era has remade Sappho in its own image, a phenomenon Monique Wittig and Sande Zeig underlined wittily: the entry for Sappho in their *Lesbian Peoples: Material for a Dictionary* (1979) consists of a blank page to be filled in by the reader.

As we fill in that blank page, I believe it is vital to show our workings.

For starters, it matters which version of the text is being talked about, which moment in a lifetime is under consideration. Take Shakespeare's *Hamlet*, a play that existed in (at least) three very different printed versions during the playwright's lifetime. Add the actual moment(s) of creation and revision, the labour of reproduction, in this case the various printings, not to mention performances of the play(s), and the timeline not only begins to stretch but becomes cluttered with Hamlets – in preparation, in printing, in revision, in performance. Not all of them can be a reaction to the death of William's son or father, the two most popular biographical interpretations, with Shakespeare's closet Catholicism a close-running third. Life and literature are more complicated than that.

I want to consider these women's lives, even when it is hard to do so, especially when it is hard to do so. In writing these chapters, I have foregrounded the fragmentary nature of what has survived – the torn pages, the lost works, the missing decades, the suppressed ideas, the births and deaths, the journeys and the love affairs about which we know nothing. And I want to explore difference as much as similarity, because there is no single story of 'women's writing'.

One woman's life and work can never, should never, stand for all women's lives and works.

V

We ask a lot of our female authors. We expect them to do some heavy lifting, then – and now.

Some people, especially women who look like me, are disappointed if other women don't sign up to what have been described as the goals of White Feminism: personalised autonomy, individual wealth, perpetual self-optimisation, the practice of power as men practise it. The truth is an awful lot of writing by women from earlier eras does not criticise patriarchal views of male–female relations, and an awful lot of writing by women from earlier eras supports and attempts to enforce Christian teachings including unquestioning submission to men. Those literary detectives uncovered the lives and works of women who had very little agency, expressed few signs of resistance and were, whether by choice or necessity, the pawns of the men around them. Having worked so hard to recover writings by women, what happens when that work doesn't fit with a specific feminist agenda?

The answer is not to exclude some writers (not feminist enough) or to distort others (what she *really* meant was …) or even to see all women as (openly or covertly) subversive or transgressive, but instead to attend to their lives and work, even – *especially* – when they are different to us.

It is not simply a matter of recognising that many of the authors in this book lived and worked in deeply religious societies in which any and all questions were understood and explored through the lens and language of faith. Our perspectives and vocabulary might have changed but the questions have not.

More importantly, let's recognise that many women, past and present, feel fear. Many, over centuries, have sought *not* to stand out,

have made sure not to challenge their society's view of womanhood, have maintained anonymity for self-protection. One glance at social media today is enough to suggest the reasons why. We should not, we must not, blame those who have been silenced or are compliant with their own oppression for not being brave enough. But nor should we end up in a place where talking about the sex and gender of authors is deemed irrelevant. We need to ask why, still, the vast majority of works considered 'great' are male-authored. Why men's work has endured more steadily than women's. Why, still, men read men. The questions appear simple. The answers can be complex and, sometimes, uncomfortable.

The parameters of this book are self-evident. I selected great authors with compelling and surprising life stories. All are white and were born in England, their careers spanning approximately five hundred years, roughly 1400 to 1900. These parameters reflect my particular areas of expertise but it is impossible, I hope, to miss the parallels with other authors who have been sidelined by traditional literary history, whether because of their class, ethnicity, sexuality or the colour of their skin. Pre-echoes of our world now can be heard on every page. But my primary concerns are sex and gender, and my primary goal is to honour the memory and achievement of those born female who used their words to gain a sense of control over events or their own destiny, whether in this life or the next, who took the courageous step to shape their experiences and understandings into literary form, who spent their energy fighting battles simply by virtue of their gender.

So, let's scavenge and rebuild in the face of the destruction of women's work. Let's find the scraps, or rather the precious gems amidst the rubble: they form the foundations of the book you are now reading. Let's be aware of the danger of trying to arrange (in the words of Anna Fisk, the biblical scholar who made me think again about Esther) 'the torn-apart fragments into a new harmonious whole'. Let's leave in the mess and the contradictions – and explain why they are there.

& blysse þe lord, for mary mawdelyn, for mary Egypcyan, for seynt
powlesse for seynt Austyn. And as þ haþt schewyd þi mcy to hem
so schewe þi mcy to me. Tpre alle þ aftyn þ may of hert . þe
pees & þe rest þ þ þ haþt beqwothyn to þi dyscyplys & to þi
louarys þf stone pees & rest mote þ beqwothyn to me in erth .
& in heuyn wtowtyn ende. haue mend lord of þe woman
þ was takyn in þe aduterye & browte be forn þe. And as þ dreue
a wey alle hyf enmyys fro hyr þe sche stod alone by þe so
uerily mot þ dryuyn a wey alle myn enemyys fro me þþyn
bodyly & gostly þ I may stondyn alone by þe & make my
sotble ded to alle þ þoyrs of þe world & glory & grace
to þy cõtemplacyon in god. haue mend lord of lazar þ lay
iiij dayis ded in hys graue & as I haue ben in þ holy stede
þ þ body was qwyk & ded & cursyd for mannys synne &
þ lazar was reisyd fro deth to lyfe sw twyftly lord yf any
man er woman be ded in þe owld be dethly synne & yf any
þcar may helpyn hem there my pyerys for hem & make
hem to lewyn wtowtyn ende. & I þ cry lord for alle þe
synnys þ þ haþt kept me frowþyheþt I haue not do. And
I þ cry lord for al þe forwe þ þ haþt gowyn me for þ
þ I haue do. ffor yer grace & for alle oþ þyys wheþt twn
nedful to me & to alle ye creaturys in erth. And for alle
þ þ ferthyn & trustyner xul ferthyn & trustyn in my pyerys
in to ye worldys ende. wheche so as yer defuryn gostly er
bodyly to ye pfite of her sotblyoþ þ ye lord grauwt hem
for ye multitude of þ mcy. Amen ꝯ ꝯ ꝯ ꝯ ꝯ ꝯ

Julian of Norwich
and Margery Kempe

*'This is a vision shown, through God's goodness,
to a devout woman'*

ORWICH, EAST ANGLIA, some six hundred years ago, and an old woman, nearing seventy, has a conversation with a woman thirty years her junior. The younger woman, who has travelled from her home town of Lynn (then Bishop's, now King's), some forty miles away, is keen to reveal the 'very many holy speeches and conversations that our Lord spoke to her soul', the 'many wonderful revelations' she has experienced. For all their wonder and holiness, she is profoundly anxious about these conversations and revelations. Is it God who is speaking to her – or the devil? The older woman offers a measured, conditional answer: if the visions are 'not against the worship of God or the profit of fellow Christians' then they are the work of a good, rather than an evil, spirit. At least, she hopes so. She is more confident when asked about the younger woman's prolonged, uncontrollable bouts of crying – days, not hours, of distress – citing the words of Saints Paul and Jerome in support of tears. She offers a final consolation, recognising that whilst both women have received 'spite, shame, and rebuking', the attacks of their enemies have in fact served to raise them in the 'sight of God'.

The middle-aged woman is Margery Kempe: daughter, wife, mother, pilgrim, visionary. The older woman is Julian, who has chosen the life of the anchorite, to be secluded in a small cell within which she has already made her grave by scraping the soil from the floor. Kempe is very much in the world, public and active; Julian very much apart from the world, private and contemplative. But both women are authors. Their meeting in Norwich in the early 1400s is a phenomenal coincidence. Even more remarkable is that, somehow, these medieval women's writings survived. This chapter tells the story of the making, the meaning – and the survival – of those writings: *The Book of Margery Kempe* and Julian's *Revelations of Divine Love*.

The *Revelations* came first. Julian of Norwich created what is known as the 'Short Text' soon after coming close to death in the spring of 1373, capturing her very real terror of death and the spiritual comfort she received from her visions. You can now see the beautiful, lightly decorated parchment that records her experiences on the British Library website. Even in digitised form, the Library is right to say it has a 'searing immediacy' from the first lines which identify the author: '*Julyan that is recluse ate Norwyche and ʒitt on lyfe*' ('Julian, who is a recluse in Norwich and is alive').[1]

Like Julian's 'Short Text' of the 1370s, *The Book of Margery Kempe*, originally created between 1436 and 1438 according to one of its scribes, survives in a solitary manuscript. It was compiled perhaps a decade later, in the later 1440s. (A letter, from Peter de Monte to William Bogy of Soham, Cambridgeshire, and dated 1440, is bound with the manuscript so it cannot have existed before that date. The paper belongs to the late 1440s, which pushes the transcription even later.) And, as with the *Revelations*, you can view the *Book* on the British Library website.[2] There you can see how one scribe, as was common practice, used red lead ink to help readers navigate the sprawling narrative: 'Book I' is particularly long, whilst 'Book II' and the closing prayers are easier to find your way through. The same scribe, or another, filled in some of the red capitals with faces. One, rather wonderfully, wrote his own name into the *Book*: 'Salthows'.

(Salthouse is a village thirty-five miles from King's Lynn, and the British Library speculates that he was a monk at the Benedictine priory at Norwich, now Norwich Cathedral.)

The manuscript of *The Book of Margery Kempe* may not have the 'searing' immediacy of the 'Short Text' *Revelations* but it still offers a powerful connection to a world almost six hundred years gone. The third remarkable textual survival offers even less of a direct connection to the medieval, since it dates from the later seventeenth century, but in content it is perhaps the most precious. Julian's 'Long Text' returns to, and greatly expands, her earlier work in (or after) '*twenty yere saue thre monthys*' ('three months short of twenty years'), recording her attempt to understand the true meaning of her revelations.

I

The most shocking claim made by both authors is the one that allows them to write. They each have a direct line to God, the supreme *auctor* or authority. It is God's '*wille*' (both his goodness and wish) that Julian creates her book, a justification she repeats throughout the *Revelations*. Don't shoot the messenger, she is saying. All she is doing is reporting the 'words exactly as our Lord revealed them to me'. Kempe's *Book* is more anecdotal but ends up in the same place. Margery is in church, and 'our Lord Jesus Christ, with His glorious mother and many saints too, came into her soul and thanked her, saying that they were very pleased with the writing of this book'. As in the *Revelations*, these moments recur again and again.

It was not a good moment for a woman to communicate directly with the divine – it probably never is. In the early 1400s, it smacked of heresy. Merely writing in English rather than Latin of religious matters was suspect. This was the era of John Wycliffe and his Lollard followers, who, in addition to dismissing the value of pilgrimage, opposing the Church's ownership of land, and being sceptical as to

whether the Eucharist was the actual transformation of the blood and body of Christ, believed that the Bible ought to be translated into the English language, the vernacular. The hope, for the Lollards, was a more direct communication between Christians and their God through the Word. The fear, for the established Church, was religious anarchy, a collapse of authority. This fear drove a punitive act of 1409 which declared it heretical not simply to create but even to have in one's possession a single biblical verse in English. A new punishment for heretics was devised, a grotesque form of execution: to be burned alive.

Both authors wrote this hostile climate into their work. Margery Kempe's *Book* tells of frequent run-ins with the authorities including a confrontation in the garden of Archbishop Thomas Arundel, heresy-hunter extraordinaire. And yet Margery Kempe survived to tell the tale. Perhaps her thoroughly orthodox devotion to the Eucharist, to the saints and to pilgrimage placated her interrogators. Perhaps her *Book* records just enough proper femininity to satisfy her critics, presenting her as obedient wife, devoted mother, venerator of the Virgin Mary. Or perhaps the Archbishop and all the other senior clergy simply thought she was just another crazy woman.

Julian of Norwich also recognises she is entering a minefield and treads cautiously. She acknowledges that her Church bars females from preaching and teaching not only because 'they are easily seduced, and determined seducers' but also because 'it is not proved that they are witnesses to divine grace'. Julian sensibly, humbly, acknowledges that she cannot be a preacher or teacher, 'for I am a woman, ignorant, weak and frail'.

So far, so compliant. In her very next sentence, however, she asserts her right to share her writings since they come directly from God, 'him who is the supreme teacher'. Not only that, she tackles head on her Church's misogyny: 'Because I am a woman, must I therefore believe that I must not tell you about the goodness of God, when I saw at the same time both his goodness and his wish that it should be known?' The double negatives serve to soften the blow, and Julian

tactfully follows up this defence of a woman's right to 'tell' about God with a reassurance that although she may be writing of 'deep theology and great' (in itself a huge claim for a woman) 'everything is in accordance with holy scripture and grounded in it'. She is being thoroughly disingenuous, since Julian's 'deep theology' will skate close to the heresy of universalism, the belief that everyone will be saved at the Last Judgement, and her *Revelations* insist that the author encounters Christ '*without any meane*' ('intermediary'). This does not leave much place for the Church and its clergy.

Already, it's clear that both Margery Kempe and Julian of Norwich write in acute awareness of their gender and their era's misogyny, a word not yet available to English speakers but foundational nevertheless. Having said that, it can be easier to label an era misogynist than to see how misogyny worked, and even more uncomfortable to acknowledge women's complicity in its perpetuation. Take (male scholar) Jean Gerson and (female poet) Christine de Pisan who both, in the late fourteenth century, pronounced that women had a 'natural' aptitude for contemplation. This sounds like good news, a bit like twentieth-century women being informed they have a 'natural' aptitude for talking about feelings, or in the words of John Gray, author of the bestselling *Men are from Mars, Women are from Venus*: 'Just as a man is fulfilled through working out the intricate details of solving a problem, a woman is fulfilled through talking about the details of her problems.' It's where one goes with that belief about essential differences between men and women that matters. Gerson argued that, precisely because women had a heightened spiritual awareness, they needed strict regulation since they had an equally innate propensity for 'partnering with the devil'. Gerson praises well-behaved, contemplative women but condemns any woman who expresses an opinion or asserts her authority. Christine de Pisan's approach looks, at first sight, to be very different to Gerson's, more allied to that of Kempe and Julian. She claims, like them, that she has been commanded to write a book to counter the contemporary attacks on women ('Take the spade of your intelligence and dig deep …

mix the mortar well in your inkpot and set to on the masonry work with great strokes of your pen'). But whilst de Pisan makes the case for women's intellectual gifts, she ends up arguing that those gifts should be used appropriately, leading her to imagine a city of 'good' women: houses of virtuous maidens, faithful wives, respectable widows, good mothers, a place pious enough for the Virgin Mary to take up residence.

Kempe and Julian challenge the misogyny of their time very differently. What they give with one hand, they seize back with the other. There is something rather glorious in the way that Julian seems to acknowledge her womanly ignorance, weakness and frailty before launching into one of the most intelligent and powerful devotional works in English – a work that enriched her young language, jostling as it did alongside the many other literary and religious tongues of the British Isles: French, Latin, Scottish Gaelic and Scots, and Welsh. Equally glorious – and challenging – is the moment towards the end of *The Book of Margery Kempe* when God reassures Margery that her life and her writing are pleasing to him, much more so than if she wore 'chainmail or a haircloth next to the skin', if she fasted on bread and water, or said a thousand prayers each day. Speaking directly to her, God says: 'you should not please me as well as you do when you are silent and allow me to speak in your soul'. Margery is 'silent', but still speaks. It's a superb way to write as a woman in a world which sought to deny a woman a voice.

The phrase 'You can't be what you can't see' may belong to our time, but it will haunt many of these chapters. Not so much this one, however, because Julian and Margery did not have to look too hard for models for being a woman and a writer, turning not, it seems, to France and to Christine de Pisan for inspiration, but east across the North Sea to the life and work of the most celebrated religious woman of her era, Bridget (Birgitta) of Sweden, and, to a lesser extent, to Italy and Bridget's younger protégée, Catherine of Siena. Both Bridget and Catherine travelled extensively, met the most powerful figures of their time, and actively intervened in the kinds

of spiritual and political matters normally reserved for men – and normally forbidden to women. Both women created texts advocating reform, designed to reach readers from popes and royalty to laypeople from every walk of life, and both collected admiring followers, men and women, who ensured that their writings were copied and disseminated, often in beautiful illuminated manuscripts that spread across Europe. The very fact that these women lived and worked far from East Anglia tells us a lot about England's connectedness to the continent at this time, and not just through war, although this was the era of Agincourt. Bridget and Catherine appear together in a remarkable East Anglian rood screen at Horsham Saint Faith, whilst Alan of Lynn – friend to Margery Kempe – created an index to one of Bridget's texts. The English world in which Kempe and Julian lived was no insular backwater.

The similarities between Kempe and Julian are obvious: same time, same place, same gender, same misogynistic climate, same concern to find a way to be an author despite the last two. Focusing on their sex risks two things. One is that these writers appear only in an appendix marked in invisible ink: 'women's writing'. The conventional literary history of the time tells of a great flourishing: William Langland; the Gawain Poet; the Wycliffite translators of the Bible; the anonymous author of the prose work *The Cloud of Unknowing*; John Gower; the big guy, Geoffrey Chaucer: Julian and Kempe are absolutely at the heart of this. The other is that the differences between the two women are flattened out – and those differences are intriguing.

II

The starkest difference is that Margery Kempe travelled and Julian remained enclosed in her cell. The upshot is that *The Book of Margery Kempe* is as much a travelogue as it is a work of devotion and for many, including me, this makes it compelling reading.

Kempe had Swedish Saint Bridget very much on her mind during the *Book*'s composition. Like Margery, Bridget had married young and borne numerous children. Like Margery, visionary Bridget transformed her life, first by pilgrimage and then by taking a vow of chastity within marriage. Fêted throughout Europe, put up for sainthood, and author of *Liber celestis revelacionum* (*Revelations*), Bridget was a clear role model for Kempe. She was also, more surprisingly, a competitor. For that's how Margery sees it, recounting the time when she saw the Sacrament shaking and flickering like a dove. Christ tells Margery that 'Bryde' (Bridget) never saw him like this. One up to Margery.

The truth was that Margery was never in the same league as Bridget: merchant class to Bridget's noble; a failed brewer, not a royal courtier; friends with the local clergy rather than followed by admiring priors, bishops, theologians across Europe. Margery Kempe of Lynn struggles even to get her book written, let alone circulated. Bridget's prophecies were conveyed to the Pope in Avignon, to the kings of France and England.

Bridget offered Margery something even better than a template for a writing woman: she embodied the lure of travel. Because Margery wanted to get away from Lynn, and not just to Walsingham (twenty miles away) or even Bridlington (over a hundred), although she visited both pilgrimage sites. Bridget's example was a counterblast to those who believed holy travel to be a dubious and unnecessary business, that there was 'no need to run to Rome or Jerusalem to look for [Jesus] there, but turn your thought into your own soul where he is hidden'. So wrote the mystic Walter Hilton, whose advice to stay home and journey inwards went completely unheeded by Margery Kempe. She wants to travel, she needs to travel, and it is as a pilgrim traveller that Kempe comes into her own. She journeys to Rome and Jerusalem, to Santiago, Wilsnack and Aachen – and Bridlington. For me, these journeys are the engine-room of her writing. Margery's pilgrimages as much as her visions offered a way for her to become an author.

For us now, the *Book* offers a rare and intriguing glimpse of the everyday reality of late-medieval travel. Pilgrims were, of course, supposed to be undertaking their arduous journeys for a clear spiritual purpose. In practice, pilgrim tours have been likened to package holidays, group travel on well-worn paths, journeys undertaken for more worldly reasons than penance. Chaucer's infamous Wife of Bath, keen on 'wandering by the way', was looking out for her fifth husband en route to Canterbury. Then again, to liken a pilgrimage to a package holiday is to minimise the challenge – and the expense. One traveller to the Holy Land tallies up tributes to the Sultan, charges to guards and consuls, entries to different ports, fees for camels and cameleers, payments to look after luggage and wine, and the fees paid to enter the Church of the Holy Sepulchre and then the Sepulchre itself. Apart from the cost, pilgrims faced challenges ranging from a complete incomprehension of local customs through getting lost to theft and rape. Wars, many and various, made the traveller's life even harder, as casually mentioned by Kempe who notes she can't 'travel easily by land, for there was a war in that region'.

And then there was the in-fighting. Kempe is a great one for annoying – or worse – her fellow pilgrims. Almost every group she joins finds her a difficult companion. All this makes for entertaining reading, six hundred years on. Her *Book* offers a glorious mix of relentless, high-level self-vindication and more visceral, everyday problems.

Another time, this creature's party wanted to go to the River Jordan and would not let her go with them. Then this creature pleaded with our Lord that she might go with them, and he charged that she should go with them whether they wanted it or not. And then she set out by the grace of God and did not ask their permission. When she came to the River Jordan, the weather was so hot that she believed her feet should burn for the heat that she felt.

The party continue to Mount Quarantine, 'where our Lord fasted for forty days'. Her companions refuse to help her up the mountain, primarily because they:

> could barely help themselves up. Then she had much sorrow, for she could not get up the hill. And then a Saracen, a good-looking man, chanced to come upon her, and she put a groat into his hand, making signs to him to take her up the mountain. And swiftly the Saracen took her under his arm and led her up the high mountain where our Lord fasted for forty days. Then she was terribly thirsty and had no sympathy from her party. Then God, in His high goodness, moved the Grey Friars with compassion and they comforted her when her own compatriots would not even acknowledge her.

Searing heat, sore feet, thirst, language barrier, a handsome Saracen – and Margery gets up the mountain.

Yes, these episodes (and there are many of them) have a devotional function, helping the reader to understand their own travails, however mundane, as opportunities to practise their faith. But they are also mightily enjoyable to read about.

As with all good travel writing, the reader gets a vivid sense of place. Jerusalem comes alive in the *Book*. Entertaining it is, but – like many other great works of travel literature – not always entirely accurate. The Church of the Holy Sepulchre is called the Temple, confusing it with a separate Temple of Our Lord (the Temple Mount, with the Dome of the Rock and al-Aqsa Mosque) held to be the site of Abraham's binding of Isaac and the First and Second Jewish Temples. At the time of Margery's visit, these buildings were Islamic, as they had been for two hundred years since the recapture of Jerusalem by Saladin. No matter. More importantly, the crises keep coming. The final journey in Kempe's *Book* is packed with them (the ostensibly pleasant stranger who turns nasty; the Teutonic Knights who stop her leaving Prussia; a kindly merchant from Lynn who steps in to help; uncomfortable nights on 'just a little straw' or a 'heap of bracken

in an outhouse') and equally packed with evidence of Margery's determination.

> It was a great marvel and miracle that a woman unaccustomed to walking, and also about sixty years of age, should daily endure to keep her pace on her journey with a brisk man travelling vigorously.

Onwards towards Calais goes sixty-year-old Margery, 'travelling by tiring and dangerous routes in deep sand, over hills, and through valleys, for two days before they got there, suffering great thirst and great penance, for there were few towns and very poor lodgings.' Nights are spent awake, fearful of being 'raped or dishonoured'.

Occasionally, Kempe's *Book* makes the case that she is more interested in 'contemplation than place-names'. There's a guilty awareness here that the true journey for Margery is (or should be) the inward, spiritual one, that the travelogue is a mere side-product of her religious awakening. Yet the pilgrimages form the backbone to her *Book*, perhaps even its narrative arc. After all her trials and tribulations, Kempe makes it back to Lynn, and finds that the friends who loved her before she left still loved her '*whan sche come hom*'.

Along the way, the most significant moment occurs in Jerusalem, the city crucial to Margery's outward and inner journey. She understands this, because having seen the earthly city, she prays to see 'the blissful city of Jerusalem above, the city of heaven'. The earthly city was, in the early 1400s, a provincial backwater with a population not much more than Margery's hometown of Lynn, not worthy even of being fortified. The Franciscans were the only representatives of western Christianity, permitted by the Mamluk Sultan to hold services in the Church of the Holy Sepulchre. But it was still Jerusalem, and by travelling there Margery was quite literally following in the footsteps of centuries of previous pilgrims – and authors. A thousand years before Margery set out from Lynn, Egeria, a fifth-century Galician nun and the earliest writer of a Christian pilgrimage narrative in Europe, headed to the Holy Land. The climax for Egeria would be

her visit to the tomb of Christ in Jerusalem's Church of the Holy Sepulchre. And so too for Margery, for it is there that she experiences her first bout of intense crying. It is there that she truly encounters Christ. The pilgrimage has worked.

III

Julian, in sharp contrast, had no need 'to run to Rome or Jerusalem' in order to encounter the divine. She was quite able to talk with God in Norwich. But place is as important to her as it is to Margery. Norwich has been called medieval England's most religious city, with only London as rival. Julian's home city was wealthy and busy, trading with the rest of Europe, thoroughly receptive to the religious developments across the North Sea. For women especially, from cloistered nuns to hospital sisters, Norwich offered something of a spiritual centre.

Julian was one amongst many, therefore, but she chose an extreme form of enclosure for her life religious. Her anchorhold was a small cell built against the wall of a parish church. She would have had three windows: one onto a parlour, through which she could receive food and pass out bodily waste; the second onto the street; and the third, the 'squint', which looked onto the chancel of the church, so that she could witness Mass and take the Eucharist. Windows but no door. A priest would have marked her enclosure with the Office of the Dead, a stark reminder that Julian was no longer of this world. Life in her anchorhold, for all its privations, gave Julian, to echo Virginia Woolf writing some six hundred years later, a 'room of her own'. (Not only that, she must have had the equivalent of Woolf's £500 a year since, to be enclosed, Julian would have needed to convince her bishop that she would not be a drain on the church's resources.)

She was not, however, entirely cut off from her contemporaries. The walls of the anchorhold were more permeable than one might think, something that inspired anxiety in some churchmen who

sought to limit the size of the windows – any larger than strictly necessary and the place would become a 'brothel'. (It is depressing that there appear to be precisely two settings for women in the minds of some: utter chastity or sexual depravity.) Julian had daily contact with her one or two servants and engaged with those in spiritual need who sought her out for her powers of intercession, confession and above all spiritual counsel – people such as Margery Kempe, who consulted not only with Julian but with various of 'God's servants, both anchorites and recluses and many other lovers of our Lord' and who chose an anchorite as a 'principal confessor'. Beyond this, however, anchorites were also encouraged to do manual labour, including 'the writing of material that is holy and edifying'.

Which is precisely what this dead woman did from her anchorhold, creating one of the most remarkable works in the English language. Author Julian has a deceptively simple goal. She hopes that God's message, 'we are all one in love', will comfort others as it comforts her. Her *Revelations* have done just that over the centuries, her words of comfort proving powerful and enduring. Her most famous phrase, 'But all shall be well, and all manner of things shall be well', is the culmination of a subtle analysis of sin. It is something 'befitting' which only exists in the suffering it causes, and therefore is not to be feared, since through that suffering we know God better. It is so easy to relate to Julian's fears, so lovely to bathe in her generosity of spirit, so consoling to feel protected by her God:

> Although our Lord showed me that I would sin, by me alone
> I understood everyone. At this I began to feel a quiet fear, and to
> this our Lord answered me as follows: 'I am keeping you very safe'.

At each moment that Julian experiences anxiety, even a desire to die (if only to be in heaven), God reassures her, telling her she will reach heaven, so why 'fret about suffering for a while, since it is my will and my glory?' Over and over, Julian calmly reminds us that each and every one of us can be saved, that God loves us, that God is doing

and has done all he can for each of us, and that God can hold fast the strength of 'our Enemy', the devil. Although she is drawing on a tradition of writing by or for similarly enclosed women, such as the renowned twelfth-century 'how-to' book for anchoresses, *Ancrene Wisse*, Julian of Norwich opens up new vistas, for she is not only writing for her fellow women, but exploring the potential of the contemplative life for all. In doing so, she joined Richard Rolle, Walter Hilton and the author of *The Cloud of Unknowing*, authors using the English vernacular to explore matters spiritual. For some, such as her editor A. C. Spearing, she surpasses her male contemporaries to produce the 'most remarkable *theological* achievement of the English late Middle Ages' (my emphasis), her 'quiet struggles with her mother tongue' allowing her to 'release richnesses of meaning'.

IV

Quiet (or not so quiet in the case of Kempe) struggles of other kinds lie at the heart of both the *Book* and the *Revelations*. The works challenge their society's deeply ingrained beliefs about the physical, intellectual and moral inferiority of women to men, beliefs which underpinned each and every institution from Church to state to family. Their authors do so by presenting themselves as mere conduits for divine *auctorite*, whether understood as authority or authorship. Going further, they make the radical claim that no one can speak of God without the visions and conversations they have experienced. They imply that one does not reach God through rationality and language. Insights are achieved in a space beyond reason or words, a place of mystical emotion.

Julian and Kempe's literary work is formed in the crucible of their struggle to use their 'physical tongue' (as Margery puts it) to 'utter' what is inexpressible in language. This is not just a matter of finding the right word in English, but finding *any* words.

Julian – capable, analytical Julian, a woman fond of a list or two – claims to be defeated. She admits that she 'neither can nor may show … openly or fully as I would like to' what she knows in her heart. She hears many times 'the voice of a sweet bird singing in her ear', 'sweet sounds and melodies' she is unable to describe. Margery is frustrated, plain and simple, that she cannot 'tell' of 'the grace that she felt, it was so heavenly, so high above her reason and her bodily wits, and her body was so feeble in times of the presence of grace that she could never express it with words as she felt it in her soul'. Margery's feeble body nevertheless speaks louder than words. To lose control, to moan, to weep, even the loss of reason, now become signs of the power of faith. It is one of the reasons Margery is so striking and so disliked.

What is exhilarating is that Margery and Julian take these potential signs of feminine weakness (the emotions, the inability to communicate) and make them a crucial part of their new form of religious experience. In doing so, both authors reveal the extent of their connection to the Europe-wide upsurge in personal, affective forms of devotion, forms which came to have a particular resonance for women. For centuries, women had been offered the opportunity to relate emotionally to Mary, mother of God, whether viewed as child and mother, teacher and intercessor, Empress of Heaven and Empress of Hell. Now, however, a new intensity was encouraged, and Margery, never one to use restraint, therefore passionately *identifies* with Mary when she enters the burial place of Jesus, the Holy Sepulchre in Jerusalem. There she immediately:

> fell down with her candle in her hand, as if she should die of sorrow. And after that she got up again with great weeping and sobbing, as though she had seen our Lord buried right in front of her. Then she thought she saw our Lady in her soul, how she mourned and how she wept for her son's death, and then our Lady's sorrow was her sorrow.

Julian's spiritual encounters with Mary may be calmer, but equally direct. She is given insight into Christ's love for his mother and realises, through that, how much she, Julian, is loved. 'Would you like to see in her how you are loved? For love of you I made her so high, so noble and so excellent; and this makes me glad, and I want it to gladden you.'

For all the heightened emotion, the experiences are recounted in a homely, domestic way which, in itself, carries a profound theological message. God himself is 'homely' in all its medieval richness of meaning: friendly, familiar, intimate, courteous. Margery even has regular chats with Christ, God and the Virgin Mary. One of my favourite moments is when she retorts to someone, 'My Lord Jesus Christ told me as much just now.'

Which brings us to Jesus, since, for all the interest in his mother Mary, the main goal for both Margery and Julian is the possibility of an ecstatic union with God made man, with Christ himself. Both authors offer their readers a visceral, sensual, bodily engagement with the humanity of Christ. Julian visualises his suffering on the cross in painful clarity. She writes of the discolouration of his face, of his shrivelled nose, his flesh ashen, blue, 'then darker blue', colours 'fresh, red-tinted and lovely'. She sees Christ's thirst. This is painful, emotive writing.

> And in this, sodenly I saw the red bloud trekile down from under the garlande, hote and freshely, plentously and lively, right as it was in the time that the garland of thornes was pressed on his blessed head. Right so, both God and man, the same that sufferd for me. I conceived truly and mightily that it was himselfe that shewed it me, without any meane.

Margery is equally engaged with the crucifixion. When she sees the wound in Christ's side:

> shedding forth blood and water for her love and for her salvation – then she fell down and cried out with a loud voice, marvellously

twisting and writhing in her body on every side, spreading out her arms wide as if she should have died, and could not keep herself from crying and from these physical movements, due to the fire of love that burned so fervently in her soul with pure pity and compassion.

Bodily sickness is the beginning, for both women, of their closer relationship with Christ, the catalyst for spiritual self-transformation. Julian is near death. A priest and a boy come, they show her a crucifix, the last rites are underway. But at this critical moment, as her own body is dying, Julian has her vision of Christ's crucifixion and is so overwhelmed that her mother who is watching over her believes she has died. Instead, this is the beginning of her journey to the anchor-hold, to religious insight. Young wife Margery's account of breakdown is equally moving, equally real, and Christ plays an equally important role. Pursued by devils, she would have:

> killed herself many a time at their promptings and been damned with them in Hell, and in witness of this she bit her own hand so violently that the scar could be seen afterwards for her whole life. And she also violently tore her skin on her body over her heart with her fingernails, for she had no other instruments and she would have done something worse but that she was bound and forcibly restrained both day and night so that she could not have her way.

Then, thankfully and remarkably, Jesus comes and sits on her bed and talks to her. He reassures her that although he loves chaste virgins and widows most of all, he also loves wives. He comforts Margery by telling her that she will feel better when she has another baby. She should not worry about her (unnamed, indeed never to be named) sin. It is not what you've done, it's what you are going to do that matters. Mary Magdalene is held up as an example, along with Saint Paul. And Margery begins to recover.

Both authors, throughout these passages, throughout their works, proclaim the devotional validity of precisely those aspects of their womanhood that should disable them: their bodies and their emotions. Somewhere, somehow, out of all the misogyny surrounding them[3] – women as the 'unhappy source', the 'evil root', the 'corrupt offshoot' of man, bringing 'to birth every sort of outrage throughout the world', to quote one Marbod of Rennes – Kempe and Julian found a way to reclaim their bodies as spiritual vessels. This was no mean feat. Yes, as mentioned in my opening chapter, I can point, somewhat gleefully, to a medieval poem in praise of genitalia (Gwerful Mechain's *Cywydd y gont* or *Poem to the cunt* celebrates 'a fine bright cunt', not to mention the 'fur of a fine pair of testicles', 'lovely bush, God save it'), and yes, we are decades into feminism's attempted deconstruction of the male gaze, but then and now there were and are some powerfully destructive beliefs about women's bodies. One example should do. Across the fourteenth century, there was only one hospital in Norwich that catered for pregnant women and breastfeeding mothers: Saint Paul's. Other charitable institutions excluded them because their bodies were so visibly polluted, and even Saint Paul's insisted on chastity and continence from its nursing staff if not its patients. The spectre of women's monstrous lusts, the fear that they would lead men into temptation, above all women's essential capacity to defile solely by existing, infused every aspect of life, from the size of anchorhold windows to the care of expectant mothers. Overlaying this disgust with the faulty female body was the dismissal of the inadequate female mind. Since the expulsion of our first parents from the Garden of Eden as a result of Eve's sin, God had decreed that, in a fallen world, the more rational male should have authority over the irrational, desire-driven woman. Therefore patriarchy.

But when Julian and Margery meet, emotion, the mark of corrupt woman, is redeemed. Julian validates Margery's feelings: it is the very intensity of her emotions which gives her authority and authenticity. Margery's weeping becomes a sign of her genuineness and her faith, despite or because of the constant critiques of her contemporaries:

Her weeping was so profuse and so constant that many people assumed that she could weep and then leave off whenever she wanted, and therefore many people said she was a false hypocrite and that she wept in public for comfort and for worldly profit. And then very many people who had once loved her whilst she was in this world abandoned her and would not acknowledge her, and all the time she thanked God for it all, desiring nothing but mercy and the forgiveness of sin.

Margery Kempe's *Book* makes us see that the demonstration of emotion through the female body could work as a badge of piety but could also lead to rejection and abuse, accusations of insanity, or worse, of demonic possession. The *Book* knows this, drawing repeated attention to those who believe she is a deluded fake at best, a deluded victim of the devil at worst, with charges of madness, epilepsy and drunkenness thrown into the mix as well.

What is so moving about her *Book* is that Margery herself is one of her own critics, racked with fear that she has indeed 'lost her wits'. Again and again, she is anguished by her feelings:

These feelings and similar ones, many more than can be written down, both about living and about dying, of some who will be saved, of some who will be damned, were a great pain and punishment to this creature. She would rather have suffered any physical penance than have these feelings, and she might have put them aside as she was so afraid of the illusions and deceptions of her spiritual enemies. She sometimes had such bad trouble with these feelings when they did not seem quite accurate to her understanding, that her confessor worried that she should fall into despair over them. And then, after her trouble and her grave fears, it would be shown to her soul how the feeling should be understood.

Margery doesn't need her enemies to tell her that these 'feelings' could be delusions, that they might not be true, that she might be mad, that

they might be the work of the devil. She and her contemporaries viewed the devil as an active player in the world, only too ready and willing to plant a demonic vision in a weak person's mind. Indeed, some commentators condemned any and all visions: 'You should not regard any vision that you see, whether in a dream or a waking state, as anything but a delusion, because it is nothing but his [the devil's] trickery', says *Ancrene Wisse*.

All this makes it the more astonishing that Margery stands by her emotional responses. When she is challenged by a friar to admit that she is physically ill, she responds robustly: she '*hirself knew wel be revelacyon and be experiens of werkyng it was no sekenes, and therfor sche wolde not for al this world sey otherwyse than sche felt*'. Kempe walks the fine line between excessive emotion and madness, but she walks it. Six hundred years on, and we are still pathologising or medicalising Margery. Kempe's 'abnormal psychology' is pored over: she is a neurotic; she is suffering post-partum psychosis; she is paranoid; she is bipolar. She is experiencing sexual hysteria; she is psychopathic; she has frontal-lobe epilepsy. Maybe she suffers from Tourette's, which might explain the crying, or, my favourite, she is menopausal.

Seen from another angle, these attempts to control through labelling are in fact a sign that literature by women is doing some powerful work, and I have not even got onto the aspect of both the *Revelations* and *The Book of Margery Kempe* that has the ability to challenge and disturb us most, now.

V

First Margery, who ends up in a remarkable place in part because of her preoccupation with virginity, or more precisely, her lack of it, since she is married and has a baby when she suffers her first breakdown. To many of us – though not all – in the twenty-first century,

this preoccupation seems extreme but Margery knows (because her Church tells her) that virginity is the highest form of womanhood, so she sets out to become one. Her first, striking step is to negotiate a celibate marriage, negotiations which are, shall we say, frank and to the point. Margery goes to her husband and offers to pay all his debts before she heads off to Jerusalem, so long as he doesn't come into her bed. She will then make her body 'freely available to God, so that whilst you live you never make any demands of me to ask for the matrimonial debt after this day, and I shall eat and drink on Fridays at your command'. What a deal! Margery casually alludes to her pilgrimage to Jerusalem, which needs the permission of her husband and the Church authorities, and offers as *her* great sacrifice to eat and drink on a Friday. Delightfully, her husband agrees: 'May your body be as freely available to God as it has been to me.' Rather touchingly, Mr and Mrs Kempe then pray together, 'kneeling under a cross, and after that they ate and drank together in very high spirits. This was on a Friday, Midsummer's Eve' (the day of the week making clear that Margery keeps her side of the deal immediately). So far so good: Margery rolls back the years, erases her decades of marital sex and childbearing, and becomes once again chaste, if not strictly virginal.

And yet earthly lust does not disappear, much to Margery's distress. She's a woman who contemplates 'Christ hung before her in His manhood before her physical eye', who experiences (aural) reading and (dictated) writing as profoundly sensuous experiences. She hungers for God's word, she wants to be filled with the divine. She dreams of bathing, cuddling, kissing the Christ child. The *Book* is clear, explicit even, about her sexual desires. A man she likes says he will have sex with her. After much toing and froing, she offers herself to him, and he rejects her. This erotic crisis precipitates a remarkable intervention from Jesus Christ, who commands his creature, Margery, 'to call me Jesus boldly, your love, for I am your love and shall be your love without end'. It doesn't stop there. Margery receives a vision of Jesus while she is at church. He tells her to take off her hair-shirt, to stop eating meat, because she should eat only

his flesh. He will never forsake her: 'neither devil in Hell nor angel in Heaven nor man on earth shall ever part you from me'. Margery wears a ring, by God's command, inscribed with the words '*Jesus est amor meus*', for as Christ explains to Margery, the more intimate she is with him on earth, the 'more worthy and right it is that I shall be more intimate with your soul in Heaven'.

Now, there are sound theological foundations for this intimacy with 'our Lord', who is 'so familiar and courteous', in the scriptural references to the Bride of Christ. All devout Christians can connect, metaphorically, with the divine in this way and, although Margery and Julian ramp it up a bit, bonding over their love for Jesus ('the anchoress and this creature had much holy conversation in talking about the love of our Lord Jesus Christ for the many days that they were together'), we can place this all safely within the affective piety spectrum. Over a hundred years before Kempe's *Book*, *Ancrene Wisse* had suggested that during the taking of the Eucharist, women might experience a state of ecstasy in response to the bodily presence of Christ in the consecrated bread and wine. Ecstatic symbiosis took different forms, but included women joining in the bodily experience of the Virgin Mary, holding Christ within her womb and able to bring him into the world. In *Ancrene Wisse*, the woman 'quite out of the body' joins with Christ her lover in a 'burning love embrace'. There, 'hold him tightly until he has granted you everything that you ask'. The goal of this affective piety? Mystical union.

But it could all get very real. It certainly does for Margery. Her response to Jesus's body is intense and sensual – he has blissful hands, tender feet (she's noticing these things in a man who is being crucified) – and culminates in a full-blown erotic encounter with him, complete with intense smells, burning heat and fire, not to mention some white flashes. (These 'symptoms' according to some scholars indicate variously the hot flushes of menopause or an epileptic attack. Some of us might see them differently.) Almost every aspect of Margery's relationship with God is framed in sexual terms. Mary Magdalene, as had Bridget, becomes Margery's rival for the love of

Jesus: she wants Jesus 'by herself alone'. She therefore reimagines the biblical Mary's encounter with the risen Christ. In Scripture, Mary Magdalene is obedient to Christ's wish not to be touched, accepting his famous command '*noli me tangere*'. In Kempe's *Book*, Margery longs to be touched. To Margery, not Mary, Christ reaches back.

Kempe is not interested in the modern feminist biblical scholar's rehabilitation of 'sinner' Mary Magdalene as the most prominent of Jesus's female disciples. Nor does she enquire as to whether Mary was the sister of Lazarus and Martha, and thus the same woman who anointed Jesus's feet before the crucifixion, a controversial identification (currently rejected by both the Roman Catholic and Eastern Christian Church) which makes the Magdalene crucial to the key moments in the Passion narrative: anointing, crucifixion and resurrection, the *noli me tangere* exchange. And therefore, not for Kempe the route taken by twentieth-century writers like Margaret Starbird, who views Mary's anointment of Christ's feet as a literal marriage preparation, carrying symbolic associations with the anointing of the masculine by feminine secretions during the joyful consummation in the secluded bridal chamber. It is only a short step (and Dan Brown makes it in *The Da Vinci Code*) to view Mary Magdalene as Jesus's lover, his wife, the mother of his child. The success of that book and the popularity of views such as Starbird's suggest that we, today, want Jesus to be a bridegroom in the sense of being a guy with conventional heterosexual needs, a wife and a kid. We want to put Mary Magdalene, tart with a heart, in bed with Jesus as his wife, or as Scorsese's *Last Temptation of Christ* has it, Jesus fails in the eyes of Mary by not having 'the courage to be a man'. But it is not a step that Margery takes. Her glorious egotism means that *she* is to be Christ's Bride, not Mary.

At first sight, it appears that Julian takes the theological temperature down a degree or two. Although she insists, like Margery, that we *look* directly at Jesus's body and she achieves, like Margery, an immediate connection, right here, right now, with the divine, spending her days (and nights) in the presence of God, the *Revelations* have none of

the *Book*'s variously distressed, joyous or frenzied sensuality. But look more closely, and Julian is in fact the more radical of the two writers.

For all her fantasies of sucking at Jesus's breast, Kempe will not reimagine God as both male *and* female, perhaps even beyond our categories of sex and gender. But this is precisely what Julian of Norwich does, taking an understanding of that other Mary (the Blessed Virgin) as mother to us all, running with it, and reaching an astonishing statement: 'our Saviour is our true mother in whom we are eternally born and by whom we shall always be enclosed'. What is more, Julian understands the Trinity as both male and female: 'the great power of the Trinity is our father, and the deep wisdom of the Trinity is our mother, and the great love of the Trinity is our lord'. These are not metaphors, these are truths: 'As truly as God is our father, so truly is God our mother'. Jesus is 'our true mother by nature', a creative, nourishing Christ. In this feminised theology, crucifixion is reconfigured as rebirth, and in the Eucharist, Jesus gives the believer his body, just as a mother feeds her baby: a 'mother lays her child tenderly to her breast, but our tender mother Jesus, he can familiarly [Julian uses that word *homely* again here] lead us into his blessed breast through his sweet open side'.

Scholars point, solemnly, to scriptural precedents. Isaiah, in the Old Testament, asks 'Can a woman forget her infant …?' Yet the biblical metaphor is only briefly sustained, and the response to the question emphasises the mother's potential inadequacy: 'If she should forget, yet will not I forget thee'. Others, quite rightly, point out that other writers used mothering as a description for the nurturing, loving and disciplining that the soul receives from God, or represented Jesus as lactating and birthing mother. But Julian does something new, as the authority on all things literary and medieval, Caroline Bynum, explains. God's motherhood, expressed in Christ, is 'not merely love and mercy, not merely redemption through the sacrifice of the cross, but also a taking on of our physical humanity in the Incarnation, a kind of creation of us, as a mother gives herself to the foetus she bears'. Or as Julian herself puts it, 'the second person

of the Trinity is our Mother in nature in our substantial creation, in whom we are founded and rooted, and he is our Mother of mercy in taking our sensuality'.

Julian is joyous and explicit in her revelation of God as mother creator, father – and spouse:

> And so I saw that God rejoices that he is our father, and God rejoices that he is our mother, and God rejoices that he is our true spouse, and our soul is his much-loved bride.

For many, this is what makes Julian special. I'm happy to consider that, when she uses an illogical phrase such as 'Our mother Christ, he gave us …', that masculine pronoun may have been put there to protect its writer from the charge of feminising Christ. But both genders are there, and they stand, six hundred years on, as a powerful challenge to reductive understandings both of sex and the divine.

VI

Time to ask a question that possibly crossed your mind earlier in this chapter. Who actually was the author of *The Book of Margery Kempe*, a work written almost entirely in the third person? One straightforward answer, offered by many if only to get women on the literary history radar, is that Margery Kempe (born in Lynn in Norfolk in around 1373) wrote the *Book*. This makes her the first woman to write an autobiography in English. For all the feminist mileage in this, the answer looks simplistic from the first page of the *Book*, in which Margery Kempe appears as a character, 'this creature'. The male scribes who report the experiences and insights and memories of 'the creature' are, it seems, the actual authors, with Kempe the *source* of the work's material. Indeed, the activities of scribes, listeners, amanuenses and collaborators are foregrounded

throughout the text, so that the reader can never forget that this is a work that has been created for illiterate Margery by the hands of others. The most extreme answer to the question is therefore that the *Book* is entirely the creation of male scribes and clerics, who, even if Margery's experience provided the raw material – and even that is not accepted by all – wrote or rewrote the text so completely that it becomes their (men's) work. *The Book of Margery Kempe* should therefore be thrown out of this chapter, this book.

Or not. For starters, Kempe is the dominant figure both within and outside the text. It is 'the creature', for example, who is described as controlling the manuscript's moment of creation, waiting for twenty years to pull the trigger. There are other hints that 'the creature' may not, in fact, be illiterate. The character's guard slips when, very occasionally, she mentions reading or hearing things read. Perhaps Kempe is being as strategic as Julian of Norwich, who claimed to be a '*symple creature vnlettyred*' in the midst of a text which shows her to be anything but unlettered or simple. Some scholars go even further. They argue that the male scribes in the *Book* are sophisticated fictions, created to legitimise Kempe's literary creation and to deflect criticism from her authorship. No scribes, therefore, but a woman 'of forty-something (that age, thought of as post-menopausal and thus less "female" in which so many medieval women began to write), who sits down to record a series of visions and adventures that occurred some years before', in the words of Lynn Staley. Put another way, even if the scribes had not existed, Kempe would have been required to invent them, if only to give her words the authority of the Church.

Was Margery Kempe perfectly capable of writing her own book, but used the fiction of male scribes to authorise her foray into the male world of authorship? We need a subtle definition of literacy to answer that question. The *Book* records that Margery '*cowde no letter*', that she is unable to understand Latin, that she cannot even read her own name in a vision of the Book of Life. Yet her *Book* is also filled with echoes of and quotations from other narratives; works that were read to 'the creature', preached to her; stories experienced by her in

mystery plays, liturgical processions, church murals and stained glass windows. Kempe engages with Scripture orally and aurally: she can even quote Latin if it is from the Psalter, she has heard it enough times. (It doesn't do her any good in this particular confrontation because even though, intellectually, she wins the argument by citing Scripture, her opponents are horrified at her doing so in the first place.) In other words, Margery is in fact literate in the sense she has knowledge of literature, even if she might not actually be able to read, let alone form letters.

In her time, this was the norm. Most of her contemporaries (men and women) used scribes, and almost all her contemporaries accessed texts aurally rather than visually. Even those who *could* read often chose not to do so, preferring to *hear* books in group settings, whilst solitary reading was usually conducted aloud, and writing was performed orally, by dictation, not least because the act of transcription, the craft of the scribe, was so challenging. Even before ink could be applied to vellum, both materials had to be created. An animal carcass would be soaked in lime solution to remove hair and flesh, stretched, bleached and scraped to create an even thickness – then cut to create pages. Oak galls needed to be collected (swellings on oak trees formed around gall wasp eggs), smashed into powder, mixed with copperas (iron sulphate), covered with water, left in the sun for days, then mixed with gum arabic. Then your quill: a feather from a goose or swan, the nib cut with a pen-knife. A chain of people, animals and insects went into the making of the vellum, ink and pen even before a word was set down. The process is emblematic of a time and world in which books were shared, in which reading and writing were neither solitary nor silent activities.

This is how I see Kempe. She is not *reliant* on scribes, she is creatively collaborating with them. I would go further. I find it hard to see *any* literary work of any era as emerging from a solitary individual and this fact in and of itself leads to the misunderstanding or devaluation of women's achievements. Remember Lara Rutherford-Morrison's description of the Matilda effect? When men and women

work collaboratively or on similar projects, 'the men's – very real – accomplishments were lauded, while the women's were downplayed or even erased'.

Collaboration in the medieval era was built in to the process of creating literature, and all the more so for women who, even if they operated behind the screen of anonymity, would need to work with others, whether practically (getting the materials necessary to write, employing the skills of a scribe) or institutionally, gaining permission from their superiors to create and circulate a piece of writing.

I see the words 'the priest who wrote this book' and imagine a cleric transcribing Margery's words, preparing his quill, scraping off mistakes with his knife, perhaps trying to keep the sheets of vellum in order. I can even imagine the young priest who was Kempe's most significant collaborator, a man with whom she read books for seven or eight years. I see a reciprocal relationship, with Margery causing the priest to read 'much good Scripture' and *many a good doctowr whech he wolde not a lokyd at that tyme had sche ne be*', and providing him with spiritual solace. Her male scribe finds writing to be an emotional experience, with intense bodily reactions: 'he who was her writer sometimes could not stop himself from weeping'. This is not Margery being read *to*, but reading *with*, someone and that someone is as much her 'son' as she is God's 'daughter'. The *Book* never names the priest, despite Margery being devoted to him – a reminder that we have a very modern need to put names and places to people, rather than to understand the priest by what he *does*. How much more would we actually know of him if we found he were called Brian?

None of this makes Margery Kempe any less of an author because, although I see the young priest, I also read this:

And she was ill many times during the writing of this treatise, and as soon as she set about the writing of this treatise she was suddenly healthy and fit.

Two kinds of 'writing' are in play here, although the same word, *writyng*, is used in the original. ('*And sche was many tyme seke whyl this tretys was in writyng, and, as sone as sche wolde gon abowte the writyng of this tretys, sche was heil and hole sodeynly in a maner.*') Is it too much to think that there is a contrast between those times when the book was being written *for* her (during which Margery was frequently ill) and the times when she is more actively engaged with the writing, during which her health is restored?

VII

Kempe's *Book* is most often described, and finds its place in literary histories, as the first autobiography in English. In my opening chapter, I wrote about how the emphasis on being 'first' can distract from a full appreciation of a woman's work. To label *The Book of Margery Kempe* as an 'autobiography' is equally reductive. It is a triumphant, confusing *mélange* of genres: *peregrinatio* (pilgrimage literature), mystical revelations, confession, travelogue, spiritual biography, extended prayer – with a dash of romance, prose tales and biblical parable thrown in – and all perhaps in the service of making a saint's life, hagiography. Autobiography is also far too narrow a term for such a *collaborative* way of writing. And, bluntly, the *Book* doesn't look much like an autobiography: written in the third person, riddled with gaps and inconsistencies, not least that the reader is told that 'the creature' had fourteen children, but the text mentions only one son, and not even by name.

All this gives literary historians and biographers a headache. As Sarah Rees Jones observes, there is 'no evidence outside the text that Margery Kempe, either author or subject, ever existed', which forms part of her argument that the *Book* was perhaps 'written by clergy, for clergy, and about clergy'. What we think we know about the flesh and blood woman who (might have) lived some six hundred years ago can

be scribbled on the back of an envelope, or conveyed in a couple of tweets. Daughter of John Burnham, five-time mayor. Native of Lynn in Norfolk. Married Mr Kempe when she was almost twenty. Had a son who did business between Gdańsk and East Anglia. A 'Margeria Kempe' is admitted to the Lynn Guild of the Holy Trinity in 1438. The next year, her name appears again, but then nothing. By the end of the decade, it is assumed that she is dead.

The *Book* itself is, however, packed with places that exist (Venice, Santiago, Rome, Jerusalem and Bridlington) and people who lived. The protagonist, the 'creature', Margery, has run-ins with the Bishops of Lincoln and Norwich and the Archbishop of Canterbury; she is defended by Richard of Caister; she visits Julian of Norwich. Brave scholars see this rich circumstantial evidence and devise coherent, almost plausible chronologies for these journeys and encounters, all in the service of traditional life-writing. On 21 May 1415 she is in Norwich, and receiving communion dressed in white. Two years on, in July 1417, she leaves for Santiago de Compostela from Bristol. Margery first attempts to get her revelations set down in 1432, also the year (perhaps) of her husband's and son's deaths. In 1433, she sails from Ipswich to Gdańsk via Norway; visits Wilsnack and Aachen, returning to Dover via Calais.

To this personal chronology are added the kinds of events that get into traditional histories, such as the deposition of Richard II by Henry IV in 1399. Is it significant (maybe it is) that in the year we think Margery receives communion dressed in white, the Council of Constance confirmed Bridget of Sweden as a saint? Is it significant (maybe it is not) that this, 1415, was also the year of Agincourt? The *Book* doesn't seem interested in the kings and queens of England. Indeed, it operates differently, blissfully unaware of our modern historical and literary methods. When it seems to offer up a date, it works as much symbolically as historically. It is suspiciously seren-dipitous that the book is started on precisely 23 July, the day after Saint Mary Magdalene's feast day, and the day of the feast of the death of Saint Bridget. Even if Margery's scribe did not begin to

write on 23 July, it made good sense to say he did, harnessing the Magdalene and Bridget to the *Book*'s cause. More often than not, the *Book* is less concerned with precisely *when* events happen, more with the transformational nature of the events themselves. Does it matter in which year the eight months of illness after the birth of her first child occurred, or the exact moment Margery was freed from sexual obligations to her husband? No, what matters is that these are both steps on her journey to her mystical marriage with the Godhead in the Apostles' Church in Rome. Even this notion of a linear 'journey' may be missing the point. Scholars point to the co-existence of several different and sometimes contradictory kinds of time in the medieval era: agrarian, genealogical, cyclical, biblical, historical. Add the mystic's celebration of the 'everlasting now' and our modern concern with linearity begins to seem reductive. One thing does lead to another, but for the *Book* to work – whether we purely want to know more about Margery, whether we are seeking spiritual consolation – we need, perhaps, to abandon our attempts to impose an orderly temporal arrangement of events.

Something more interesting, more literary, is going on. The *Book* is created from memories, from the contents of Margery's mind.

> This book is not written in order, each thing after another as it was done, but just as the story came to the creature in her mind when it was to be written down, for it was so long before it was written that she had forgotten the timing and the order of when things happened. Therefore she wrote nothing other than that which she knew full well to be the whole truth.

Linearity is not the point. Authenticity is.

To be writing about the self at all, as the *Book* does, in the early fifteenth century is, bluntly, remarkable and exciting. Yet, still we want Margery's work to stand as conventional autobiography – whether because it gives her a place in the literary history books, or because we don't want to see it as a fiction. We want Margery to be real.

Scholars have come up with a useful term, 'autography', to describe works which offer an account of a person's life but, at the same time, foreground the difficulty inherent in reproducing lived experience. These are literary texts that reveal the necessity of gaps and silences, that draw attention to the self-in-the-making. 'Autography' may be a deliciously sophisticated way to understand *The Book of Margery Kempe* but when readers are faced with full-on Margery the wheels tend to come off this nuanced postmodernism. Even the most sensible of literary critics engage with Margery rather than the *Book*. She, the woman, is sometimes praised – intense and authentic, energetic and mobile – but far more often disparaged: changeable, 'queer' (used pejoratively in the 1930s), a wet blanket, difficult, egotistical, neurotic and sick, deeply aggravating. Even her fans have called her not merely garrulous but at times downright irritating. It seems that Margery annoys us now as much as she did her contemporaries.

But we are still talking about her. Margery herself (see, I am treating her like a real person), when disliked by her fellow pilgrims, took comfort in her memory of Christ's words to her before she left England: 'Daughter, I shall make all the world marvel at you, and many men and many women shall speak of me out of love for you, and worship me in you.' For Margery – whatever each of us means by Margery – is indeed marvellous.

Julian's *Revelations* too are structured around things recollected, sometimes from long ago, and now revisited in the author's mind: she specifically says that she reads the memories of the revelations ('showings') as if they are a treasured book. We know, if anything, even less about the author of the *Revelations*, yet it does not trouble us in the same way. It was only in the twentieth century that anyone bothered to suggest who Julian was, but once a skeleton for her biography was created (as with the *Book*, based on the *Revelations* themselves, rather than external documents) it was only a hop, skip and a jump to a really quite detailed author bio. Julian may have been born in 1343, the same year as Geoffrey Chaucer. We are pretty sure that by 1390, she had taken anchoritic vows and entered the cell

at the Church of Saint Julian, and that church might have been in Conesford. We think she began writing the book future generations titled *Revelations of Divine Love* five years later. We don't know when she died. She may have been a nun, an unmarried daughter or a widow before choosing the life of an anchoress. She may have been a mother, because she writes about motherhood. We all bend the incredibly sparse historical facts to fit our notion of the author. So, one account of Julian's Norwich insists that it is entirely fitting that she was enclosed in Conesford – a run-down, red-light area with a certain reputation – because the *Revelations* show her understanding of a Christ sharing in the sordid mess of human existence. Elsewhere, another local historian reassures me that the Church of Saint Julian stood in a wealthy residential area: no sex workers loitering around the church in this version.

Few have argued or would argue that 'Julian of Norwich' is an enabling fiction. Almost all accept that an actual woman wrote the book. In the end, though, we have only a location and a rough time-frame. Julian, named after her church, is present as a female authority, but invisible as a particular woman. She may well have had good devotional, theological reasons to subsume her individuality. Any spiritual experience she has belongs to everyone: 'I saw that I, yes, and every creature living that would be saved, could have strength to resist all the fiends of hell and all spiritual enemies.' When she moves from 'we' to 'I' ('thus I wish to love, and thus I love, and thus I am saved'), she offers an immediate clarification: 'I am speaking in the person of my fellow Christians.'

Julian, here and throughout her work, has the ability to speak across the centuries, and to speak about the difficult things. Because, when it comes down to it, this is why these women, these books, matter. Every reader will relate to Julian and Margery Kempe in a different way, draw different things from their words. For some, Julian of Norwich is a superb chronicler of something we might now call depression. She captures a fleeting moment of 'spiritual pleasure', when she is 'filled with eternal certainty', but this is only

too quickly followed by darkness: 'then my feeling was reversed and I was left oppressed, weary of myself, and so disgusted with my life that I could hardly bear to live'. She is painfully aware of the difference between knowing something rationally and feeling it truly. She has, she understands, 'faith, hope and love', yet at the same time 'I could not feel them in my heart'. As for Margery, whether you see her as quirky or infuriating, she is a survivor. To borrow from the Kempe scholar, Rebecca Krug, Margeries wobble but they don't fall down. I could have chosen a moment from her travels to illustrate Margery's sheer guts, but perhaps one of her encounters with a man of the Church is more telling.

The episode begins 'one day long before this time' (a typically vague reference, frustrating to anyone trying to impose a chronology upon Margery's adventures) on 'a Thursday just before noon'. *This* is what matters, because Margery has offered to speak with a certain churchman in the afternoon, once he has eaten. There is a delicious sense of strategic precision here, a sense that Margery knows that she stands more of a chance of telling her story to a man once his belly is full. And so she does, speaking of her redemption, her powerful engagement with the Passion of Christ. As she talks, she becomes overwhelmed and distraught, because the images she sees are so powerful, so clear. She collapses, but instead of stopping, she doubles down, telling the churchman 'how sometimes the Heavenly Father conversed with her soul as plainly and as truly as one friend speaks to another in bodily speech'. These conversations are better than anything 'she ever heard being read'. There's more. The saints and the disciples speak to her, and it is these conversations that lead her to weep so uncontrollably – and lead her enemies to condemn her because they do not believe 'it was the work of God but that some evil spirit had vexed her in her body, or else that she had some physical sickness'. The *Book*, this episode, confronts head on the problem that is Margery. Is she possessed by an evil spirit? Is she physically ill? Is she rejecting the Church as intermediary between her and her God? Is she a fake? Is she a heretic?

The answer is, of course, a resounding no. The Vicar believes Margery, and the *Book* reassures us that 'he was a good, devout man'. He 'assuredly believed that she was very learned in the law of God and provided with the grace of the Holy Ghost, to whom it belongs to inspire wherever He will. And even though His voice is heard, the world does not know from whence it comes or whither it goes'. The Vicar recognises not only the mysterious workings of God's voice but stands up for Margery when she is questioned by the Bishop. Once again, Margery wins.

But it is with Julian that I will end. Her words have such power to comfort in part because she acknowledges so fully those moments of fear, confusion and despair. Her gift is not only to explore the fine line between illness of the body and mind, but to articulate what she calls the 'sicknesses' of impatience, despair and incomprehension. For Julian, terror comes in the form of hearing two voices, 'jabbering at the same time', of being unable to understand anything they say. But it is at these moments that God comforts her soul, 'by speaking aloud as I should have done to another person who was distressed'. And she gets through the night. Not only that, she is 'filled with the Godhead', she knows Jesus will never leave her, experiences what she calls a ravishing and restful vision. But still there is doubt: is this a form of madness or delusion? No, answers God. It is no delirium: 'accept and believe it, and hold to it, and you shall not be overcome'. And again: 'You shall not be overcome'.

Afterword

It is not enough to be a woman who writes – or in Margery Kempe's case, a woman who has a story to tell. Your words need to find a material form, which is challenging in itself, but then they need to reach people, reach readers. For that women usually need men.

Bridget of Sweden showed how it could be done, medieval-style. She instructed Alfonso, a well-placed supporter, to edit and publish her work after her death. She was lucky (and I write this having seen similar instructions from female composers over the centuries, instructions which were promptly ignored once the woman had died) that Alfonso did what Bridget asked, from editing her work through to ensuring that one of the best scriptoriums in Naples produced multiple copies, then to writing or commissioning further works which insisted on the authenticity of Bridget's visions. The goal was sainthood for Bridget, a campaign which began as soon as she died. Alfonso and others made sure that deluxe, illuminated copies of her *Revelations* were sent out to a who's who of medieval religious and secular leaders. Bridget was not only duly canonised, but her vision for a female monastic order became reality. Her work has been translated into numerous other languages, sometimes harnessed to the work of the younger Catherine of Siena. Followers of Bridget read, copied and translated Catherine's works and vice versa and thus the two women's words found their way into private humanist libraries, monastic collections and royal archives. With the arrival of the printing press, the texts just kept on coming – and keep coming, unto this day.

Christine de Pisan's route to the same destination was different but equally successful. Born in Venice in 1364, but moving to France as a child, Christine claimed to be pushed into authorship by the death of her husband and her need to support her family. (Very few women, in any era, have been brave enough to say they are writing primarily because they want to. Need is a great justifier.) Commissions flowed not least because Christine was extremely well connected to the French court of Charles V, her father having been the king's doctor and astrologer, and then, like Bridget and Catherine, Christine ensured that her work was circulated, getting her verse copied, illustrated and bound. She did not sell her books, since that is not how things worked then, but offered them as presents to the powerful. In return Christine received valuable gifts, her male

relatives were given posts at court, and she ensured we now have a robust textual legacy.

Margery Kempe? Almost nothing. Although some point to the *Book*'s remarkable survival, or the text's endurance, it is in fact a rather sorry story and this despite the fact that canonisation was most likely part of its *raison d'être*. *The Book of Margery Kempe*, if intended as hagiography, was a complete failure in its own time. There isn't even a half-hearted attempt at a cult. Margery's grave does not become a shrine. And yet, for some reason, in 1501, Wynkyn de Worde of Fleet Street, London, published *A shorte treatyse of con-templacyon taught by our lorde Jhesu cryste, taken out of the boke of Margerie kempe of lyn* and twenty years later another London printer brought out extracts from the *Book* as part of a collection of mystical works, identifying Margery as an anchoress – which is quite amusing given her complete inability to stay at home quietly. Despite these two publications from the earliest years of English printing, the *Book* disappeared once again, for another four hundred years.

Then, in the 1930s, a manuscript was found. The literary detectives have worked out that, on the basis of the paper's composition, it was probably created near Lynn, but that by the end of the 1400s, the manuscript had made its way to the isolated Carthusian monastery of Mount Grace in Yorkshire. The monks annotated it – more red ink – so we do know they read it. It is a minor miracle that this small (only 215mm by 140mm) paper codex, having lost its clasps and protected only by a medieval binding of tawed parchment over bevelled wooden boards, survived.

After that, it is all guesswork. Julie A. Chappell suggests, for example, that the *Book* travels from Mount Grace to the literary community of the London Charterhouse, in an attempt to protect it from the reformist agents of Henry VIII during the split from Rome. From there, it goes from one English county family to another (Digby to Butler-Bowdon), to be discovered in the country house of the latter.

It is a great story, a great find (imagine if we found a Shakespeare manuscript!), but in the 1930s, the response to Kempe herself was

ridicule. Commentators dismissed and derided her as hysterical, expressing particular discomfort about her laywoman's claim to be the Bride of Christ.

Julian's *Revelations* has fared marginally better in terms of reputation and visibility but not in the author's own time, with only that solitary fifteenth-century manuscript of the 'Short Text' surviving. The lack of contemporary copies leads some to argue that the work was not circulated during Julian's lifetime in order to keep its mystically challenging message away from 'inexpert readers'. But other mystical writers, such as Richard Rolle and Walter Hilton, reached a wide readership – including Margery Kempe – and there are forty extant manuscripts of *Incendium amoris*, the Fire of Love, by the first of those men. The 'Long Text' of the *Revelations* was first published in 1670, but the real breakthrough for Julian came in 1901 when Methuen published a cheap edition of Julian's work which immediately became popular – and loved.

Janina Ramirez, reflecting on the differing fortunes of the two writers with modern readers, points to the sheer medievalness of Margery's *Book*, how alien her 'vociferous mysticism' is to us now. No saint, in both senses of that phrase, Margery Kempe is:

> very much of her world, while Julian seems to transcend it. There is an almost remarkable absence of historical references in *Revelations of Divine Love*. Julian lived through turbulent times, but her work moves beyond the politics and issues that surrounded her, in search of more eternal truth.

I would suggest that Kempe is as much concerned with a quest for eternal truth as Julian. She just goes about it more messily. The *Revelations* and the *Book* have, perhaps unsurprisingly, had differing trajectories. The latter has been co-opted into a tradition of queer reading and writing, as in Robert Glück's 1994 novel *Margery Kempe*, republished with an introduction by Colm Tóibín and described by one reviewer as an embrace of pulp gay erotic fiction. The more

establishment-friendly Julian of Norwich's most famous words have been placed in a stained glass window created for the Golden Jubilee of Queen Elizabeth II in 2002 in the Chapel Royal at Saint James's Palace. Both works still live.

SALVE DEVS
REX IVDÆORVM.

Containing,

1 The Passion of Christ.

2 Eues Apologie in defence of Women.

3 The Teares of the Daughters of Ierusalem.

4 The Salutation and Sorrow of the Virgine Marie.

With diuers other things not vnfit to be read.

Written by Mistris *Aemilia Lanyer*, Wife to Captaine *Alfonso Lanyer* Seruant to the Kings Majestie.

AT LONDON
Printed by *Valentine Simmes* for *Richard Bonian*, and are to be sold at his Shop in Paules Churchyard, at the Signe of the Floure de Luce and Crowne. 1 6 1 1.

CHAPTER TWO

Aemilia Lanyer

'Then let us have our liberty again'

T WO CENTURIES ON from that meeting in Norwich, Aemilia Lanyer becomes the first English woman to have a volume of her original poetry in print. The poems themselves are compelling and challenging, but so too is the story of Lanyer's journey to this point, for music – not words – was this poet's birthright.

I

Baptista Bassano, Aemilia's father, had arrived in England from Venice with his brothers, all musicians and instrument makers, in the reign of Henry VIII. Famous for their family recorder consort, the Bassano boys had done very well in their new country, assimilating both professionally and domestically and thriving in the reign of Henry's daughter, Elizabeth I. Aemilia's mother, Margaret Johnson, Bassano's 'reputed' (probably common-law) wife, came from an equally musical family which included Robert Johnson, the man who wrote music for Shakespeare's plays. As usual, we know less

about Margaret than we do about Baptista. Margaret and Baptista's daughter, christened at Saint Botolph without Bishopsgate in January 1569, would be a Londoner born-and-bred.

For the first seven years of her life, Aemilia's father continued, as he had been before her birth, to be 'bounden to give daily attendance upon the Queen's Majesty', which meant supplying recorder music for any and all courtly entertainments. Baptista earned over £30 a year, and was close enough to the Queen to gift her a Venetian lute and get money and plate in return. If Aemilia was watching, she saw, first-hand, the curious position of court musicians, at one and the same time artisan servants but also mixing with royalty. The Bassanos lived on the margins – quite literally, in Saint Botolph *without* Bishopsgate, outside the city gates – but they were also close, so close, to serious power and wealth.

Aemilia was seven when Baptista died, leaving Margaret and Aemilia poor. Then – a transformation. The little girl was plucked from the streets of London and transported to a very different world, joining the household of Susan, Dowager Countess of Kent, the 'noble guide of my ungoverned days', as Lanyer would write later. Susan was a young dowager, widowed at only nineteen, and it is entirely unclear why the Countess would scoop up Aemilia Bassano (daughter of a woman who could only sign her name with a cross, for like most women of her era and class, Margaret had not been taught to write), let alone provide her with an excellent, extensive and rare education – rare because most girls and women were denied access to learning. There were exceptions, women such as Queen Elizabeth I herself, a royal product of the new humanist ideals about the need for women's learning, or Susan's mother, Catharine Bertie, Dowager Duchess of Suffolk, a devout, even radical, Protestant. Perhaps Susan felt equally ardent about the vital importance of female instruction.

Then again, did any of this actually happen? Some do not buy into this Cinderella story, arguing that Aemilia straightforwardly lied about her youth in the Countess's household. It is what she would *like* to have happened and, it has to be admitted, what feminist

critics want for her. Instead, Aemilia Bassano remained a low-born Londoner, as 'far from her noble patrons as the moon' in the words of sceptic critic Leeds Barroll. To get her into the Bertie household, you have to accept the following statements: musicians could be and were valued members of great households; Susan Bertie's mother had been a close friend of Katherine Parr, Henry VIII's sixth wife; the Bassano brothers served both Queen Katherine and her brother William as musicians; therefore Susan Bertie takes up Aemilia. It's a stretch, but yet, somewhere, somehow, during these years Aemilia received a rigorous education to rival that of any boy of the time – certainly as much as a young lad from Stratford-upon-Avon with his small Latin and less Greek.

That gift of education, wheresoever it came from, didn't help Aemilia much, at least in the short term. In 1587 her mother Margaret died, meaning that, at eighteen, Aemilia was on her own. She had her mother's 'leases, goods, and chattels', and the prospect, when she turned twenty-one in 1590, of a £100 legacy from her father. Nothing was forthcoming from Susan Bertie, all grist to the mill of those who question the fairy tale of the young Dowager Countess and the musician's daughter.

We do know what happened next. Henry Carey, Baron Hunsdon, a rich, well-connected courtier, cousin to the Queen, with lands in Essex, Hampshire, Wiltshire and Buckinghamshire, took Aemilia Bassano to be his mistress. He was well into his sixties. She was in her late teens. The Queen liked and trusted Henry Carey, the son of 'the other Boleyn girl', Mary – some even said that his biological father was Henry VIII – appointing him to her Privy Council and as Lord Chamberlain in 1583. Elizabeth also liked and trusted Carey's wife, Anne Morgan, who bore Henry twelve children and who turned (or had to turn) a blind eye to her husband's affair with the young Aemilia. As mistress of the Lord Chamberlain, the man in charge of theatre in England, patron of his own band of players, Bassano was now immersed in a London world of musicians, actors and playwrights. To paraphrase the comedian Caroline Aherne as

Mrs Merton: 'what first attracted Aemilia to this wealthy member of the royal family?'

What first attracted Henry to her is more elusive. Was Bassano a beauty? As with Kempe and Julian, we have no idea of her appearance, although there is one small description that survives: 'she hath a wart or mole in the pit of the throat or near it'. It's not much to go on, and in any case, Bassano needed more than beauty to gain the continued attention of a powerful figure such as Henry Carey, as even the sceptic who questions the reality of her time in a noble household as a girl acknowledges: 'it was no simple matter for someone in Aemilia Bassano's position simply to walk in off the London streets and to encounter the Lord Chamberlain of England at Court'. It is almost *impossible* to imagine if one sees her noble connections as strategic fantasy. But that is exactly what Aemilia did, and she did not simply 'encounter' the Lord Chamberlain of England but became his long-term mistress. Words written years later hint at the emotions: 'a noble man that is dead hath Loved her well & kept her and did maintain her Long'. The relationship was clearly more than a fling.

By the time she was twenty Aemilia Bassano's understanding of what it was to be a woman was broader than most. On paper, a woman had three 'estates' in life: unmarried virgin, wife and widow. In practice, Aemilia knew – from her late teens, from personal experience – of a fourth, mistress, and she liked it if only for the simple reason that it gave her financial security. In retrospect, she would say these were the best years of her life, 'fornication' or no. She had, she remembered nostalgically, enjoyed the good favour of Queen Elizabeth 'and of many noble men & hath had great gifts & been much made'.

Some see a hint here ('many noble men') that Aemilia was not only the mistress of Henry Carey, Baron Hunsdon. Some name names: William Shakespeare – hardly 'noble' but still. It's true that Carey had retained a company of players since the mid-1560s and that when he was appointed Lord Chamberlain, these actors became the Lord Chamberlain's Men. It's also common knowledge that when, in 1594,

the troupe brought in new actors and shareholders a thirty-year-old William Shakespeare joined the team. Unfortunately for those who want to put Will and Aemilia in bed together, the dates don't quite work for them to be lovers. But they both were most definitely products of the same world: specifically, the collaborative, chaotic, creative streets of London in the early 1590s.

William Shakespeare left Stratford and his wife and three children to pursue his career as playwright poet. What of future author Aemilia Bassano? The theatre-loving nobleman's well-educated young mistress fell pregnant with Henry Carey's child. Suddenly everything changed. After a long summer of plague, when those who could flee London did so (not Aemilia), she married. Not the father of her child, Henry Carey, Baron Hunsdon, of course – he was married already, and, anyway, that's not how the world works. On 18 October 1592 at the church of Saint Botolph without Aldgate – close to the other Saint Botolph where she had been christened, still outside the city gates – Aemilia married the musician Alfonso Lanyer.

The Lanyer family were another immigrant dynasty of court entertainers, Huguenots from Rouen. Alfonso, unlike Baptista Bassano, was not content to earn his living as a mere musician. He sought, almost entirely unsuccessfully, a less artisanal career, striving through these years to become a follower of the up-and-coming young courtier Robert Devereux, Earl of Essex.

Early in 1593, Aemilia gave birth to baby Henry, named after his biological father. She had just turned twenty-four. Beyond the name, Baron Hunsdon had very little to do with his bastard son, or his bastard son's mother. He would only live for another three years, and toddler Henry's life remained unchanged by Carey's burial in Westminster Abbey at the Queen's expense. Henry's father was, to all intents and purposes, Alfonso, reluctant but at least working musician. His mother was Aemilia – not yet writer.

The years go by. From mistress to wife was a comedown for Aemilia Lanyer. Although she had brought a substantial dowry in money and jewels to the marriage (Baron Hunsdon made it easy for

Alfonso), she learned quickly that anything she had was now her husband's. She also learned just how much Alfonso could spend, all towards the elusive goal of 'preferment' at court. We know this because, four years after the birth of little Henry, Aemilia began visiting the astrologer Simon Forman.

A controversial man in his own time, Forman is a deeply unreliable witness and there are good reasons to take his notes of his meetings with Aemilia in 1597 with a very large pinch of salt, but it's the closest we get to hearing her voice. And she is complaining about Alfonso: 'her husband hath dealt hardly with her and spent and consumed her goods and she is now very needy and in debt'. Alfonso was something of 'an adventuresome schemer' (in the words of Lanyer's biographer, Susanne Woods) but he was also just one of the many aspiring, but unsuccessful, men who were drawn to battles and expeditions in the hope that this time, he'd return home with the spoils of war. Sadly, Alfonso chose his ventures poorly: the disastrous Islands voyage of 1597, and the equally futile English engagement in Ireland in 1599, both led by the Earl of Essex, whose own career was in deep, deep trouble by this stage. Lanyer was frustrated with her husband, but despite or because of this she sought advancement for him. Indeed, this is her main reason for visiting Forman in 1597: she wants to know if Alfonso would gain anything from the Islands voyage of that year. She still had hope. For both husband and wife, Alfonso's musician's salary (in 1593 he was earning more than £30 a year with a yearly livery allowance of £16 2s. 6d.) was not enough.

That Forman in his notes calls her Aemilia 'Bassana' might be telling. Married for five years, she is still using her maiden name. Lanyer was almost as good a currency in the musical world as Bassano, but Aemilia kept the connection with her younger self: perhaps her father's daughter, perhaps Carey's mistress, perhaps a woman in her own right, not merely the wife of Mr Lanyer. For she may have asked Forman for his prediction and advice about her husband's career, but she was equally concerned about her *own* prospects for social advancement – 'whether she shall be a Lady & how shall she speed'.

At the time of her first visits (in May 1597, when she visited weekly, as one would do a therapist today) she was living in the Longditch area of the City of Westminster – close to the royal deer park of Saint James, not far from the royal court. But still too far for Aemilia.

II

The story I have told so far is pieced together from a few archival documents, mainly relating to the men in Lanyer's life, Simon Forman's unreliable notes and Lanyer's own, occasional and possibly equally unreliable, references to her early years in her poetry.

Others tell her story in far more sensational ways. Controversial twentieth-century historian A. L. Rowse put Lanyer on the literary map as his contender for Shakespeare's loved/hated promiscuous mistress, the real-life model for the so-called Dark Lady of the *Sonnets*. Rowse viewed Lanyer's own poetry as her revenge on Shakespeare ('something personal had aroused her anger'), was surprised that she was a 'fair poet' – one of the best of her age though this 'is not saying much' when it comes to women's writing – and published her work as *The Poems of Shakespeare's Dark Lady*. Others go even further, seeking to demonstrate that Lanyer *was* Shakespeare. The argument goes: if the dying swan is 'the standard symbol' for the author, then it becomes significant that the four times the symbol appears in the plays it echoes Lanyer's four names: Aemilia (in *Othello*), John-son (*King John*), Willough(by) (*Othello*) and Bassanio (*The Merchant of Venice*). Willoughby was the family name of Susan Bertie's mother. Oh, and there are 2,000 musical references in the plays which are 300% more musical than any others of the time which makes it obvious that someone from a musical family wrote the plays. Enter Aemilia Bassano, the Bard of Bishopsgate. More recent openly fictional takes on Lanyer make her a cross-dressing lesbian. I doubt this too.

It's fairly easy to see how Forman's depiction of a promiscuous, lustful, amoral Aemilia Lanyer can lead someone to map her onto the Dark Lady of Shakespeare's *Sonnets*, a literary fiction created in the dark corners of the Bard's psyche and his era's misogyny. This, like so many of the biographical takes on Lanyer, is grounded on the quicksand of conjecture about her skin colour, sex life and religion. Most summaries these days stop just short of making her black, the consensus being that she was dark-haired due to her Venetian heritage. We are, most of the time, less prurient about her bearing of Carey's child, less willing to take Forman's word for Lanyer's promiscuity. Her Italian roots are undisputed, but now taken in new directions, with Lanyer learning the lute as a child as a professional skill, then offering that skill along with poetry and sex to Henry Carey, modelling herself on the Venetian *cortigiana onesta*. Maybe. Aemilia's Jewish heritage is still often asserted as fact, with a respected encyclopedia of music presenting the Bassanos as secret Jews, conforming outwardly wherever they might find themselves, Catholic in Venice, Protestant in recently reformed England. That there is no firm evidence may only reveal that, in a profoundly anti-Semitic Tudor world, discretion was certainly the better part of valour. There's just as much circumstantial evidence to suggest a background of family allegiance to the hotter forms of Protestantism. Uncovering anyone's religious beliefs is a tricky business. In Lanyer's time, unless you were willing to be, at best, fined and, at worst, burned to death, most people quietly conformed outwardly with the Church of England's *via media*.

But it is Black-British, Jewish-Italian, lover-of-Shakespeare Aemilia that gets into our culture. Sexing up the Lanyer dossier began early, with Forman. The woman he met was, according to him, 'brave' (probably 'finely dressed; splendid … showy'), assertive, attractive, ambitious – a woman who has 'something in the mind she would have done for her'. The astrologer, attracted to Aemilia, and who couldn't keep his hands off many of his patients/clients, believed that she would welcome his advances. After all, she had a low opinion of her husband, and he had definite knowledge of her financial

desperation. Aemilia would be easy pickings for him because, as he put it, 'necessity doth compel'.

Forman offers a detailed account of what happened next. (I am grateful to the experts who have deciphered most of his notoriously difficult handwriting and explicated his fantastical vocabulary – words such as 'halek' for sexual intercourse.) He:

> went and supped with her and stayed all night. and she was familiar & friendly to him in all things, but only she would not halek. Yet he felt all p[ar]tes of her body willingly & kissed her often, but she would not do in any wise whereupon he took some displeasure & so dep[ar]ted [i.e. stopped being] friends but not intending to come at her again in haste.

He adds, in lighter ink, at a later date, 'but yet they were friends again afterward/but he never obtained his purpose & she was a whore & dealt evil with him after'. In a move as old as time, Aemilia Lanyer is branded a 'whore' because she *won't* have sex with her medical consultant.

III

Aemilia comes to Forman for his help because – since the birth of Henry – she has suffered a series of debilitating, distressing 'false conceptions' or what we would call miscarriages: 'much pain in the bottom of the belly, womb, stomach & head and ready to vomit'. Aemilia may have wanted more children and sought from Forman the secret to conception and carrying to term. She may have been exhausted and seeking *not* to fall pregnant, seeking to avoid the agony of another miscarriage. Whatever her motives, the outcome of the first consultation was distressing. Forman found that the baby she was currently carrying 'kicks not her body'. He gave Aemilia a 'purgative decoction'.

Miscarriage or a stillbirth followed, probably not long after. From this point on, Forman gives Lanyer little hope of having a child, but instead turns his attention to her hopes for her husband: he will succeed, but 'she shall be first in despair of it'. She returned to Forman in September free from pain, focused on her social goals and preoccupied by her lack of money. A few months later, Aemilia would fall pregnant and carry the baby to term, a daughter with the beautiful name Odillya. She was baptised on 2 December 1598, buried on 6 September 1599. Alfonso and Aemilia had no further children. Whilst her father's family continued to thrive, exporting their instruments all over Europe, earning good money making music, second- and third-generation Bassano men marrying into the gentry, Lanyer had certainly not married up – although Alfonso never stopped hoping. In one of the rare moments he turns up in the records after 1600 he is being arrested in Hackney, a village four miles north-east of London.

Little is known about the next ten years of Lanyer's life. A few years after baby Odillya's brief life, it is probable (Lanyer herself says it happened, and why disbelieve her?) that she spent a period in the household of the Countess of Cumberland and her daughter Anne Clifford. The two women, three with Aemilia, were living temporarily at Cookham on the Thames in Berkshire, a place that came to assume an almost mythical significance in Lanyer's mind. It is unclear exactly when she was there, or indeed why. We can speculate: did Aemilia teach music to the young Anne Clifford? The evidence is tenuous. There's a portrait, commissioned by Anne herself in later life, which shows her younger, fifteen-year-old self with books and music. As Susanne Woods writes: 'Anne Clifford knew and valued music when she was fifteen, and someone must have taught her.' It's a bit of a leap to then say that someone was Lanyer, but at least it gets her to Cookham – as a music teacher.

By the time she was forty, in 1609, Aemilia Lanyer knew what it was to be daughter, mistress, wife and mother. She had been intimate with one of the most powerful men of her time; was enmeshed in

the literary, musical and dramatic worlds of London and the court; and had supported her husband's ambitions at court and in war. Her class was that of many contemporary authors, or more precisely those who wrote for money or preferment, men such as Christopher Marlowe (father a shoemaker) or Ben Jonson (stepfather a brick-layer). She had been born and lived in the right place, London. Even Warwickshire lad Shakespeare's working life was spent in the city. Somehow, somewhere, she had gained the necessary education. She even had aristocratic connections. Aemilia Bassano Lanyer had the learning, ambition and contacts of her now canonical literary con-temporaries. But she was not an author.

Until suddenly, in 1610, she turned poet.

IV

The Stationers' Register for 2 October of that year reads: 'Entred for his Copye under th[e] [h]andes of Doctor MOKETT and Th'wardens, A booke called, *Salve DEUS Rex Judaeorum*.' By the fol-lowing year, you could buy *Salve Deus* from the publisher/bookseller Richard Bonian 'at the Signe of the Floure de Luce and Crowne'. The first volume of original poetry to be published by an English woman was out in the world.

The very publication of *Salve Deus* was wonderful, in both senses of the word. Lanyer's move into print is as striking as the contents of the volume itself. She lived and wrote in a world in which circu-lating your work in manuscript was, in many ways, easier and safer, particularly for a woman. A woman need not expose herself, or get involved in the messy, sometimes dangerous, always tedious business of censors and licensers and printers. But Lanyer chose print. All is guesswork, but perhaps she knew well that manuscripts have a much lower survival rate than books. Perhaps she was aware that women's writings in manuscript (the ones we know about) usually stuck to

genres and subjects deemed appropriate to their sex; in other words, short prose works primarily of a religious nature. Women remained discreet and modest in both their choice of content and the circulation of their writing, sharing their work only amongst family and friends. There was an edgier, influential and at times subversive 'transcriptional culture' that ran alongside the growing, but more highly regulated, print industry, but it had its home in the universities and the Inns of Court, the royal courts and the Houses of Parliament, taverns and, later, coffee houses; in other words, male arenas. Born female, the manuscript circulation of suitably devotional women's work didn't cut it for Aemilia Lanyer.

She still had a mountain to climb, as a woman, to get her poetry into print, and she climbed it. Like her predecessors, Julian and Margery, she could not do it alone, but the people she needed were different. Doctor Mocket, an ecclesiastical censor, signed Lanyer's work off, perhaps thinking it was only another one of the conventionally pious works that passed across his desk. The printer, Valentine Simmes (one of the better printers of the era, although that's not saying much), turned her manuscript into a small, quarto volume, a book created by printing eight pages on a single sheet of paper, then folding the sheet twice to form four leaves, then binding the sheets together. *Salve Deus* was bigger than the really tiny octavo books, which were small enough to hang from a belt or hide in a pocket and thus the preferred format for religious texts, being suitably portable, possible to consult in quiet moments. But a quarto remained an unprovocative format, roughly the size of the Penguin paperback edition of her poetry I have beside me now.

Unprovocative was a wise choice for a low-born female author entering male territory. Censorship (even imprisonment) was a danger for any writer, but print publication was particularly fraught for women. If print was viewed with suspicion because once out there, the words were uncontrollable, that fear of unlimited circulation was magnified and sexualised for women to the point that, by Lanyer's time, some were making the argument that to sell one's words was

equivalent to selling one's body. The equation of print with prostitution or sexual availability is a powerful one and endures to this day but in different forms: any woman in public life is, somewhere along the line, asking for it. A couple of generations after Lanyer, Aphra Behn, the first female professional playwright, will experience the full and toxic effect of this understanding of the creative woman, but with added venom because she makes money from her words. None of the authors from now on in this book can truly escape this landscape of belief, however virtuous, retiring – or poor – they strive to be.

In Lanyer's time, even elite women struggled in this environment. Ten years after Lanyer's venture, Lady Mary Sidney Wroth, noble niece of the noble Sir Philip Sidney, published her works in an ostentatious folio, the format of choice for display Bibles and volumes of religious prominence. The folio signalled that the material was serious, that the author had aspirations, and, more cynically, that the printer believed he (or occasionally she) could make money from a text that demanded such a large initial outlay. Wroth had good reason for the ostentation: her high status, her Sidney connections, the length of the work – almost six hundred pages – and the mix of genres, all made it a suitable project for folio publication. Wroth also had enemies. Edward Denny, Baron of Waltham successfully petitioned for the book to be withdrawn for its perceived libel against him and his family. What hubris on the part of Wroth! A lady does not expose her friends to the gaze of the public. Certainly not in a folio. Wroth's work was, needless to say, not reprinted.

Some historians seek to reassure us that things were not really that bad for women authors. There were discouragements, but, writes Marcy L. North,

> female authors and translators were surprisingly visible in the early print market. In most years from 1545 on, a buyer at a London bookseller's stall would have found one or more publications attributed to a woman. If first-edition, singly authored, literary publications proved scarce, as they sometimes did, the bookseller

could have pointed the buyer to popular reprints of women's devotional and didactic works or to the many smaller contributions of women: Queen Elizabeth's prayers tucked into any of two dozen editions of Thomas Sorocold's *Supplications of Saints*, Margaret Ascham's prefatory epistle to her late husband's *Scholemaster*, or one of several poems in verse miscellanies attributed to anonymous women.

'One or more' books, 'most years', some tucked into other books, is hardly a tidal wave of female creativity.

Lanyer's ground-breaking decision to print her original poetry was exceptional and brave. It was also strategic. Money was not her goal: Bonian the bookseller/publisher would receive anything that was to be made from *Salve Deus* as was standard for the time. Instead, it's fair to assume that, along with pretty much every other writer of her time, Lanyer was hoping for some kind of support or recognition from a wealthy, well-placed patron through the publication of her work. Most male poets of the era, and many writers in other genres, relied on a patron to keep body and soul together. With room and board in their patron's house and access to their patron's library, they could get on with their writing. Patrons offered another kind of protection. If a writer stepped out of line, a well-placed patron might save them from prosecution or worse. All this in return for words, words, words: a dedication here, an epithalamium there, elegies and eulogies, all in a day's work. In pursuit of this, authors prefaced their work with dedications, even Shakespeare – notoriously Shakespeare, with his dedications to the sexually ambiguous Earl of Southampton and his deliciously elusive offer of his *Sonnets* to Mr W. H., the 'only begetter', fodder for academics and conspiracy theorists alike since we have no idea who Mr W. H. was, and no idea if Shakespeare even wrote the dedication to the 1609 *Sonnets*.

It was never going to be easy for Lanyer, not least because she was throwing her hat into the patronage ring at a particularly bad moment, particularly for poets. Over the second decade of the

seventeenth century 'Chapman's hopes were crushed, Donne finally went into the church, and Campion was questioned for complicity in Overbury's murder ... Jonson, on the other hand, weathered the transition [between patronage and professionalism] triumphantly, and his Folio is one testament to that success', writes Martin Butler. It was tough, it's still tough, to make a living from poetry.

Lanyer remained undeterred. She delivers some rather elegant flattery. Her attempt to praise one noble patron is to 'set a candle in the sun/And add one drop of water to the sea'. She sends out advance copies, one reaching King James I's son, Henry Prince of Wales: the *Salve Deus* in the Victoria and Albert Museum Library bears his coat of arms. Another has the inscription: a 'gift of Mr. Alfonso Lanyer'. It looks as if Alfonso was backing Aemilia's quest for patronage as best he could. Perhaps over time Alfonso came round to the belief that his wife was the better bet for social advancement. So far so conventional.

But there are dedications and dedications. Lanyer's make up half her book. Most authors, if they offered a dedication at all, stuck at one. What was she thinking? Having said she was not in search of money, she might have taken a look at the maths of cash patronage. One-off gifts from dedicatees, if you were lucky enough to receive one, usually came in at around £2 or £3. Back in the day, however, Aemilia Bassano received £40 a year from Henry Carey, Baron Hunsdon. She needed a lot of patrons to come through in 1611 to get close to that figure.

Dedications were, however, never solely about money. They were a vital way to show the world who your supporters were, whether as shield or cheerleaders, whether in the present or (fantasy) future. Lanyer aims high. She starts at the political top, Queen Anne, wife to King James I, and packs her dedicatory squad with powerful players: literary titans such as Mary Sidney, sister to Sir Philip Sidney, or Lady Lucy, Countess of Bedford, patron of John Donne and Ben Jonson, together with more royalty, such as the young Princess Elizabeth and more problematically, the imprisoned Lady Arbella Stuart.

Many view her approach as inept. Key figures, the Countess of Cumberland and her daughter, Anne Clifford, were not only out of funds in 1611, but almost powerless. Then there's the blunder when Lanyer places women of lower social status ahead of their superiors in the running order: it wouldn't win her friends in a profoundly hierarchical society. And, last but not least, there's that misguided dedication to Arbella Stuart, a cousin to King James, indeed a rival to him in the 1590s as people pondered who would succeed Queen Elizabeth I. By 1610, Arbella Stuart was under house arrest on account of her secret marriage to William Seymour, who also had a claim to the English throne. The following year, she was in the Tower, hardly the best place from which to bestow patronage on, let alone provide social and political protection for, a poor poet. Clumsy, Mistress Lanyer.

I see these dedications as neither inept nor merely inflammatory. Lanyer shows loyalty to the Clifford women (who were in the midst of a protracted dispute surrounding the right of a woman to inherit); she challenges the emptiness of rank; she points to a female tradition of literary production in the form of Mary Sidney and Lucy, Countess of Bedford; and she demonstrates her support for a woman who was imprisoned primarily because of a king's fear for his own throne.

I think, I would like to think, Lanyer had her eye on a different prize. She wanted to reach an emerging female readership. No longer was it only members of the nobility and religious orders who could read. The Protestant Reformation had changed things (a bit), because church leaders wanted (up to a point) women to be able to read the Bible and other religious materials (and thereby instruct their children). However circumscribed, female literacy was increasing. The difference between Margaret Johnson signing her name with a cross, and her daughter Aemilia Lanyer writing *Salve Deus Rex Judaeorum*, tells its own story about a generational shift. A steady trickle of books were being aimed directly at women readers: tracts, dictionaries, household manuals, advice books, as well as the usual fare of devotional texts. And authors were addressing these readers

directly. Every book Bonian published in these years, from *Salve Deus* to the gloriously titled *Satan's Sowing Season*, has a general epistle to readers as well as an appeal to a specific patron. Lanyer's, however, is the only book of original poetry written by a woman.

So, Lanyer appeals to Queen Anne, King James's wife, and to Arbella Stuart, King James's rival (and gets a copy to Prince Henry, King James's son and also rival) but she also, crucially, appeals to 'all virtuous Ladies in general'. She is identifying and constructing a new community of female readers. This is what she has to say to them, to us.

V

What a title! Hail God, King of the Jews – it's ambitious, it's in Latin, it's direct.

What a subtitle! All the big-hitters of Christianity are there: Christ, Eve, the Daughters of Jerusalem, the Virgin Mary.

All 'written by Mistris Aemilia Lanyer' who is a wife to Captain Alfonso Lanyer, who is servant to the King's Majesty.

Relief all round: the author might be a woman but she is thankfully a wife, and her (recorder-playing) husband is a servant to the King. A husband and/or father was the governor of his family and household, that is, not solely over his wife and children but also his wards and servants, a role that was God-given, natural, and vital to the continuance of a stable society. His dominion over his household was a mirror of the king's dominion over his people, and both a mirror of God's dominion over all creation.

God, King, Husband are in place. The trinity of patriarchy is not threatened. Or is it? For, from the very title page of *Salve Deus* – reproduced at the start of this chapter – the feminine divine and masculine patriarchy struggle for control. The clash is even more radical when we see where Christ is placed in the struggle. He is

in with the women both in Lanyer's account of the crucifixion and her concluding vision of an all-female utopia – with Christ the only man allowed in.

Here on the title page of *Salve Deus*, for a moment, women are literally on top. And it is Lanyer who has 'written', in a world which instructed women, every single day of their lives, in the virtues of silence, obedience and chastity. It was a simple message but one that was repeated over and over again. Simply to speak, let alone write, is, by implication, to demonstrate *dis*obedience, *un*chastity.

Turn the page of *Salve Deus*, and the first woman addressed is, fittingly, Queen Anne. She is an Empress in her own right, not merely the wife of a king. Lanyer does not even mention her husband, King James I. It is Anne who is asked to read 'that which is seldom seen/A woman's writing of divinest things'. Indeed. This is not patriarchal business as usual.

Even Lanyer's gestures of humility have a bite to them. She presents herself as 'unlearned', 'mean' – low-born, not a great lady – and, on occasion, even as a thing of 'darkness'. But precisely these qualities serve to make Aemilia more like Christ 'whose days were spent in poverty and sorrow'. Which is where things get thoroughly political. Lanyer reminds her (royal) reader, for she is still ostensibly addressing Queen Anne, that it is only Christ who is a 'mighty Monarch': 'all Kings their wealth of him do borrow'. In *this* world, Aemilia Lanyer is 'mean'. In Christ's world, Lanyer is a great landowner. And at the Creation itself? 'What difference was there when the world began?' This is the Book of Genesis as class war: once all were equal.

Lanyer – a fairly low-born woman – is sending a rare and powerful message. She offers her book to women, to *all* women, urging them to come together as they engage with her words. Even more remarkable, picking up on the earlier point about the absence of 'difference' at the Creation, Lanyer offers a direct attack on the class distinctions that serve to divide and conquer women, placing her 'fair Queen' and any and all 'virtuous ladies' together in a community of readers,

inviting them all to take on the role of priestly interpreter, arguing for what Theresa M. DiPasquale terms a new 'gynocentric ecclesiology', a priesthood of all believers which includes women. She is not advocating that women should become priests (she knows that's not going to happen – four hundred years on we are still struggling with the idea) but claiming that women have *always* had something of a priestly role. And she does so with audacity, reworking the reading given to new bishops (1 Pet. 5:2–4) for her own purposes: Bind up the broken, stop the wounds that bleed, Succour the poor, comfort the comfortless.

There's more, because this is Lanyer. Along the way, she reimagines the Eucharist, offering some passionately sensuous writing about the eating and drinking of Christ's body and blood. Almost every word is taken from the Bible – it's how Lanyer puts them back together that's so unsettling, so powerful. In a strong echo of Margery Kempe's work, Christ himself becomes an object of desire. And like Julian of Norwich, everything Lanyer writes has an impeccable theological pedigree – the true believer as the Bride of Christ.

Lanyer knows exactly what she is doing, because she asks Queen Anne to judge whether she is indeed being true to the Bible, whether her poem agrees 'with the Text'. By now, she has moved on to re-writing Eve's place in the Fall, challenging the way in which the Genesis account has been used to justify centuries of oppression for women, daughters of Eve. As she writes to Queen Anne: if it does agree (and it does), 'why are poor Women blamed/Or by more faulty Men so much defamed?' It's a good question.

Lanyer's dedications are in danger of almost overbalancing her little book, but she saves the best till last. She appeals not to the political elite, but the ordinary women who will buy *Salve Deus*. Addressing 'the Virtuous Reader' – every woman, Everywoman – Lanyer urges women to save their energy to fight the men who oppress them. And she repeats her defence of Eve, reminding us why she is writing her book in the first place: 'all women deserve not to be blamed' for Eve's mistake. Men need to remember they 'were born of women,

nourished of women, and that if it were not by the means of women, they would be quite extinguished out of the world'. Women deserve respect rather than oppression and abuse.

Her next step is a shocking one for her time. The kind of men who oppress and abuse women today are the kind who dishonoured Christ and his disciples. It was men who killed Christ. And God knows this, because He has (enter Deborah, Jael, Hester, Judith and Susanna 'with infinite others', a roll-call of Jewish biblical heroines) given power to 'wise and virtuous women, to bring down their [men's] pride and arrogancy'. These are women of 'invincible courage, rare wisdom, and confident carriage'. It's stirring stuff, but Lanyer's still not finished. Jesus (without the assistance of a man – she's absolutely determined to write men out of the story) was:

> begotten of a woman, born of a woman, nourished of a woman, obedient to a woman; and that he healed woman, pardoned women, comforted women; yea, even when he was in his greatest agony and bloody sweat, going to be crucified, and also in the last hours of his death, took care to dispose of a woman: after his resurrection, appeared first to a woman, sent a woman to declare his most glorious resurrection to the rest of his Disciples.

Speak well of 'our sex', says Lanyer, speak well of female wisdom, strength and virtue.

And then, at last, she begins her story: Christ's last hours, his Passion. Lanyer knows the scale of the task she has set herself. She is out of breath, as if running up a hill. She fears that she is unworthy but she hopes that God will 'illuminate' her. He does.

At the heart of Lanyer's telling of the Passion is a very human Jesus: frightened, abandoned and misunderstood by his friends, his *male* friends, who Lanyer insists have no 'apprehension of thy pain'. Throughout, what Lanyer does, brilliantly, is to make her readers conscious of gender. Here it bears in upon us that the disciples are men: men who give up, betray, forsake their friend, the Son of God.

Her account of the crucifixion itself is painfully graphic, and followed by an erotically charged celebration of the resurrection: Christ's body is central to both. In a passage filled with allusions from the Bible's most erotic book, the risen Christ is both like the *bride* in the Song of Songs ('lips like scarlet threads, yet much more sweet/Than is the sweetest honey dropping dew') and the bridegroom: 'His cheeks are beds of spices, flowers sweet;/His lips like Lilies'. This is heady poetry. To view Christ as a woman is not, however, to demean him – quite the opposite in fact, in this world of the feminine divine. Lanyer creates a Christ who is 'mean' like the author herself, a Christ who, Lanyer insists, is more glorious in his weakness than the kings, governors and soldiers of the masculine real world. I love DiPasquale's summary: Lanyer's 'Jesus is – simply put – God's gift to women.'

As Julian of Norwich and Margery Kempe had done, Lanyer is working at one level well within the Judeo-Christian tradition of the sacred feminine. From the divine Wisdom of the *Book of Proverbs* to the 'bride' of the Song of Solomon, from the Virgin Mary to the idea of the Church as female ('Ecclesia') in Paul's letters, symbols of female agency are present in the Bible. In practice, however, one's place in what DiPasquale calls the 'economy of redemption' is 'indelibly stamped by the sex of the body' in which the soul is housed, even if the soul itself can be understood in feminine terms. Thus far and no further, if you are born female.

Lanyer is pushing, and pushing hard, on a lot of fronts. In one of the most powerful emotional passages in the poem, she asks the reader to join with Mary in her desperation as she witnesses the death of her son on the cross. As Julian and Kempe acknowledged, to celebrate women's feelings in a world which used their God-given emotional instability as a justification for men's rational sovereignty can be a double-edged sword. Lanyer is in dangerous territory. If women have a natural and innate sympathy with suffering which allows them a greater spiritual proximity to Christ than men, that's all very well, but it does not overturn the reasoning behind the subjection of their sex in this world. Mary's tears do not remove the stain of Eve's sin.

Unlike her fifteenth-century forerunners, Lanyer tackles this head on, by re-writing Genesis. Yes, she concedes that Eve did do something foolish (her 'former fault') but it is nothing compared to what men did to Christ. Eve gave to Adam only what she 'held most dear'. Eve was 'simply good' – she didn't know what she was doing, she couldn't see into the future, with the implication that she had not been told, she had not been warned. 'Had she known' then all would have been well. She was deceived.

Eve does not appear in *The Book of Margery Kempe*. Julian writes only of 'Adam's sin' as the 'greatest harm', the 'first sin', making no comment on Eve's responsibility for that sin. In both medieval works, there is silence about Eve even when, say, Julian is trying to work out why God has allowed sin to exist when the simple answer should be that it was Eve's fault.

Lanyer not only brings Eve into the room, but asserts her goodness. This is inflammatory enough, but yet again she goes further: 'But surely Adam can not be excused'. Adam had the power and strength to refuse (he was Lord of all, *he* had been warned), yet he took the fruit from Eve knowing it meant death ('danger and disgrace'). Worse still, he then blamed Eve and all women with the result 'That we (poor women) must endure it all.'

And this matters, right here, right now to Lanyer and her readers.

> Then let us have our liberty again;
> And challenge to your selves no sovereignty;
> You came not in the world without our pain,
> Make that a bar against your cruelty;
> Your fault being greater, why should you disdain
> Our being your equals, free from tyranny.
> If one weak woman simply did offend,
> This sin of yours, hath no excuse, nor end.
> To which (poor souls) we never gave consent,
> Witness thy wife (O Pilate) speaks for all …

It is hard to overestimate the amount of work this passage does. Just look at those words: *liberty, equals, sovereignty, tyranny, witness, consent*. Women did not consent to the killing of Jesus. Men should bear the blame. And, specifically, Pontius Pilate should have listened to his wife who 'speaks for all'.

Pilate's wife? Who? Lanyer brings a character from the margins of the Bible on to centre stage in her re-envisioned Passion of Christ, a woman who appears in only one biblical verse (Matt. 27:19), and even then in an elusive way: 'his wife sent unto him, saying, Have thou nothing to do with that just man: for I have suffered many things this day in a dream because of him'. To Pilate's dreaming wife, Jesus is a 'just man' and, taking the hint, Lanyer creates a scene in which wife pleads with husband not to order Christ's death, which is followed by a remarkable defence of ('Apology' for) Eve, which in turn segues into the passage quoted above.

Unlike Julian and Kempe, Lanyer is not interested in Mary Magdalene (or the 'other Mary') who returns to the sepulchre. All she writes (following Matt. 27:61, 28:1) is that 'The Maries doe with pretious balmes attend'. Otherwise, Mary Magdalene is absent, and certainly not foregrounded as penitent sinner or lover of Christ, let alone 'apostle of the apostles' as some have her now.

Lanyer may take care to ensure that her poem 'agrees' with the Bible, but this is a Bible transformed – to celebrate the feminine, feminised divine, to overturn conventional pieties, to make a passionate plea for all women's liberty – right here, right now.

VI

After all this, Lanyer's final section to *Salve Deus*, her *Description of Cookham* – a vision of a utopian world in which women wander round a beautiful landscape, talking and reading together, not to mention kissing trees – might seem a bit tame. What's more,

Cookham takes the form of a country house poem, a genre notorious for its conservatism.

Not for Aemilia Lanyer. *Cookham* becomes the culmination, the realisation, of the ideas and arguments and imagery developed in the earlier pages of *Salve Deus*: a vision of a perfect community of women, a new, feminised Garden of Eden. Here women exist in spiritual equality with each other, and in erotic dynamic with words. Poetry gives pleasure to women, women give pleasure to other women.

The erotics can be as comic as they are touching. Lanyer describes a moment of farewell to Cookham in which her mistress, Lady Clifford, appears to kiss the poet: 'and with a chaste, yet loving kiss took leave'. The reader quickly realises that Lady Clifford has kissed a tree, rather than the poet (cue laughter). The speaker then kisses the tree. Perhaps Lanyer is pointing to the unbridgeable social gap between her, daughter of a musician, and Lady Clifford, noblewoman. Perhaps she's hinting at the impossibility of lesbian sex. Or perhaps it's a joke about her own invisibility and irrelevance.

For all the wry modesty, Lanyer is doing something very new – nature writing – and doing it with a swagger. The poem reeks of the classical pastoral traditions of Horace and Martial (where *did* she get her access to books, let alone formal education?), as if Lanyer is saying to us: I've transformed the Bible, now I'm going to take on the Latin poets.

Does it matter whether she was ever at Cookham on the Thames in Berkshire? If Lanyer was not, then the poem becomes (and some are stern about this possibility) an exercise in wishful thinking, akin to her reminiscences about receiving an education with the noblewoman Susan Bertie. If she was, then the poem stands as a grateful, deeply nostalgic recognition of past kindness from Margaret Clifford, née Russell, Dowager Countess of Cumberland, temporary mistress of Cookham. Past kindness, because the Countess and her daughter Anne had left Cookham by 1605, some five or six years before Lanyer published her poem. Whatever the poem's genesis, Lanyer could

not have failed to know of Margaret Clifford's struggle to obtain her daughter's legitimate inheritance from her father. Anne Clifford was the rightful heir. But the sheer weight of the system, controlled by men, was against her. It's another reminder that nothing in *Salve Deus Rex Judaeorum* can or should be consigned to the realm of the abstract, angels on a pinhead. Words mattered, the Word mattered, because they, It, determined women's lives.

Whatever your take, whether convenient fantasy or nostalgic homage, Lanyer admits that she no longer has contact with the women she is praising, the great 'difference' in 'degree' has ensured that. What was possible at Cookham (and in Eden, of course, where 'difference' did not exist), the social levelling which allowed 'mean' Lanyer to commune with noble ladies, has not survived departure from this special place. It is a melancholic ending to a feisty, articulate, visionary poem, a hint that its author knew she would not be heard in her time.

Lanyer uses her closing words to address her reader, us, directly:

Gentle Reader, if thou desire to be resolved, why I give this Title, *Salve Deus Rex Iudæorum*, know for certain, that it was delivered unto me in sleep many years before I had any intent to write in this manner, and was quite out of my memory, until I had written the Passion of Christ, when immediately it came into my remembrance, what I had dreamed long before; and thinking it a significant token, that I was appointed to perform this work, I gave the very same words I received in sleep as the fittest Title I could devise for this Book.

At first sight she is doing something similar to Margery Kempe and Julian of Norwich, presenting herself as a mere conduit, and perhaps for similar reasons. Lacking any authority to speak because of their female bodies, these women claim to be channelling divine authority. Taken to its extreme it is a profoundly troubling view of women's creation. I can't help hearing the voice of the composer Lili Boulanger,

three hundred years after *Salve Deus*. Boulanger had worked tirelessly, strategically, and with ruthless ambition, towards winning the most prestigious composition prize of her era. Having duly won, the first woman to do so, she was interviewed by the press. Lili presented herself as a child, who innocently 'dreamed' her winning composition. The public were disarmed: this was not a fearsome professional *hommesse*, the French word created for women who were turning into men due to their usurpation of the latter's rightful roles. Lili, nicknamed Bébé, was a passive empty vessel, a child-woman waiting to transcribe a dream.

It's certainly one strategy for a creative woman who wishes to succeed in a male world. It is not, in fact, Lanyer's. Instead, she exudes an immense authorial confidence. She tells us why she chose her title (this is a woman who dreams in Latin), insists that her little book has been long in the making, and that she has 'been appointed to perform this work'. In 1611, Aemilia Lanyer changed the game for ever. She would not merely translate. She would re-write, transform, her Bible. She damn well knows what she is doing, and why it matters.

Yet most of us do not even know her name.

VII

Leaving a legacy is, plain and simple, one of the toughest things for a female author.

Compare the fate of *The Tempest*, for many centuries viewed as Shakespeare's final play, his farewell to theatre (if you ignore his future collaborations with other playwrights). It was first performed in 1611, the year of *Salve Deus*. Back then, however, blink and you would have missed it. William Shakespeare was not too concerned about posterity, at least when it came to his drama. The only works he printed and put his name to (with relatively restrained dedications) were his narrative poems back in the early 1590s, nearly twenty years

earlier. Only nineteen out of his thirty-seven plays appeared in quarto editions before his retirement, and none were supervised or authorised by the playwright. *The Tempest* itself was not published until 1623, seven years after Shakespeare's death. It fell to his posthumous admirers to put together the First Folio, the collected works, to make Shakespeare's ephemeral playtexts into canonical literary works.

Another iconic work appeared in 1611 when the King James Bible, eight years in the making, was finally published. The work of forty-seven men representing the full range of theological belief within the Church of England, it was a large book, even by the standard of folios, with thick pages, destined for the lectern, 'appointed to be read in churches', a work designed to be heard more than read. As with *The Tempest*, more so even than *The Tempest*, the King James Bible's afterlife is its defining feature. It is a profoundly influential work, described by Gordon Campbell, who has written its history, as 'the most important book in the English language'. It might even be the bestselling book of all time.

No women were involved in the creation of *The Tempest* and the King James Bible in 1611. They could have been. A few women had written plays, but they were closet dramas, designed to be read in the privacy of the home, not performed on the public stage. A few women had, on occasion, translated devotional works, Mary Sidney famously among them in her translation of the Psalms. But the very venues in which the editorial committee instructed to create the new Bible met would have been off limits: whether Oxford University, Cambridge University or the Jerusalem Chamber off the entrance to Westminster Abbey in London. These were all spaces barred to women, unless you count whores, and historians have tended not to. It was a step too far to think that Sidney or any of her fellows could contribute to the Authorised Version.

Compared to all the people, over the past four centuries, who have read the King James Bible, or seen *The Tempest* performed, Lanyer's readers are like a few grains of sand on a vast beach.

Afterword

There was no second edition of Lanyer's work. *Salve Deus* seems to have sunk almost without trace, though some have argued that one John Milton was profoundly influenced by the work when he came to write his own take on Genesis, *Paradise Lost*.

Things were changing in Lanyer's England, but they were changing for men. Take the theatre world in which a (mere) actor could and did become a playwright – and shareholder – and have friends and supporters enough to ensure that his ephemeral playtexts would be published in folio. Or the Church of England, in which a low-born boy could become one of the translators of the King's Bible and in which another of the illegitimate sons of Henry Carey, Baron Hunsdon, could become the Bishop of Exeter. Boys had education, were enrolled in creative communities. Boys had permission to speak; permission to perform whether on stage or pulpit; permission to write, and to make money from writing.

It was a generation of marvels, from Edmund Spenser to John Donne, from Christopher Marlowe to William Shakespeare. Lanyer should be in there too. Somehow, somewhere, she had gained the confidence in her ability to go beyond translation or paraphrase of religious works, to recognise that she could transform the stories her society, her Bible, told about Jesus, about Mary, about Eve. She knew what it was to be a woman in a man's world, and she knew about the particular forms of suffering that afflict the powerless. Her life taught her many things about what we now call gender, about riches and poverty, about power and weakness, about love and about loss.

That only nine copies of *Salve Deus* survive has led some to speculate that the book was pulled because it offended someone. Did one of the dedicatees feel it falsified a relationship? Did Lanyer libel someone? Libels were a big thing in Stuart England, and individuals who believed they had been libelled could and did have books suppressed by the High Commission. However, no one sought to suppress Lanyer's work and, in fact, nine copies is not bad going.

Only thirteen copies of Shakespeare's *Sonnets* have come down to us. Without the Folio, would he be the Great Bard?

The disappearance from our literary history of *Salve Deus* is the quiet work of patriarchy. More than any other work in this book, its recovery is important, a vital link in the chain stretching back and beyond to Margery Kempe and Julian of Norwich and forward to our own day. I like to think that Lanyer chose to print her poetry, to reach out to all women who had the money to buy the book, and the education to read it. I like to think that Lanyer chose to print her poetry because such a book might survive to be read – four hundred years later, by a woman sitting in an Oxford library, now.

THE
TENTH MUSE

John Brand 1795

Lately sprung up in AMERICA.
OR

Severall Poems, compiled
with great variety of VVit
and Learning, full of delight.
Wherein especially is contained a com-
pleat discourse and description of

The Four {
Elements,
Constitutions,
Ages of Man,
Seasons of the Year.
}

Together with an Exact Epitomie of
the Four Monarchies, *viz.*

The {
Assyrian,
Persian,
Grecian,
Roman.
}

Also a Dialogue between Old *England* and
New, concerning the late troubles.
With divers other pleasant and serious Poems.

By a Gentlewoman in those parts.

Printed at London for *Stephen Bowtell* at the signe of the
Bible in Popes Head-Alley. 1650.

CHAPTER THREE

Anne Bradstreet

'these Poems are the fruit but of some few hours,
curtailed from her sleep'

IN THE MIDST of Britain's civil wars, a generation after Lanyer's *Salve Deus* fluttered briefly into life, some men decided to publish a volume of poetry. They made their plans three thousand miles distant from the battlefields, in the New English colony of Massachusetts. One of the men, probably John Woodbridge, packed a handwritten manuscript of fifteen poems into his trunk and headed for the mother country, Old England. The year was 1648 and, the Atlantic crossing safely made, godly minister Woodbridge found himself too busy to do anything about the manuscript. The parliamentary leaders were negotiating with King Charles I and needed him as chaplain. Their forces had won the war on the field; now they sought a settlement with the Crown. It didn't happen. On 30 January 1649, the King was executed. By May of that year, England was a Commonwealth. A few months on and Woodbridge was settled as rector of Barford Saint Martin in Wiltshire, where he would serve until the next regime change, when Charles I's son was restored to the throne in 1660.

In Wiltshire, he was at last able to turn his attention to getting the poems published, and the manuscript duly appeared in printed form in 1650, complete with a preface and prefatory poems written

by Woodbridge and an array of other gentlemen supporters. It was a thoroughly godly affair, produced and sold by Stephen Bowtell at the sign of the Bible in Pope's-Head Alley in London. Every word of the prefatory material aimed to dispel any concerns the prospective reader of *The Tenth Muse* might have about the volume and its author: a Gentlewoman.

I

That Gentlewoman was Anne Bradstreet, and with *The Tenth Muse* she became the first American poet, the first American woman, the first American, to appear in print.

The men were, for all the reasons touched on in the previous chapters, anxious about the move. Woodbridge and his all-male team of collaborators obsess over Bradstreet's status as a female poet, and while most of them are keen to celebrate her literary prowess, insisting that (astonishingly) the poems are indeed all her own work, they are even more concerned to reassure readers that her abilities do not represent any threat to the conventional gender hierarchy of their day. Women remain the 'inferior sex'. Bradstreet is exceptional, praised at the expense of other women: 'Your Works are solid, others weak as air'. There's more, because there always is. The reader's mind is put at rest because Bradstreet is the right *sort* of woman. She is:

> honoured, and esteemed where she lives, for her gracious demeanour, her eminent parts, her pious conversation, her courteous disposition, her exact diligence in her place, and discreet managing of her family occasions; and more than so, these Poems are the fruit but of some few hours, curtailed from her sleep, and other refreshments.

God forbid that Anne Bradstreet should have neglected any aspect of her domestic and familial duties while she produced her major

collection of poetry. The homemaker author is, relief all round, virtuous and modest.

Indeed, Bradstreet's virtue and modesty lie behind her unwillingness to let her work see the (public) light of day. *The Tenth Muse* appears without the author's 'knowledge and contrary to her expectation'. This was a very familiar line in the publishing industry of the time. Many authors (or convenient author's friends) complained that they had been forced into print, whether to counter unauthorised versions of their work or to obey the wishes of their supporters. That Aemilia Lanyer did *not* take this stance is yet another way in which she stands out in her own century. In 1650, in his warm-up act for *The Tenth Muse*, Woodbridge regrets that 'broken pieces' of Bradstreet's work have already appeared and casually mentions the many people who have expressed an 'earnest desire' to see a 'view of the whole'. All this might be true, but it is also a tired formula to justify print publication.

What was the real reason for these men to go public with Anne Bradstreet's poetry? Something overruled their fears. The poems could have stayed in handwritten form. In fact, many of Bradstreet's poems did, with the opening poem in *The Tenth Muse* telling of her preparation of a manuscript collection of her work for her father, Thomas Dudley. In circulating her poetry within her own family and community, and in writing poetry as a devotional exercise, she was working within the creative parameters of her godly colony. So, why expose this private work, and why in London?

The men behind the volume, Anne Bradstreet's husband, Simon, and her father, Thomas – along with brother-in-law Woodbridge – could well have had a strategic, political agenda. Both were committed to, indeed present and future leaders of, the Massachusetts colony. Anne Bradstreet's work (and the woman herself) could act as a powerful advertisement for the new society across the Atlantic. The title page, reproduced at the start of this chapter, of *The Tenth Muse* proclaims not the name of the poet but her gender and her location: America. Look how civilised we are, even in the wilderness amongst

heathen savages! Even our women! Simon Bradstreet and Thomas Dudley both had a huge stake in getting this message across. Surely it is no coincidence that *The Tenth Muse* endorses the particular brand of militant, but not revolutionary, Protestantism espoused specifically by Anne's family.

Another push factor was more personal. Bradstreet's poetry was suspiciously useful to the Dudley/Bradstreet family as a way of countering the toxic fallout from the behaviour of one of Anne's sisters, Sarah. Her story is an unhappy one. Sarah Dudley was married to Benjamin Keayne. He left her and returned to England. She followed him, but he had decided that the marriage was over. To ensure that it was, he accused her of infidelity and infecting him with a sexually transmitted disease (since virtuous Benjamin had not had sex with anyone else). Sarah had 'unwived herself'. All this was bad enough, but Anne's sister proceeded to make things far worse by becoming 'a great preacher' in London, then continuing to preach on her return to Massachusetts and doing so to mixed congregations. If that was not enough to damn her, there were reports that Sarah was having sex with a man who had been excommunicated from the colony.

Thomas Dudley, father to Sarah and Anne, had to act quickly. It was his duty. He first granted Keayne a divorce (the first in the colony), then found a new husband for his daughter. Accused of 'unsatiable desire and lust', she needed the supervision and the sexual services of a man. (Dudley's own behaviour when his wife, Anne's mother, died confirms his staunch belief in marriage and childbearing as one's pious duty. Aged seventy, the widower remarried within months, and fathered three more children.) How convenient to be able to publish the work of exemplary wife, mother and daughter Anne! In 1650, the Dudley Bradstreet brand needed burnishing, particularly that of its womenfolk.

Almost everything I have written so far suggests that Anne Dudley Bradstreet did not have much to do with becoming the first American published poet. Perhaps I am taking at face value her male supporters' insistence on her lack of involvement. Was she quite as passive as the

prefatory material makes out? Opinion is divided. At one extreme, there are those who see her poetry as straightforwardly appropriated by her family. At the other, there are those who see Bradstreet pulling the strings behind the scenes, using her male family members as a conventional shield – doing a Margery.

By 1650, Bradstreet had already spent many years writing and circulating her work within her own godly, familial, colonial network. As such, she was already a 'published' poet, if we understand the word according to Margaret Ezell's ground-breaking analysis of manu-script circulation, which defines publication as 'the serious pursuit of literary excellence shared with a select audience of readers using the medium of circulating handwritten copies'. In practice, scribal publication offered a kind of security for the author, ensuring – up to a point at least – that readers would be likeminded, receptive, accepting. No wonder, then, that manuscript circulation provided a vital creative arena for women writers. Wonder instead that Lanyer rejected it.

Bradstreet appears to know about the risks. One of her poems, titled 'Prologue', imagines – or possibly *records* – with anxiety and some bitterness what can happen to women's work when it leaves the relative safety of friends and family.

> I am obnoxious to each carping tongue
> Who says my hand a needle better fits.
> A poet's Pen all scorn I should thus wrong,
> For such despite they cast on female wits:
> If what I do prove well, it won't advance.
> They'll say it's stolen or else, it was by chance.

This is strong stuff. Bradstreet challenges those who despise 'female wits'; she complains that even if her work is good, it won't 'advance' because people will say she has plagiarised or has by chance stumbled upon a few good lines. But above all, don't tell her that she should be concentrating on her sewing.

Funnily enough all these things and more have been said about her and her work over the centuries. Bradstreet is condemned, for example, for being imitative. Readers fail to hear the poet's own voice, so dependent is she on the work of the male authors to whom she is responding. For me, what is interesting is *how* a woman negotiates with her default-male literary heritage, rather than setting up some impossible standard of a separate female tradition, unsullied by men and their words.

Whether Bradstreet's vehemence about the aspersions cast on 'female wits' by 'carping tongues', the concern with plagiarism, is born of lived experience or fear is not the point. She sets out, clearly, exactly what those opposed to women's writing believed and said. The thought had crossed her mind. She knows. Whether that knowledge made her wary of print publication, or simply made her canny in its management, is impossible to tell.

II

I have written very little about Anne Bradstreet herself which is, I suppose, my point about *The Tenth Muse*. The truth is we know very little about her as an individual, a bit more about the world she lived in. Her life story is often harnessed to a slow-to-die 'pioneer' arc of triumph over adversity, a founding narrative for (white) America. A year before the arrival of the *Arbella*, Bradstreet and her fellow colonists' ship, into Salem in 1630, 180 'indentured servants' (English people who had sold their labour in exchange for a free passage to the New World) had been sent ahead to clear the land, plant crops and build houses in preparation for the arrival of the godly families. Eighty had died, and the rest were weak and malnourished, 'in a sad and unexpected condition'. The indentured had gambled, and lost. The incoming settlers had no choice but to release the survivors from their contracts, at which point most returned to England.

The colonists were on their own. The Bradstreet Dudley household somehow survived their brutal first New England winter. Almost all other families lost someone. The rest is white American history.

Massachusetts would be Anne Bradstreet's home for the next forty-odd years but neither the land nor its indigenous people are present in her writing. In 1630, when she arrived, only around three hundred Europeans lived in the region. Those few hundred had been enough, however, to kickstart the decimation of the Algonquian-speaking Native Americans whose land it was: the Pequot, Massachusett, Pokanoket, Nipmuch, Pawtucket and Narragansett 'nations'. The arrival of the Massachusetts Bay Company colonists, along with tens of thousands of their compatriots, only accelerated the process. The precise numbers are disputed (100,000 in 1620? 10,000 in 1640?), but all agree: the Native American population plummeted in these years by ninety per cent.

This did not trouble the colonists. Some exceptional individuals, men such as Roger Williams, argued for Native American land rights, but the Massachusetts Bay Company was having none of it, and burned his writings. On arrival, the English saw empty land, cleared by God in anticipation of their arrival. Until recently, intensive farming, seasonal migration and the controlled burning of woodlands had afforded the indigenous people subsistence. None of this was visible to the incomers who saw, to use Bradstreet's word, 'wilderness'.

And yet Bradstreet's life was enmeshed with those of the surviving Native Americans. The godly household, in the words of historian M. Newell, was the centre 'for the most intimate kinds of cultural and material exchanges' between the indigenous peoples and the incomers. New English families 'acquired slaves directly through capture or legal means'. Indigenous women took on much of the domestic work for their English mistresses, whether childcare or cooking, and the communities 'shared foodways, work methods, and technology. They attended each other's funerals, religious services, and celebrations.' Elite New Englanders (and Bradstreet was elite) effectively recreated the manors of their former homeland with retinues of Native

American dependants. Occasionally, the archive offers a glimpse of an individual. In the year of Anne Bradstreet's death, 'Tom Indian', also known as Thomas Robins, was accused by her husband Simon Bradstreet of breaking into his home. The Salem Quarterly Court ordered that Robins be 'branded in the forehead with the letter B' and fined fourteen shillings. Two years later, the Ipswich Quarterly Court found Robins guilty of drunkenness and assault and ordered that if he could not pay his five-pound fine he 'was to be sold to pay it'. In the words of Kathleen J. Bragdon: 'Frequently dismissed by contemporaries and more recent scholars as having been "unable to adapt", these were the most troubled survivors of groups whose subsistence base had been destroyed, who had been thrust into dependence and depleted by disease.'

Maybe it's not so strange that the landscape of 'wilderness' America and its exploited peoples are invisible in the first book to be published by an American. Then again, Anne Dudley Bradstreet is hardly more visible in the archive than Thomas Robins. Something of her life can be pieced together from the documentary record of her male relatives and phrases from Bradstreet's own spiritual autobiography, written as a religious teaching aid for her children. From this, we learn that God kept her 'a long time without a child' which was 'great grief to me, and cost me many prayers and tears'. Thankfully, the babies started coming when Anne was at the advanced age of twenty-one, five or six years into her marriage to Simon. The family moved from Salem to Boston, and from there to Newtown (later Cambridge), Agawam (later Ipswich), and, a last move in 1644, to North Andover. Bradstreet mentions that she was often ill with a 'distemper of weakness and fainting' and 'grinding pains', and a poem tells of the disaster in 1666 when the family home was destroyed by fire: over eight hundred books, a remarkable number for a New England household at this time, were lost. We know that Anne Bradstreet died in North Andover on 16 September 1672 of consumption, but we do not know her place of burial. Husband Simon lived on almost to the end of the century, dying at ninety-three.

These scraps of a life feed a soft-focus, persistent and problematic nostalgia for the early colonial era. We may be less complacent about the virtues of the 'pioneer' life these days, but it is all too easy to read of the physical challenges of the English in Massachusetts and be quite simply astonished that Bradstreet could write poetry on top of the housework and those eight children. Initiatives such as the 1619 Project, commemorating the arrival in that year of enslaved Africans in the Virginia colony, continue to shake things up, but other more traditional histories still have currency and Bradstreet is placed within them, a domestic, modest woman managing, magnificently, her household responsibilities, utterly astonished by her fame as America's first published poet. Charlotte Gordon's biography, more rigorous than most, is packed with the details of early colonial life, delivered with a dash of cosy feminism.

> But unlike male poets of the time, Anne came up with her lines as she rocked her baby to sleep in the middle of the night, as she stirred the soup on the fire, or as she bathed a child's cut. And so, as she turned her attention to the martial poem she wanted to write, she again decided not to underplay her identity as a woman but to put it to good use.

III

I don't want to dismiss this kind of thing (believe me, I know just how tough it is to write anything at all with babies and small children to feed and care for) but to look at Bradstreet through a lens of domesticity is to continue the work of the 1650 volume: a *Gentlewoman* ... in *America* ... would you believe it?! It's a distraction from thinking about what enabled Bradstreet to become an author, and, even more, a distraction from thinking about what stood in her way, because

every factor that appears to enable her holds, at second glance, a trap for the unwary female writer.

So, at first sight, that Anne Dudley was born into a privileged, Protestant family in England seems like a huge plus. A few facts: born in 1612 or 1613 in Northampton, Anne was the second child of Thomas Dudley and Dorothy Yorke. Thomas was steward to the godly Earl of Lincoln, but the Dudleys were a well-established, elite family in their own right. They were also keen followers of radical Protestant preachers such as John Dod and John Cotton. Indeed, they literally followed Cotton when he and his congregation relocated to Boston, Lincolnshire. This background ensured that there was both the money and the will to offer girls as well as boys an education. As with the Bertie family who may or may not have given an education to Aemilia Lanyer, the Dudleys, ardent in their reformed faith, believed that literacy was crucial to the primary task of the godly sinner, to engage directly with the Word of God.

But what the godly gave to women with one hand, they took with the other. Famously, in Bradstreet's own Massachusetts, Governor Winthrop decreed one Anne Hopkins's loss of 'understanding and reason' as a direct result of giving 'herself wholly to reading and writing'. He also condemned her husband for not doing his duty by her: he should have insisted his wife remain focused on her womanly duties. In other words, a girl could and should be educated in order to be able to read and interpret the Bible, but thus far and no farther. Her role remained as helpmeet to the men in her family (first father, then, naturally and early it seems, husband) and to raise the next generation of baby Protestants.

Which is precisely what Bradstreet, the good wife, mother and homemaker, did during the years in which she was writing poetry. She bore eight children (six already by the time *The Tenth Muse* appeared, with two more after the book's publication). She managed the household duties, from the vegetable garden, to the farmyard of pigs, chickens, sheep and cows, to the orchard; from baking bread to pickling vegetables to brewing cider and beer; from producing

clothing to medicine, and all points in between. And we know she fulfilled her most socially valued role, instructing her eight children in their Christian duty. And then on to the grandchildren.

That privileged, reformed, English upbringing had not necessarily been the best preparation for an adult life in Massachusetts. Anne Dudley had grown up reading works by Protestant writers that were far from plain in their literary style. Writers like Sir Philip Sidney and his sister, Mary, Countess of Pembroke showed that the devout could also be witty, learned, allusive. Across the Atlantic, a new, more puritanical, cultural and religious politics was being formed. Bradstreet brings these two traditions together with some panache. There is something rather wonderful in how she manages to have it both ways (in a similar way to her almost-contemporary George Herbert), espousing plainness and directness whilst at the same time doing some very clever things with words. She is perfectly capable of apologising for her lack of skills in a dazzling display of just those skills. Her love of language's riches is evident in her preference for the King James Bible over the more strictly Calvinist Geneva Bible favoured by the most radical Protestants, including the communities in New England.

But despite this, despite her obvious appreciation of writers such as Sidney and (as we shall see) Sir Walter Ralegh, Bradstreet's style remains straightforward, characterised by pentameter closed rhyming couplets in which the sense ends at the end of the line. Only occasionally does she play with metre. This is a cautious kind of poetry, in terms of form, rhetorical strategies and the use of metaphor. The overall effect is directness, a thoroughly 'plain' style. Which is exactly what was required by her New England community. Indeed, Bradstreet is praised for avoiding a 'high-flown' language, and rewarded with a poet's laureate wreath made of, wait for it, parsley. Woodbridge is once again reassuring his readers that this is a woman poet who is happiest in the kitchen.

These tensions between richness and plainness in Bradstreet's poetry, between apparent opportunity and actual repression in

Bradstreet's life, run deep. They touch not just matters of house-hold management, education or literary style, but self-expression and political engagement. On the one hand, non-conformist religious practice, unusually for the era, allowed some women some opportunities to engage in spiritual matters. The practice of one's faith could be, and was, a chance for self-expression and creativity – up to a point. The Massachusetts Bay Colony would not, however, tolerate direct political speech or religious preaching from a woman.

Witness the case of Anne Hutchinson. Her sin was to claim a direct line to Jesus (shades of Margery Kempe) obviating the need for male political and religious governors. As Hutchinson said: 'now having seen him which is invisible I fear not what man can do unto me'. Theologically, she took the orthodox Calvinism of the Massachusetts Bay colonists and went further, to antinomianism, arguing that human actions were entirely irrelevant to salvation, espousing a doctrine of *free* grace which denied any significance to works. Even more troubling to the authorities, she claimed to be able to identify the 'elect', those who were saved. Worse still, she knew who was not. But above all, she preached, and to men as well as women – just as, to the Dudley family's horror, Anne's sister, Sarah, had done. It didn't help that, like all godly women, Hutchinson knew her Bible. Her accusers insisted that if the Bible mentioned women teaching it would be 'privately, and upon occasion', not 'set meetings for that purpose', and that such teaching as there was should follow Titus's instruction to women to 'be discreet, chaste, keepers at home, good, obedient to their own husbands, that the word of God be not blasphemed' (2:5). Hutchinson read her Bible, not least the Book of Titus, in a different way.

Hutchinson would be put on trial in 1637, seven years after Bradstreet's arrival in the New World. Eleven years later, the Massachusetts Bay Colony tried and executed an accused witch for the first time, one Margaret Jones, a midwife from Charlestown, hanged at Gallows Hill in Boston. Hutchinson did not die that way.

Exiled by the Colony, she endured and survived the stillbirth of her badly deformed baby, an event viewed by the Massachusetts governor as further evidence of its mother's spiritual deformity. Six years later, exiled Hutchinson and almost all her family were killed in a Native American raid. The same governor rejoiced that this 'American Jezebel' (as he called her) had met the end she deserved for defying God's elect and presuming, as a woman, to exert authority over men, contrary to God's dictates.

Anne Bradstreet cannot have been unaware of Hutchinson. Her husband, Simon, was one of the men who had voted to banish her. Surely she knew, too, of Margaret Jones. Her achievement, if that is the right word, was to find a voice for herself but avoid the fate of those others, avoid being the wrong sort of woman.

IV

The voice Bradstreet found was political rather than domestic.

The only way that her home, America, finds its way into her poetry is as a place where her faith is tested: 'Remember, Lord, thy folk whom thou/To wilderness hast brought'. Bradstreet is tested, but not found wanting, for, in her brave new world, she can write boldly that, for all her admiration of Sir Philip Sidney and the Old English literary great and good, God is inspiring *her* in a small town in New England. Only in reformed Massachusetts can she be the next truly Christian poet.

Godly, political Bradstreet is most fully on display in *A Dialogue between Old England and New, concerning their present troubles, Anno 1642*. Country and colony are mother and daughter, the former miserable, the latter confident. The devout ('saints') have escaped to New England, fleeing Sabbath-breaking and alcohol. In Old England, no one is listening to the preachers who cry 'destruction to my wicked Land'. Bradstreet references, among other things, debates about royal

powers and prerogatives and the abuse of the Star Chamber court. In other words, she knows exactly what's happening back home in the old country.

The *Dialogue* provides Bradstreet with an opportunity to offer a hot Protestant take on the old country's history. She runs through a list of all the supposed threats to English liberty, from the Normans to the Spanish, from civil wars to plague, with a nod towards dubious monarchs such as Edward II. But these are as nothing to the true threat of false religion: the rise of 'Idolatry', that the 'Gospel is trod down', that 'Church Offices are sold and bought for gain', that the Pope is determined to establish 'Rome here again'. The real energy of the poem lies here, and in the (to me repellent) New World's call to violence: 'We hate Rome's Whore, with all her trumpery.' Starting with the call to cleanse England of popish superstition – 'Hang 'em, hang 'em (load Tyburn till it cracks)' – Bradstreet continues with an appeal to sack Rome, then on:

> with brandished swords to Turkey go
> (For then what is't, but English blades dare do)
> And lay her waste, for so's the sacred doom
> And do to Gog, as thou hast done to Rome.[1]

It is a violent, apocalyptic rallying cry. Bradstreet insists that New England can and will 'tell another tale'. Massachusetts offers both a new society and a new way of writing. Even in the final poem of 'The Four Ages of Man', which is ostensibly about old age, Bradstreet has a lurking political agenda, evident in the praise of Queen Elizabeth ('I've seen a Kingdom flourish like a tree/When it was ruled by that Celestial she') and her review of recent English history. The civil wars have been the 'desolation of a goodly State'. Then Bradstreet puts in a remarkable full stop and a stand-alone line.

> These are no old wives' tales, but this is truth.

Ventriloquising through an old man, Anne Bradstreet bears religious and political witness. Her confidence grows to the point that she makes claims for women's ability. All feminine modesty is forgotten as she challenges the reader to consider the achievements of Queen Elizabeth I:

> Now say have women worth? Or have they none?
> Or had they some but with our Queen is't gone?
> Nay masculines, you have thus taxed us long
> But she though dead, will vindicate our wrong.

The modesty is a blind.

> To sing of Wars, of Captains, and of Kings,
> Of Cities founded, Commonwealths begun,
> For my mean Pen are too superior things ...

Her 'mean', lowly, pen? These opening lines to her justly famous 'Prologue' belie the fact that this is *exactly* what Bradstreet is going to do, as flagged up by her echoing of the first lines of the *Aeneid*, Virgil's Latin epic. Elsewhere, there's a triple blast of humility in Bradstreet's *Four Monarchies*, her retelling of universal history (hardly a small undertaking): she has a 'tired brain', she should leave the work to 'a better pen', the work 'befits not women, like to men'. But the blast comes over 1,700 lines into the mammoth third book of this work. It is very, very late in the game for an apology. I can't help smiling that Bradstreet then claims the subject is too high for her by using a *Latin* quotation: *ne sutor ultra crepidam* ('Cobbler, not more than the sandal') – in other words, stick to what you know.

Anne Bradstreet's confident political and religious statements, her aggressive godliness, in *The Tenth Muse* are taken straight from her colony's male leaders' playbook. However, she is not purely speaking for her Massachusetts colony, but for her specific family. In the

run-up to and fall-out from Charles I's execution, a power struggle broke out between the Dudley/Bradstreet 'accommodationist' faction who argued, as long as they could (and then again with the Restoration), for obedience to the King's wishes, looking always to England. The opposing 'Commonwealth' or 'Separatist' faction was far more keen to break completely with the old country, most notably at the Restoration. Bradstreet's father and his supporters hoped and believed that their colony would not only offer an example to those back home of a truly pious community, but might also give a spine to wavering Old England, threatened from within and without by papists. Thus the rallying cry to retake Catholic Europe and then move on to crush the Muslim Ottomans.

The *Dialogue* is dated to 1642, the year that Bradstreet gave birth to her fifth child, Hannah. It is the parliamentary struggle against the forces of religious corruption and monarchical absolutism that get a look in, not the new baby. Indeed, what is missing, and startlingly so, from the 1650 volume are any what we would call 'personal' poems. Bradstreet had in fact written some, powerful, moving short poems about the death of her mother, or her own fears ahead of giving birth. But these are excluded.

Anne as mother or daughter is not present in *The Tenth Muse*, but motherhood is. In 'The Four Ages of Man', the opening poem about childhood actually spends more time considering the mother than the (boy) child. There is some heartfelt writing about the 'nine months' weary burden' of pregnancy, the 'bearing pangs', the sleepless nights, the mother's 'weary arms', her attempts to 'appease' the baby 'with her breast', the lullabies: 'she danced, and "*By, By*" sung'. This is a poem about childhood that includes gripe, teething, indigestion, diarrhoea, 'vomit, worms and flux'. Bradstreet's 'Four Seasons' (nature writing which conjures up remembered English rather than lived-in American landscapes) is packed with allusions to babies and children. Winter lies 'In swaddling clouts, like new-born infancy,/Bound up with Frosts, and furzed with Hails and Snows,/And like an Infant, still he taller grows'.

These glimpses of the work of motherhood, the workings of the female body, are exciting. But Bradstreet is writing utterly from within her community's ideal of woman as wife and, crucially, mother. And the *good* mother breastfeeds her child, rather than using wetnurses, or so one of the leading aristocratic figures in Bradstreet's childhood, the Countess of Lincoln, insisted. Bradstreet's women's bodies are present, and only present, to be mined for their *metaphorical* significance. That Bradstreet is named (no less than five times) in the prefatory material, following the gender reveal on the title page, only underlines this. It matters that a 'Gentlewoman', Anne Bradstreet, of Massachusetts – wife of Simon, daughter of Thomas Dudley – wrote these poems. That this is woman's work is part of the volume's selling point. But it is women's work in the service of a godly patriarchy.

Of course, we love the moments when Bradstreet is gutsy. 'Who says my hand a needle better fits' is a great line, then and now. But to the disappointment of many, the moments when she tackles the perceived problem of her own gender are actually few and far between. Bradstreet's feminist gestures (if that word is even relevant, and I am not sure it is) are hardly sustained. She, of course, wants to prove a point that women can write poetry too, yet she has internalised traditional understandings of what is appropriate for a woman, in writing and in life, and thus always steps back, and not at the last minute either, from any challenge to the 'precedency' and 'pre-eminence' of men.

Why *should* Bradstreet do our feminist heavy-lifting? She has her own political agenda and a powerful way of delivering it in punchy couplets: 'She like a brave Virago played the rex,/And was both shame, and glory of her Sex.' Bradstreet sets out, clearly and succinctly, the take-home message of providential historiography:

> Thus Kings, and Kingdoms, have their times and dates,
> Their standings, over-turnings, bounds, and fates.
> Now up, now down, now chief, and then brought under;
> The Heavens thus rule, to fill the earth with wonder.

But 1650 Anne Bradstreet is not quite what a twenty-first-century feminist wants from her literary foremothers – whether because of her compliance with patriarchy, her blindness to others' oppression, her calls to violence, or her focus on the public spheres of politics and history at the expense of her own private, personal experiences.

V

This 'problem' with Bradstreet evaporates twenty-eight years later. In 1678, a new edition of *The Tenth Muse* is published in Boston, complete with authorial revisions of the 1650 poems. It has a new title, *Several Poems Compiled with Great Variety of Wit and Learning*. All this is music to the ears of those who want to see Bradstreet's growing feminist awareness. The new title ditches the word 'muse': Bradstreet is no longer an inspiration *for* poetry, she's an author taking ownership of her work. There's more, a poem 'The Author to Her Book', in which Bradstreet describes the earlier collection as a 'rambling brat', a child that has been snatched by others from her side, and 'exposed to public view'. In a characteristic move, she uses a conventional metaphor, that the poem is the author's child, to say conventionally modest things – she has washed the brat's face, but it remains dirty and flawed – but runs with it in a remarkable direction, announcing that her poems have no father. Bradstreet is on one level defending herself against the charge that as a woman she would have needed male help in the writing of the poetry, but she transforms the potential shame of lacking a husband into a proud claim of solo authority.

A female poet needs no man to 'give birth' to her work. Feisty stuff, but not quite as feisty as it may seem. By the time the cleaned-up 'brat' appeared in 1678, its single parent was dead. The volume has indeed been 'corrected by the author', but it has also been 'enlarged'

with eighteen poems found amongst Bradstreet's papers after her death. Crucially, these new poems are more traditionally 'womanly' than those of 1650. And we like them.

Take this poem in which Anne expresses just how much she misses her husband, Simon.

> My head, my heart, mine Eyes, my life, nay more,
> My joy, my Magazine of earthly store,
> Flesh of thy flesh, bone of thy bone,
> I here, thou there, yet both but one.

It's sincere, touching, personal, but for those who know their Bible, these lines echo Adam's words about the creation of Eve. Bradstreet is offering a strong hint that it is possible to love people too much because we all know how it ended in the Garden of Eden. Calvinist poet that she is, Bradstreet reminds her reader, and herself, again and again, of the transience of earthly joy, of human relationships:

> All things within this fading world hath end.
> Adversity doth still our joys attend.

She knew this only too well, writing harrowing poems about the death of grandchildren (Elizabeth at eighteen months, another at three years and seven months, yet another at 'a month and a day'), the emotion the more raw because Bradstreet insists that she should not be grieving, because she recognises that God is punishing her for having loved the children too much. When will she learn not to love these babies? When will she learn to accept God's will?

> I knew she was but as a withering flower
> That's here today, perhaps gone in an hour.
> Like as a bubble of the brittle glass
> Or like a shadow turning as it was.

In two of the most moving lines, Bradstreet says her goodbyes, acknowledging the child will never run to her again.

> Farewell, dear child, thou ne'er shall come to me,
> But yet awhile, and I shall go to thee.

There is consolation, Christian consolation, the hope of being together in heaven, the knowledge that this earthly life is merely preparation for death. But still the deaths keep coming: Bradstreet's daughter-in-law Mercy dies at only twenty-eight, following the premature birth of a daughter, Anne. Grand-daughter Anne did not survive. Bradstreet's poem 'Before the Birth of One of Her Children' captures a moment of intense anxiety rather than excitement, the reality of her world of high maternal and infant mortality.

The one poem written out in her own hand, 'As Weary Pilgrim Now at Rest', added (a 'tipped-in' sheet) to the last leaf of the final gathering of paper, ends with Bradstreet praying to be 'ready' for the day of her death, imagined as union with bridegroom Christ: 'then Come deare bridgrome Come away.'

These are all great poems. They speak to us across the centuries. Her rightly famous celebration of her marriage to Simon is frequently anthologised.

> If ever two were one, then surely we.
> If ever man were loved by wife, then thee.
> If ever wife was happy in a man,
> Compare with me, ye women, if you can.
> I prize thy love more than whole mines of gold
> Or all the riches that the East doth hold.
> My love is such that rivers cannot quench,
> Nor ought but love from thee, give recompense,
> Thy love is such, I can no way repay,
> The heavens reward thee manifold, I pray.

Then while we live, let's so persevere
That when we live no more, we may live ever.

Yet for all that this celebration of marital mutuality is truly exciting and new, that final couplet reveals a woman living on the knife-edge of Calvinist belief. She turns away from life, looks to the time when they will 'live no more'. Bradstreet ends by hoping, tentatively, that their love might, just, be a sign of their election, their salvation. For a love poem, it is precarious, theologically driven, actually quite dark – and washed down with a dash of competition with other women who are not as blessed.

VI

Sentimentalising the 'personal' poems makes it all too easy to overlook the significance of the reprinting in 1678 of Bradstreet's more publicly engaged works, some of which she revised in light of the changing political landscape. Take the *Dialogue*, with its date of 1642, its reference to the 'present troubles'. The challenge for the godly parliamentarians in 1642 was to get King Charles I on side. There was still hope that (give or take a few battles) the King could and would be reconciled with those of his 'brave Nobles' who were critical of his moves towards absolutism and popish ritual. As Bradstreet asks: 'Which is the chief, the law or else the King?' The poem speaks to the agenda of the Protestant aristocratic opposition to Charles's abuse of divine right, an opposition led by men such as the Earls of Essex and Lincoln, Thomas Dudley's master.

When the *Dialogue* was printed in 1650, that moment had long gone. It was not a nobleman who led the new Commonwealth but Oliver Cromwell. The King was dead, his son in exile. The *Dialogue* is now a poem out of time, not quite up to speed with a world in which monarchy was no more. But that might be the point. Bradstreet is

voicing the more moderate politics of her Massachusetts, or rather more moderate when it came to the government of England, less moderate in its demands for militant Protestants to reform Catholic Europe. By the time the poem is published again, in 1678, Bradstreet's fundamental loyalty to the Crown and Church comes across loud and clear. She now describes Cromwell as a 'Usurper'. The King has been 'by force thrust from his throne'. She is equally loyal to her virulent anti-Catholicism, adding four new lines:

> Three hundred thousand slaughtered innocents,
> By bloudy Popish, hellish miscreants:
> Oh may you live, and so you will I trust
> To see them swill in bloud untill they burst.

As with the 1650 publication of *The Tenth Muse*, the publication, presumably also overseen by Bradstreet's male relatives, of the post-humous revised edition was well timed in light of the political situation in the Old and New Worlds. The year 1678 saw the end of what is often called King Philip's War (also Pometacomet's Rebellion), an armed struggle between some indigenous nations and the New England colonists and their indigenous allies. It was a good moment to promote the New English cause.

Little of this usually gets into accounts of Bradstreet's poetry, nor does it fit with traditional histories of women's writing. Instead, we focus on her directness, the sense of a woman speaking to us in plain language from across the years. It is this quality that has meant that Bradstreet (unlike the vast majority of her fellow women poets) has not needed resurrection, at least according to *The Oxford Encyclopedia of American Literature*. She has 'long been the best-known English-language woman poet of the seventeenth century and one of the most famous early American literary figures'. The personal poems found in anthologies 'offer a speaker who is clearly a loving wife, mother, and grandmother engaging the events of a woman's life: the temporary absence of a husband, the anticipation

of childbirth, and the early deaths of children. All of these become important subjects for women's poetry.'

This is precisely the problem. For all that the 1678 volume is packed with touching poems, Bradstreet (or whoever picked out these particular works for publication after her death) are pointing women towards a dangerous cul-de-sac. It is called 'women's writing'. We can smile ruefully at Woodbridge and his like, offering a parsley laureate wreath to his sister-in-law, but we are doing something similar if we only celebrate and anthologise these personal poems. We are buying into a long-standing tendency to prefer private, unstudied, apparently autobiographical writing from our female authors over work that is more obviously public, intellectual and formal.

Ironically, Bradstreet's brief spiritual memoir, published in the nineteenth century, and part of her godly mother's advice to her children, shows that even when we have something that looks like autobiography, we are guaranteed neither the personal nor the spontaneous, at least as we understand those words now. In it, she recounts 'God's dealing with me from my childhood to this day', allowing herself to be explicit about the struggles that only seep into the cracks of her poetry. She writes powerfully of her teenage battles with her 'carnal' heart, of her adult doubts and fears. She knows that God gives her afflictions to make her closer to him but she is often very, very down ('sinkings and droopings', 'in darkness not light'). She is disturbed 'concerning the verity of the Scriptures' and by atheism: 'how I could know whether there was a God'. Bradstreet even asks 'why may not the popish religion be the right? They have the same God, the same Christ, the same Word. They only interpret it one way, we another.'

Fortunately for everyone, Bradstreet retreats from becoming a Satanist/Roman Catholic/atheist/depressive because she reminds herself of Rome's vain fooleries, deceitful miracles and persecution of the saints. For all the struggles rehearsed in her spiritual autobiography, Bradstreet remains committed to her primary goal of

guiding her children in the ways of God, harnessing each and every metaphor to that cause, not least in her 'Meditations Diuine and morall' in which she likens the necessity of weaning a child from the breast to the forcing of the good Christian from their attachment to their earthly life:

> some children are hardly weaned [difficult to wean]. Although the teat be rubbed with wormwood or mustard, they will either wipe it off, or else suck down sweet and bitter together. So is it with some Christians … they are still hugging and sucking these empty breasts …

Thus God 'is forced to hedge up their way with thorns, or lay affliction on their loins, that so they might shake hands with the world before it bid them farewell'.

Bradstreet acknowledges struggle but accepts fundamentally this harsh theology. Her record of her arrival in the New World – just two sentences – is a paradigm of submission. Bradstreet:

> was married and came into this country, where I found a new world and new manners, at which my heart rose [i.e. by which she was distressed]. But after I was convinced it was the way of God, I submitted to it and joined to the church at Boston.

Above all, she knows how she wants to be remembered, how a good woman is remembered. Bradstreet's elegy for her mother praises her for an 'unspotted life', for being a 'loving Mother and obedient wife'. All Anne wants, when she imagines her own death, is to be remembered by her children as a good (Christian) mother in their eyes: 'I happy am if well with you.' Samuel, her son, wanted to be at her deathbed so that he could commit to memory the 'pious and memorable expressions uttered in her sickness'. Even in death, 'skin and bone', racked with pain, Bradstreet's words remain in the service of being the good woman.

VII

How to remember Bradstreet?

From the start, her family and friends present this 'New-England Poetess' as exemplary and exceptional, a Gentlewoman whose work set her apart from most of her sex. At the end, her funeral elegy praised her for being 'a Pattern and Patron of Virtue', a 'truly pious, peerless & matchless Gentlewoman'.

That exceptionalism is a mixed blessing. On the one hand, it does not leave much room for other women. On the other, it has ensured that Bradstreet's work has never completely disappeared from the literary radar.

Bradstreet has traction precisely because of all those 'firsts' (have I mentioned that she is the first woman to publish explicitly marital love lyrics, to be an American published poet, the first English woman and the first New Englander to publish a collection of original poems …) but, as I wrote in the opening chapter, this can lead some to assign her 'literary historical importance' and then move swiftly on to the proper writers. But it did mean that when first-wave feminists turned to Bradstreet they recognised that she did not need reviving. Instead, she needed repositioning in the literary and academic mainstream. A 'Complete Works', like those of her male contemporaries, the John Miltons and Andrew Marvells of this world, was duly published in 1967 with an inspirational introduction by the feminist poet Adrienne Rich. Later, Rich would argue that 'a place on the map is also a place in history' and that she hoped that these kinds of critical editions would secure both. Fifty years on, and Bradstreet's place on the map, and her place in history, are far from clear. A quick search of literary timelines, from Wikipedia to the British Library, shows that it is still easy to leave her work out of the story.

This may not be a bad thing according to those who question, speaking from a variety of cultural battlefields, whether Bradstreet and her work *should* have a place on the map of American literary history. True patriots complain of her failure to separate from Old

England – after all she left as a teenager in 1630 – and her failure to describe the physical wonders of her new world. The explanation that Bradstreet's fundamentally theological, intellectual take on life leads her to ignore the landscape she lives in doesn't exactly satisfy the patriots. Surely she could have written something about the fall colours?

Others are contesting a complacent history of white America in which Bradstreet features, often unthinkingly. They point out that the very categories of race and gender which haunt us now are being constructed in Bradstreet's era.[2] If you accept (and I do) that we can and should rethink the events of the seventeenth century in Massachusetts, then we can and should rethink Bradstreet's place in them. The *Arbella* voyage in 1630, which brought Bradstreet to her new world, was part of the Massachusetts Bay Company, founded on the same basis as the Royal African and East India Companies of the same era, all three initiated by the British Crown and supported by private investors. Their goal was to promote trade and development, to create revenue for Old England, and to make money for those private investors. To this end, King Charles I gave the English settlers in Massachusetts, including Bradstreet's father and husband, the title to land and natural resources in the New World, no matter that there were already people living there.

From the start, the colonists in Massachusetts were dependent on the labour of Black Africans and Native Americans. They imported slaves, along with cotton and tobacco, from the West Indies as early as 1638. People of the Pequot nation, defeated in battle, were equally essential to the labour system, equally disenfranchised. The Massachusetts Bay Colony would be the first of England's mainland colonies to make slavery legal, in 1641. It would remain so for the next 140 years.

One minister, recounts historian Newell, brought slaves into his household to ease 'his beloved wife's burdens during successive pregnancies and child rearing'. Their presence 'allowed him to pursue merchanting and farming along with his clerical duties',

thus increasing the family's wealth. I think we can assume that another beloved wife, Anne Bradstreet, would have been dependent on the unpaid labour of Native Americans and Black Africans in order to create the time she needed to write. That Anne Bradstreet remains silent on the subject of these peoples does not mean that we should.

Afterword

The scholar Gillian Wright, only slightly tongue in cheek, describes Bradstreet as an 'embarrassing' poet, seeming to require apology even from those who like her work. If you believe that some of the vital tasks of feminism are to give value to certain ways of writing which have traditionally been dismissed (the personal, the spontaneous, the autobiographical, the emotional); to celebrate the female body, so long demonised; and to reclaim the worth of those private, domestic spheres in which so much women's work takes place, then Bradstreet is, indeed, disappointing. She cannot be brought, complete and uncut, into the feminist project. You will need to confine yourself, mainly, to the poems and prose published after Bradstreet's death. After all, who wants an intellectual, bookish Bradstreet (nearly two thousand lines of angry Protestant history based on her close reading of Ralegh's *History of the World*), when we can read a short, moving poem about the death of a child? Who wants to take on board her tough Calvinism when we can imagine her happily tending her chickens?

The danger in all this is, of course, unintentionally, that we accept patriarchy's traditional understanding of woman: of the body, not the mind; less rational, more emotional. For me, therefore, the 1650 volume is Bradstreet's most radical, most interesting work. Its printing makes us ask questions about women, authorship and power – to what extent was Bradstreet in control of its publication? Its content

crackles with the tensions in the author, between her questioning, powerful mind and her godly desire to submit to God and men. This is a writer who has eight hundred books in her library, who makes sure she has the paper – a rare if not costly commodity in the New World, a penny for six sheets if you didn't need 'fancy paper' and I very much doubt Bradstreet did – and ink and time to write.[3] This is also an author who offers (almost) every word in service to her God, father, husband and children.

Agreed, we can't go to the 1650 volume for an insight into the womanly, private Anne Bradstreet, the domestic, intimate, unaffected poet. Poems from *The Tenth Muse* don't make us cry, now. Some of the poems published after her death can and do. But engaging with a woman from the past should not be that easy; we should not collapse distances of time and difference into sentiment. Instead, let's talk about, argue about, her militant Calvinist piety, her tendentious take on history, her blindness to the colonised, and her silences where we might have hoped for words.

CHAPTER FOUR

Aphra Behn

'I took her for an Errant Harlot'

I

OLD ENGLAND, March 1677, and it's opening night in London's theatreland.

The bills posted around the neighbourhood promise *The Rover, or the Banish't Cavaliers* at the 'large and handsome' Duke's Theatre, fronting the Thames just south of Fleet Street. The Duke in question was James, Duke of York – down the road his brother, King Charles II, had his own Company at the Theatre Royal – because theatre business was royal business in these years. One of Charles's first acts on his return to the throne in 1660 had been the restoration of public theatre after years of civil war and Cromwellian rule. The early years of the 1660s had been tough. Seasons could be and were disrupted or even abandoned, whether due to rioters or censors, striking actors or Puritan protestors, plague or most famously the Great Fire of 1666. Add the inevitable fallings out between actors and playwrights, owners and patrons, and it's amazing the industry survived at all. But seventeen years on from the Restoration of the monarchy the theatres were full again.

The audience gather, some young 'Men of Quality', some 'Ladies of Reputation and Virtue', while in the galleries, the 'ordinary People'. And, since the performance and sex industries have always existed in symbiosis, from Greek *hetairai* (courtesans) onwards, there are the women 'who hunt for Prey': prostitutes. They 'sit all together in this Place, Higgledy-piggledy, chatter, toy, play, hear, hear not'. So noted Henri Misson, a foreign visitor to London, eager to see how things went in England's capital. Gone were the innyard-style open-air Globes and Roses of the beginning of the century. Now the audience were comfortably indoors, theatres lit with wax candles 'and many of them'. Unlike those Globe days when Shakespeare learned his craft (as actor and playwright), London now had two, and only two, theatre companies controlled by the King's nominees, William Davenant and Thomas Killigrew. Kings of theatreland, they determined everything from ticket prices to actors' earnings – and, of course, whose plays would be performed. When Davenant died his patent passed to his widow who handed over the running of his theatre to Thomas Betterton and Henry Harris. These were the men who counted.

Londoners were proud of their new theatres, their new drama. Now all was 'civil, no rudeness anywhere'. No bear-garden this, with two or three fiddlers: now, audiences could listen to nine or ten of the best musicians. Yes, some – although far from all – of Shakespeare's (and Ben Jonson's) plays were dusted down, often in adapted form, for it was a cheap way to operate. But these old plays were hardly venerated. Samuel Pepys thought *Twelfth Night* 'silly' and *A Midsummer Night's Dream* 'the most insipid ridiculous play that ever I saw in my life'. And no more boys playing women's parts, despite the success of the earlier transvestite practice. In fact, that success was part of the problem.

A playgoer in 1610, watching Shakespeare's new play *Othello*, saw the boy actor portraying a woman ('Desdemona killed by her husband moved us especially, her face alone implored …') as an unsettling challenge to the gender binaries insisted upon

by patriarchy. Fifty years on, it became law that females should, indeed *must*, play women's parts for surely it was better to have a woman, even a woman who was no better than she should be, on stage rather than cross-dressing. In 1662, fear of homosexuality or transvestism ran stronger than misogyny. Audiences duly began to expect more flesh, because actresses could and did get more naked.

The leading lady in tonight's show, Elizabeth Barry, was only nineteen, but had seven shows behind her already. She was also rumoured to be the mistress of the Earl of Rochester. The rumours were correct. Very soon after this opening night, Barry would become pregnant by the Earl. She was unable to perform in the autumn season, and gave birth to her daughter, christened Elizabeth Clerke, in December of 1677.

Davenant and Killigrew, the men now running theatre, had seen out the Commonwealth years holed up in France or beyond, places where it was not only normal for women to be on stage, but for there to be scenery. Now English audiences looked forward to 'discovery' scenes – the revelation of a woman undressing in her closet, or as they will see tonight a candle going out, a bed descending, a character groping in the dark, and then ('the scene changes') a man seen crawling out of a common sewer, 'his face, &c. all dirty'.

The candles are lit. The audience is in the building. An actor strides on to the stage, and says he's asked the author what he thought he should say to get the audience's attention. The author says there's not much point in saying anything, he knows full well that from the pit to the gallery, people are here tonight to look at and talk with each other ('chatter, toy, play, hear, hear not', as that visitor to London had put it), rather than to see the actual play. It's a typical moment in the feisty arena that we have come to know as Restoration Drama – and prefaced one of the hits of the season, indeed of the era: *The Rover*.

II

As the title page insists, this is a *comedy*. The arrival of some 'banish't Cavaliers' in Naples at carnival time impacts three women, each of whom, in different ways and with different outcomes, falls for a cavalier. The subplot revolves around the tricking of yet another cavalier, the foolish Blunt, by the prostitute Lucetta. All ends happily. Pretty much.

Why was the play such a success? A one-word answer does for many: Willmore. He is the rover of the title, irresistible to women, admired by men, a sexual predator with bucketloads of charm. Willmore calls out the conventionally virtuous as hypocrites. He enjoys strong drink and stronger sex, scorns love and marriage. He is witty. His vicious misogyny is delivered with a smile. He tells it as it is.

Like most of the rakes on the Restoration stage, he has some great lines. After another debauched night he brags that he has had 'all the honey of Matrimony, but none of the sting'. When a woman is upset by him he turns on her: 'A 'pox o' this whining. – My bus'ness is to laugh and love – a pox on't, I hate your sullen Lover, a Man shall lose as much time to put you in humour now, as wou'd serve to gain a new Woman.'

He has a kind of honesty ('give me credit for a Heart, for faith I'm a very honest Fellow', he cries, urging a woman to take him straight back to her house – 'thy Lodging sweetheart, thy Lodging! or I'm a dead Man!', and all to satisfy his 'swinging appetite') but it is usually honesty laced with cruelty or threat – and lies.

Back in Shakespeare's time, his deceptions would have been part of the dramatic irony of the comedy, making Willmore a rogue at best, a villain at worst. Now, his shameless lies make him irresistible. One woman who falls for him, having found he spent the night with another and is lying to her face about it, says, 'Now if I shou'd be hang'd I can't be angry with him he dissembles so Heartily'.

Willmore does what he does well. He lacks some of the sheer nastiness of other rake heroes in plays of the time. We can forgive

him his sins, because his attempts at rape are always interrupted, and he doesn't quite kill anyone. His dramatic foil, his friend Belvile, is much more of a traditional romantic hero, much more sincere, and also much more dull.

Over the years, Willmore has seduced even the most sensible of critics – and the most severe of monarchs. Queen Mary (the Protestant successor to Catholic James II, who replaced his merry monarch brother in 1685) condemned *The Rover* for its amorality and immorality. She still rather liked Willmore, and the actor who played him. Indeed, the part is an actor's dream, and William Smith who played Willmore in that spring season of 1677 made his name in it.

Willmore and his friends, the 'banish't Cavaliers' of the subtitle, are former Royalist soldiers (now mercenaries) who have escaped England and a civil war that they have lost to the parliamentarians. The play is set in Naples but it doesn't really matter: anywhere but England. What does matter is that it is carnival time, permitting the masks and confusion essential to a sex comedy. Willmore meets his match, the witty, lively, determined Hellena, the part played by Elizabeth Barry capitalising on all the young actress's comic talent.

Verbal sparks fly between the two, with Hellena appearing to give as good as she gets. For Willmore, marriage is out of the question. It is 'as certain a bane to Love, as lending Money is to Friendship'. A couple of years earlier, the playwright William Wycherley had his libertine Horner ask in *The Country Wife*: why marry at all if all you want is sex? The answer, according to Wycherley's deeply unsympathetic character Pinchwife, is that it is a matter not so much of ensuring a ready supply of sex, but of owning and controlling that ready supply. Hellena, whilst happy to flirt, sees things differently. If she gives in to Willmore (for it is her lodging he wants to go to), she knows the likelihood is that she will end up with a 'cradle full of noise and mischief, with a pack of repentance'. She may talk the talk of a libertine (she plans to 'allow but one year for Love, one year for indifference, and one year for hate – and then – go hang your self – for I profess myself the gay, the kind, and the Inconstant – the Devil's in't if this

won't please you') but she will not walk the walk. She claims both to see through Willmore and to be similar to him. Their 'humours are alike', although he uses his to abuse women while she uses hers to repel dull men. Somewhat astonishingly, the play ends with the prospect of (rake) Willmore and (virgin) Hellena marrying – and, less astonishingly, decent Belvile marrying the woman he loves, Florinda, still a virgin despite the men's best attempts. Florinda had been destined for marriage with a rich old man, Hellena for the convent. The words frying pan and fire spring to mind.

One woman stands outside the comedic marital coupling which closes the *Rover*: Angellica Bianca, the courtesan. Angellica is on one level that cliché, a tart with a heart. Until Willmore arrives, however, she is unaware of this fact, as disillusioned with love as any libertine, asserting that 'inconstancy is the sin of all Mankind; therefore, I am resolv'd that nothing but Gold, shall charm my heart'. And she has a lot of gold. Enter Willmore, and her mercenary pursuit of wealth falters. She falls, heavily, for him and, even worse, wants him to love her. She offers him a deal. Knowing full well that he has not got the money to pay for her sexual services (she's expensive: a thousand crowns for a month's exclusive use), Angellica asks for a different payment: 'The pay, I mean, is but thy Love for mine. – Can you give that?' Willmore, lying – whether it's obvious or not, whether he cares to conceal his lies, whether Angellica cares are all up to the actors playing the roles – accepts her deal. 'Entirely – come, let's withdraw! where I'll renew my Vows – and breath 'em with such Ardour thou shalt not doubt my zeal'. Angellica is powerless ('Thou hast a Pow'r too strong to be resisted') and off they go.

Moretta, Angellica's servant and a former courtesan herself, is disgusted. She sees Willmore for what he is: a penniless, violent alcoholic 'that fights for daily drink, and takes a Pride in being Loyally Lousy', but she also sees Angellica's idiocy as the fate of most whores (Moretta's word).

The scenes between Willmore and Angellica are, if anything, even sharper and more erotically charged than those with Hellena.

Willmore spells out his libertine logic. Exchanging sexual pleasure for sexual pleasure is a legitimate way to go about life. Marrying for money *and* selling sex for money are not. Willmore dismantles Angellica's business model. Asking how much of her time he could buy with his single coin – it turns out it's about ten minutes, and one suspects Willmore wouldn't need much longer to show his 'ardour' – he runs with the joke, *his* joke: he might encourage his mates to buy shares in her as well. It's a brutal anatomy of a sexual economy in which marriage is only one component. It is an economy which Angellica Bianca understands, and which has made her very wealthy indeed.

Is she the real centre of the play? A woman who can charge a thousand crowns for a month of her sexual company (computed on a four-day working week) is impressive, gaming the system for her own benefit. Sex work becomes empowerment. *The Rover*'s courtesan has more depth than others in the plays of the period, not just a tart with a heart, but a woman with an interior life denied to the other characters in the play. Angellica has an honesty about her, as attractive as Willmore's. She hangs out a large portrait of herself as the sign of her sexual availability if a man has the money to pay. She knows what she is worth, quite literally. Until Willmore. Not only does he not need to pay to have sex with her, Angellica even thinks, hopes, he will be faithful to her. It is love that undoes Angellica, not selling her body for money. Broken by rejection, she is then further crushed when she lets slip that Hellena (unbeknownst to Willmore) is an heiress, worth 300,000 crowns at her marriage. By the end of the play, Angellica is thoroughly disillusioned – with herself – and thoroughly understanding of her powerlessness, both erotically and financially. What price emotional depth and interior life now?

Angellica fascinates in part because she inspires in Willmore something that might almost be sincerity: 'By Heaven thou'rt brave, and I admire thee strangely.' Although he goes straight into a self-justification of his inconstancy (Nature has decreed that he should not be the constant creature that she wants him to be), there is even,

if we are being sentimental, a moment in which Willmore imagines what it could be like to be the kind of man who could come back to the same woman, what it would be like to 'build my Nest with thee' – although only after he had 'lov'd my round', sown his wild oats. There's a wistfulness here, reminiscent of one of the Earl of Rochester's best poems, titled (but not by Rochester) *Love and Life*, which offers a thoughtful, melancholic libertinism.

> All my past life is mine no more,
> The flying hours are gone,
> Like transitory dreams giv'n o'er,
> Whose images are kept in store
> By memory alone.

No syphilis, impotence, hangovers or random knife-fights here. Instead, the emptiness glimpsed when one realises that all one has is the present moment, and even that is uncertain. The thinking libertine has only the 'live-long minute' when he is 'true' to a woman in the sexual act.

Then again, beware Willmore in sentimental mode – and beware a moment of apparent self-knowledge and reflection in a play which is short on both. (Beware Rochester too. Having impregnated Elizabeth Barry during one particular 'live-long minute', he was conspicuous by his absence after that seminal moment, only finding out about baby Elizabeth because a friend bothered him with the news: 'your lordship has a daughter born by the body of Mrs Barry of which I give your honour great joy'. Rochester, who never mentioned Barry by name in any of his letters, was unmoved by his correspondent's report of a difficult lying-in, Barry's poverty, and her anger at the father of her child for not providing money or support despite her having given him the 'full enjoyment of all her charms'.)

Willmore is a violent sexual predator. When the virtuous Florinda appears 'in an undress' at night, hoping to meet her thoroughly decent lover Belvile, Willmore attempts to rape her.

Wheeling out his libertine logic once more, he argues that it is no sin for her to be raped, because the sexual act is 'neither design'd nor premeditated. 'Tis pure Accident on both sides – that's a certain thing now.' Problems would only arise if she vowed fidelity, or he lied to her: that would 'make it wilful Fornication'. So, as a 'good Christian', Florinda is 'oblig'd in Conscience to deny me nothing'. No more 'prating'.

Florinda does her best, begging Willmore to 'unhand me', 'let me go'. He, predictably, says he can't help himself: she has such beautiful eyes. Anyway, she's asking for it, she wants it as much as he does. If she shouts 'Rape!' (as she threatens) no one will care. After all, why is she out, why is 'her cobweb door set open' unless 'to catch flies'? Willmore's patience wears thin, he becomes 'angry', he seizes Florinda, at which point his friends (including Belvile) arrive and interrupt the rape.

Willmore's excuse? 'By this Light I took her for an Errant Harlot.' Belvile, furious, cannot believe that his beloved Florinda has been mistaken for a whore, which is not quite the same as saying rape is wrong. Faced with the criticism of his friends, Willmore adopts a familiar stance – what have I done? Why are you all looking at me like that? 'I know I've done some mischief, but I'm so dull a Puppy, that I'm the Son of a Whore, if I know how, or where – prithee inform my understanding—'

Willmore is no 'puppy' and he knows exactly what he is doing. This may be the most troubling thing about *The Rover*. Actually, what is more troubling is that this episode has been described by one critic as Willmore's 'comic effort at raping Florinda', an 'exciting "woman-in-peril" moment'. For the same critic, Janet Todd, the libertine logic (that forceful men are really fulfilling women's desires) of the play might 'sound misogynist and to a modern audience' menacing, but 'it needs to be seen in context'.

III

Well, here's the context. The Earl of Rochester, he who fathered Elizabeth Barry's daughter, is the kind of man who says out loud what everyone is thinking, to paraphrase certain right-wing populist politicians of our own era. One of his characters (in his play *Vallentinian, or Lucina's Rape*) hears cries in the distance, and he can't quite see the difference 'Betwixt half ravishing which most women Love/And thorough force which takes away all Blame'. Rochester claims not only that women actively enjoy being (half) ravished – being just a bit raped – but that if they are violated with 'thorough force' then it's a win for a woman, because then she cannot be blamed. (This was Willmore's half-hearted argument to Florinda: she is not to blame if she has no choice.) If we are being generous, Rochester is attacking the sexual hypocrisy of his time by allowing women sexual desire and suggesting the only reason women behave with, or appeal to, modesty and propriety is because they are concerned for their reputations. Remove that concern about honour by making them blameless victims of rape and they can get on with enjoying being sexually attacked. These arguments don't only 'sound' misogynistic. They are and they remain so.

Another critic, David Roberts, whose work I admire and have gratefully drawn upon for this chapter, manages to normalise the performance of violence against women. He notes that there were a lot of rape scenes in Restoration drama, but not *that* many before 1670. And, anyway, it's obviously what audiences wanted. And let's remember that actresses got the chance to reverse the male gaze when they talked back to the audience. It's amazing how a sprinkling of feminist jargon softens the casual patriarchalism, allowing us the luxury of believing that actresses were seen 'not just as sex objects but as feisty professionals'.

The data show that actresses were in fact sex objects, even if not 'just' sex objects. Around one-quarter of all plays written between 1660 and 1700 feature rape scenes, and that's not including all the

other moments when a woman was required to show flesh, whether legs or breasts. The dynamic continued offstage. Elizabeth Barry was not, of course, the only actress to have sexual relationships with men who were her social superior.

> Hard by Pall Mall lives a wench called Nell
> King Charles the Second he kept her
> She hath got a trick to handle his prick
> But never lays hand on sceptre.

This celebration of Nell Gwyn, the King's mistress, continues by noting that she wisely leaves all 'matters of state to the political bitches' because she 'knows where to scratch where it itches'. She has sexual but not political power, the power to please but not to advise. The Earl of Rochester (the author of these rhymes) knows how the system works, advising Gwyn to 'with Hand, Body, Head, Heart and all the faculties you have, contribute to his pleasure all you can, and comply with his desires throughout'.

The sexual politics of *The Rover* on that first night in March 1677 were well calculated to appeal to the current crop of royals. King Charles II, who liked to see himself (or his libertine image of himself), saw Willmore. James, his brother, equally besotted with the memory of the years of exile – those cavaliers! What fun we had! – saw a rose-tinted past.

To celebrate the cavaliers of old was to take sides in a very contemporary political struggle. Parliament was stepping up its challenges to monarchical power. It was becoming time to take sides once more, if you hadn't already. The play's sentimental view of the exiles was a clear flag that its author was a Yorkist, or at least aiming to please the man that mattered, the Duke of York. And he did: James loved *The Rover*.

Not just James. *The Rover* was a success and this in a world in which fifty plays were cycled through on average each season, including revivals (dusted down and adapted for a new crisis or

celebrity). Collaboration, adaptation and translation were the name of the game in this volatile theatre world, with plenty of room for plagiarism – new plays were needed, and fast. This fuelled a steady stream of amateur efforts. After all, it couldn't be that hard, could it? David Roberts tells the story of Silas Taylor, a civil servant in the Navy Office, and friend of Samuel Pepys, who offered his play, *The Serenade, or, Disappointment,* to the Duke of York's company. After a read-through of the first act, it was rejected.

> Taylor huffily took the play to the King's Company and told Pepys, with the bravado of the failed writer, that 'it will be acted there, though … they are not yet agreed upon it'. That night Pepys asked his wife, Elizabeth, to start reading the play to him as they sat in the garden – the last that has been heard of *The Serenade, or, Disappointment.* Even the loyal Pepys did not finish it.

If a play did reach the stage, it might run for one night, and one night only. A playwright was dependent on the company, for if actors had any inkling that the play might not do well, they didn't learn their lines properly. One play, it was asserted, 'was hugely injured in the acting' because of the 'intolerable negligence of some that acted in it'.[1] It didn't see the light of day again.

Every playwright hoped for the 'third day' when the author would receive the entirety of the night's receipts, in effect a benefit performance.

Which is exactly what the young, anonymous male author invoked in the prologue to *The Rover* achieved – and more. So who was he? The actors knew, for there was a point in the play development process when the physical presence of the author was vital. It was the author who did the first read-through, to the performers and theatre owners. Sometimes poorly, as in the case of cold, flat and 'unaffecting' John Dryden, Poet Laureate. This moment was the actors' chance to get a sense of the play as a whole, because each person was only given his or her individual part to learn, with the necessary cues, as had

been the case during Shakespeare's time. The actors, therefore, knew full well the identity of the playwright, despite the attempts at anonymity in the theatre and in print. They knew 'he' was Aphra Behn.

IV

Playwriting since 1670, Behn had previously known some less-than-triumphant outings as dramatist. There were rumours that, after her flop *The Dutch Lover*, actors didn't bother to rehearse properly, believing that her plays would fail. She had been recognised, up to a point, as a poet, but only in an appendix of women authors, and even then only as an also-ran to 'the most applauded Poetess of our nation', the fragrant Katherine Philips. (Bradstreet also got a mention in the listing.)

In the run-up to the 1677 season Behn is working flat out, attempting to maximise her income stream by sketching out several plays at once. Three of her plays are performed in quick succession, including her only attempt at tragedy, *Abdelazer*. She's honing her craft, cutting down the long speeches, perfecting witty, gritty urban characters, getting backers, amongst them a mysterious Mr E. R. Some think this is the Earl of Rochester (busy fucking – his word – Elizabeth Barry) but it is more likely to be the rather ordinary poet, and possibly safer bet, Edward Ravenscroft. Not for Behn the possibilities of William Wycherley who dedicated his *Love in a Wood* to the Duchess of Cleveland, Charles II's mistress – and later his.

More significant for Behn, Thomas Betterton, the leading actor of the Duke's Theatre, sharer in the Duke's Company, theatre manager, acting coach and sometime playwright himself, believes in her talent. He knows she will make him money. It's possible he even likes her. Even then, Betterton and Behn both know that she is operating in a fast-moving, volatile theatre world set up for plays and playwrights to disappear without trace.

Behn and her work did not. *The Rover* earned £37 16s 8d over the month of March and Aphra Behn would go on to have a long, creative association with Betterton, matched only by two other playwrights, Thomas Shadwell and Thomas Otway.

But Aphra Behn did not – at least at first – put her name to *The Rover*. Why? She had been quite happy to highlight her authorship in other contexts, even using it as a promotional hook. Back in 1670, her first play appeared anonymously, but the prologue announced it as the work of a female dramatist, offering the audience that rare beast, a sexual-political comedy by a woman.

Did Behn have a sense that in *The Rover* she had stepped over a line? She worked in a world in which playwrights regularly revised, adapted, translated other people's work, one in which Nahum Tate got hold of Shakespeare's darkest tragedy *King Lear* and gave it a happy ending and nobody batted an eyelid. It is not strange, therefore, that Behn has an obvious source for her *Rover*, a play by Thomas Killigrew called *Thomaso, or The Wanderer*, although she changes all the names in the main plot, except that of Angellica Bianca. Behn improved Killigrew's play, cutting down the length of the speeches, especially the philosophical ones, reducing the number of characters, keeping up the speed, and Killigrew himself did not intervene, which he could well have done as Master of the Revels, appointed by the king to oversee the regulation and licensing of performances, whether at court or in the city. But *The Rover* remains an adaptation, rather than an original work, and Behn was attempting to pass it off as new work by a male 'person of quality'.

She was not going to get away with it. In a postscript to the second edition of her play, which comes clean (if only by adding her name to the title page), she writes that there's 'a Report about the Town (made by some either very Malitious or very Ignorant)' that *The Rover* was 'Thomaso alter'd'. This is ingenuous at best. To say that *The Rover* was heavily plagiarised from Killigrew was only the truth – neither Malicious nor Ignorant. But Behn would not admit that and instead, doubles down. How dare she be attacked for stealing other

people's lines? Unrepentant, she asserts that 'the Plot and Bus'ness (not to boast on't) is my own'. Behn admits to hanging out 'the sign of Angellica (the only stol'n object) to give notice where a great part of the wit dwelt' – a nod to Killigrew, whom she admired enough to steal from, although she stole far more than the sign from him – then moves swiftly onto the offensive again: 'as for the words and the characters I leave the reader to judge and compare 'em to whom I leave the great entertainment of reading it'. In other words, go read Killigrew if you want to be bored. And remember, if *The Rover* had been a flop ('succeeded ill') no one would be talking. She ends by quoting Virgil: 'Therefore I will only say in English what the famous Virgil does in Latin; I make Verses, and others have the Fame.'

The fact that she came out fighting suggests that Behn's original presentation of herself as a young male playwright might have less to do with any embarrassment about her borrowings, and more to do with her consciousness of the gendered criticism that any play by any woman would and did receive, let alone a play as sexually charged as *The Rover*. She knew all the familiar attacks: Behn was not (could not be) the author of her plays; she was uneducated; she wrote too much; she wrote too loosely; she was common; she wrote loosely *because* she was common; her male poet-lovers wrote the plays in exchange for sex; she *was* the author, but that made her a prostitute; and, last but not least, she actually *was* a prostitute.

Seventeenth-century society's equation of playwriting with prostitution was simple and horribly effective. A woman who made herself 'public' (by having a play produced or published) was the same as a woman who made herself 'public' by selling her body. The anxieties that simmered around publication of, say, poetry earlier in the century become explosive when applied to drama by its end. They will run like a seam through the following chapters of this book.

Competitor after competitor lined up to make the connection. Thomas Shadwell was one such, a writer to whom Betterton was as loyal as he was to Behn. Shadwell was bitter that he had received 'the Birth and Education without the Fortune of a Gentleman' (but

blind to the fact that his chromosomes had at least permitted him to receive that education). Educated Shadwell is downright nasty about Behn and another rival playwright, Thomas Otway:

> Poetess Afra though she's damned today
> Tomorrow will put up another Play;
> And Ot[wa]y must pimp to set her off.

Behn is not only a prostitute being pimped, but damned for her productivity. Robert Gould, another attacker, is equally fascinated by sex workers (or 'reeking punks' as he puts it) but raises the stakes by calling Behn 'Sappho in her wanton fit'. Putting aside the potential reference to Behn's sexual preferences, Gould is worried about society as a whole: what will happen when everyone, from courtiers to peasants (let alone women), become writers? He fears wantonness, disruption and excess, all located somehow in the woman's body and her literary output. Another long poem, probably with multiple authors – because that was how things rolled in the collaborative, imitative, matey world of the 1670s, when literary men hunted in packs – satirises numerous writers, including the 'Poetess Afra' who:

> showed her sweet face,
> And swore by her poetry, and her black Ace.
> The laurel by a double right was her own
> For the plays she had writ and the conquests she had won.

Behn is at least here recognised as author. We should be grateful that she is offered laurels rather than parsley. The praise is, however, thoroughly backhanded because she deserves the laureate wreath for her writing and her sexual 'conquests'. She also has a black arse ('black Ace'), a reference either to her dark skin or hair – like Aemilia Lanyer and Shakespeare's so-called Dark Lady – or to her excessive sexual appetite: the King was satirised for having the 'blackest arse', alluding to his insatiable lust. Or both.

Other parts of Behn are on display in the next attack.

> Once, to your Shame, your Parts to all were shown,
> But now, (tho' a more Public Woman grown,)
> You gain more Reputation in the Town;
> Grown Public, to your Honour, not your Shame,
> As more Men now you please, gain much more Fame.

This is William Wycherley, who is admired by some for at least showing some wit in his treatment of the tired clichés which linked selling one's writing with selling one's body. To me, Wycherley's tedious puns on 'parts' and being 'clapped' don't really stand the test of time.

This was the landscape of belief within which each play was written, performed and published. Behn was an easy target, with no family protection, no Mr Behn in sight, author not of religious verse but of bawdy, libertine sex comedies.

Behn fought back – with words. What else did she have? Ridiculous men litter her drama, prose and poetry. Impotence and premature ejaculation feature often, with men humiliated by their inability or too soon 'disarm'd of all his awful fires' to their female companion's dismay. *The Disappointment* is her most famous poem on the subject, for many years seen as the work of the Earl of Rochester, because how could a woman have written a poem about erectile dysfunction? In her drama, Behn uses the prologues and epilogues to take the fight back to her male contemporaries, tackling those who dismiss her writing for its 'unregulated manner', thinking she knows no better. Typically, she turns defence into attack, dismissing the tedious pedants who think they know how to write successful plays. Behn is a creative professional, not a dry theorist. And damn it, she decides what her play is and she says it's a comedy. Indeed she has hung out a sign, in a touch of the Angellicas: the word comedy is 'inscrib'd … on the beginning of my Book'. She owns her work, in both senses of the verb.

Behn celebrates and reclaims the natural right of women to give and to take pleasure, whether the pleasure she gives through her

writing, or the pleasure women seek through sex, and she insists that 'sin' is a man-made (with emphasis on 'man') construct. Her claims are ruthlessly secular. Behn never mentions Eve and the word 'Christian' only appears in this chapter in a deeply ironic context, Willmore's attempted rape of Florinda when he asks her to be a 'good Christian'. And yet her seductresses seek love and her virgins seek husbands, suggesting that Behn never quite dismantles the Judeo-Christian binary of 'woman' as dangerous seductress (Eve) versus chaste virgin (Mary). Her female characters exist in a sexual, moral economy defined by their need for men, but it is an economy still underpinned by the religious beliefs that shaped the lives and writings of Julian, Kempe, Lanyer and Bradstreet.

Behn is in fact most ground-breaking when she tackles the double standard for authors. Men can write sexually explicit scenes, and there is silence. But there is outcry if she, a woman, writes 'Such Masculine Strokes', if she deploys her 'Masculine Part the Poet' – there is a rather filthy pun in there, of course. No, she 'must not, because of my Sex, have this Freedom'. Instead men 'usurp' the ability to write about these matters. The word usurp, with its connotations of a military power struggle, goes to the heart of Behn's view of the gender wars, but she is equally capable, having made her bid for the freedom to write like a man, of flouncing out of the room, all femininity:

> I lay down my Quill, and you shall hear no more of me, no not so much as to make Comparisons, because I will be kinder to my Brothers of the Pen, than they have been to a defenceless Woman; for I am not content to write for a Third Day only. I value Fame as much as I had been born a Hero; and if you rob me of that, I can retire.

It's all a bit over the top, which distracts from the fact that suddenly Behn is making a different argument. Behn (a 'defenceless Woman'?) is now insisting that she is *not* purely interested in money. Not for her the simple goal of writing for 'the third day'. Behn wants Fame

with a capital F. Is this an attempt to put some space between her and those who do work for money (including prostitutes) or a sign that the attacks were taking their toll?

Not on the evidence of 1677, and the second printed edition of *The Rover* in which Behn's confidence as a playwright shines through. And quite right too: she is a woman at the top of her game, writing audience-pleasing drama, sycophantic to royalty, delighting the paying public. She is working in a new kind of 'public marketplace', a new creative economy, evident in the advertisements for other 'books printed this year 1677' attached to the published *Rover*. Christine de Pisan, back in the fourteenth century, may have been the first woman to earn her living as a writer, but earning her living meant gaining commissions from her patrons, and being rewarded by gifts or a court post for her son. Even a couple of generations before Behn, Shakespeare achieved financial stability not so much through his writing, but by being a shareholder in his theatre company and by investing in property and land. In Behn's own time, John Milton earned his most secure income not through writing as much as being given the job of Latin Secretary in Cromwell's civil service. Before and after this point, he needed to teach to survive. Whilst her contemporary playwrights died variously in abject poverty, drunk in a gutter or pursued by creditors, or led comfortable lives propped up by family money (Sir John Vanbrugh, for one, relied on income from his family's slave plantations), Behn kept her steady professional course.

V

She hardly paused for breath in 1677. Thomas Betterton was, understandably, eager for Behn to repeat the winning formula of *The Rover*, and so she duly followed up – quickly – with *Sir Patient Fancy*. This time she used (or should I say plagiarised?) Molière. There's more joyless sex, fewer romantic couplings, lashings of amorality, and

plenty of satire of 'cits' or citizens. The play ends with the actress Nell Gwyn directly addressing the audience:

> I here, and there, o'reheard a Coxcomb Cry
> [*Looking about*]
> Ah, Rot it – 'tis a Woman's Comedy …

It is a very funny moment, Gwyn picking on a heckler, lecturing him on history – women once 'cou'd write/Equal to men; cou'd Govern, nay cou'd Fight' – and claiming that, if given a chance, they could do so now. Gwyn's vindication of women's abilities leads quickly to an attack on foppish, unmanly men and a celebration of women's skills and sensibility, especially in Love. For love read sex. Women are:

> Quickest in finding all the subtlest ways
> To make your Joys: why not to make you Plays?

With one quick jab at the boring 'learned' plays of men, Gwyn finishes firing Behn's bullets: 'Why Women should not write as well as Men?' Behn, in her own voice, follows up in the prologue to the published edition. Yes, she is commercial ('forced to write for Bread') but she is not 'ashamed to own it'. The public want pleasing. She pleases them. It's very simple. (The only problem being, of course, that equation of sexual and literary pleasuring.) With a quick and implausible claim that she is no plagiariser, she moves on to express her frustration with being condemned for a bawdiness that would be entirely acceptable in a male writer whilst she is seen as 'unnatural'. She is furious at the hypocrisy of playgoers who condemn precisely what they queue up to see at the theatre and, in a nasty turn, she claims they only complain about bawdiness because they are not getting any in their real lives. She ends by asserting her plays are only attacked because she is the author: 'had it been owned by a Man, though the most Dull Unthinking Rascally Scribbler in Town, it had been a most admirable Play.'

Aphra Behn dedicated her next play, *The Feign'd Curtizans*, to Nell Gwyn, an indication of the actress's political rather than theatrical status. It was the first time Behn had dedicated her work to a well-known public figure. It is possible, indeed probable, that Behn may at this time have been angling for some kind of royal or courtly patronage, which almost but not quite justifies her various grovelling poems to assorted Stuart royals and hangers-on. The day job which would fund her writing was not forthcoming, and Behn did not have a husband who could reap the rewards of her playwriting with a cushy job somewhere in Whitehall. (Mr Behn has so little historical substance that some suggest he was a convenient fiction.) So she kept writing for money.

One of the very few documents in the Behn biographical archive shows Aphra Behn, the writer, at work. It is not a draft of a play, or notes for a novel, but a letter of 1683 concerning money. Behn is canny and financially aware. She is writing to her printer/publisher, Tonson, and begins by pouring oil on troubled waters, whilst stirring them up at the same time. She holds Mr Dryden in esteem but if dear Mr Tonson had heard what she had heard, well, he would understand her reaction. (John Dryden was as high as you could get in the literary food chain, appointed the first Poet Laureate in 1668.) As for Mr Creech, there's no need for him to know of her 'resentment'. Again, whether these men are friends or enemies, she is running with the boys.

The paragraph ends with a practical request: a correction that needs adding to one of her works, which can be added to the margin of every book Tonson sells. Then, almost casually, Behn moves into negotiating a better price for her 'verses' – 'I shou'd really have thought 'em worth thirty pound: and I hope you will find it worth 25'. It's an excellent example of a writer trying to push a publisher to value her work, and Behn piles on the pressure. She promises a new work, she knows her worth, why should she 'loose [sic] my time in such low gettings but only since I am about it I am resolv'd to go throw w$^{th.}$ it', she's already lost £50 by taking on the job, and, anyway, what's five pounds between friends?

It's her final throw of the dice, when she says 'I am just on the point of breaking', that gets the biographical airtime. It signals to many that Behn is a woman on the edge of a financial precipice, unable to get the 'credit' at the playhouse she 'used to have', but her postscript is all business, asking for the papers so she can get to work: 'send me an answer to-day'. I see this letter as one of strength, not weakness.

Aphra Behn, the professional writer, managing her career and her finances, speaks loud and clear across the centuries. Almost all other aspects of her life, including all familial, personal relationships, remain well hidden. She was *probably* born in around 1640, so a child during the civil wars. *Possibly* christened Aphra (the name was more common then) Johnson, possibly the daughter of the wetnurse of the Culpepper family in Kent and a barber, almost definitely not 'well-born' since others took the trouble to attack her lowly background.[2] At some point Aphra (maybe) Johnson became Mrs Aphra Behn, which suggests a marriage – but no marriage and no Mr Behn have been found, although a fast-disappearing Johan Behn has been posited. It is all very uncertain.

Strangely accepted as truth, although based on the flimsiest of evidence, is Behn's journey in the early 1660s with her mother and siblings to Surinam on the north coast of South America, and for a brief time an English colony. The acting governor did write home about a woman he calls 'Astraea', disapproving of her intimacy with the dangerous William Scot, the son of the executed regicide and former Cromwellian intelligence chief, Thomas Scot. But there is nothing in the records to suggest Behn or the Johnson family had any presence in Surinam in these years. The case for her having lived in Surinam is, in the end, based on her prose work, *Oroonoko*, with its first-person female English narrator telling the story of the life and violent death of a slave prince. The narrator tells of her father's death on his way to the West Indies, where he was due to take up an official appointment as 'Lieutenant-General of six and thirty islands, besides the Continent of Surinam'. Lieutenant-General? Aphra's Dad has come a long way from being a barber of Canterbury. Not only

that, there is no mention of such a person, or even such a job, in the colonial archives.

If not Surinam, then Antwerp. At last, something we can be sure about. In 1666 (year of plague and fire in London), and into the following year, Aphra Behn was working in the city as a spy, her task to extract information from William Scot – late of Surinam. In her letters back to her spymasters, she signs herself Astraea. There is something ironic in the fact that one of the few things we know for sure about Behn is that she was a spy.

From Antwerp, Behn wrote letters mentioning a mother and a brother still living, and that she has run up debts of £150 which no one is willing to pay. It makes sense that it was those debts (somewhere between £15,000 and £20,000 in today's money depending on whom you ask) that led to Behn writing plays at the age of about thirty. Over the following three decades, she continues to write poetry and drama, and adds prose and translation to her literary repertoire. Her writing shows that she gets better at French. She tackles heavier intellectual subjects (philosophy, religion, science) whilst not losing sight of her trademark salaciousness: Behn's 1684 translation (from Tallemant's French original) of 'Voyage to the Isle of Love' is a study of desire, courtship and consummation, which in Behn's hands becomes considerably more sensual than the original.

But so many questions remain about her life. Did she marry? Did she love women as well as men? Did she have children? Did she ever travel to South America? Was she a Roman Catholic? Sue Wiseman, author of a useful introduction to Behn's work, hopes that some of these questions will be answered in time, but I expect some of them will not. If Behn was indeed a bisexual or lesbian Catholic there might be good reason to stay in the closet in a hetero-Protestant world, even if you were hanging out with libertines. Moreover, the archives of the period work against our desire to know the private woman. In the later seventeenth century, after years of civil war and regime change, many people were very careful to make sure there *were* no personal records to find. Although we have five volumes

and counting of John Milton's *Life Records*, these volumes do not contain a single letter from the great poet to any of his three wives, his three surviving daughters, or even his brother. But the volumes exist, whereas Behn being born female means even those public and semi-public, institutional documents from which we piece Milton's life together are not available for her.

Enter stage left John Hoyle. At last, a love interest for Aphra Behn, and what a love interest: a politically radical lawyer with a tendency to violence and probably bisexual to boot. At last a way to understand *The Rover* through the lens of Behn's romantic life. In her late thirties, according to biographer Todd, she for the first time 'felt real physical desire'. Rejected by him, Hoyle becomes Behn's model for Willmore whose 'physical attractiveness, total promiscuity, certain ruthlessness' are all new to her version of *Thomaso*. Writing *The Rover* allows her to work out the heartbreak caused by the irresistible Hoyle. Or contrastingly, Hoyle is *not* Willmore because Behn is not yet ready to laugh at the man. Instead, she writes him out of her system in her one tragedy, *Abdelazer*.

This is all based on a few gossipy references such as this one, made ten years after *The Rover*: it was 'publickly known that Mr Hoyle 10. or 12. yeares since kept Mrs. *Beane*'.[3] Maybe Hoyle did 'keep' Behn as his mistress over these years, although it slightly dents the idea that she is trying to write him out of her system in *The Rover*. It is another thing to argue therefore, as Todd does, that whilst Behn 'would desire other men sexually' 'no one rivalled Jack Hoyle in her imaginative and emotional life'. Gossip aside, we know nothing about Behn and Hoyle, unless – and it is a big 'unless' – we take the evidence of 'Love-Letters by Mrs. A. Behn', eight letters published seven years after Behn's death, as an added extra to an edition of Behn's prose works: 'Never before Printed'!

The letter writer, who signs herself Astraea (Behn's codename as a spy), is a female playwright: 'I stay'd after thee tonight, till I had read a whole act of my new play'. The addressee is named Lycidas, one of the names Behn allegedly used for Hoyle. And the letters 'repeat,

or reflect, happenings' in Behn's poetry, all of which gives them 'the ring of authenticity', argues Todd.

The letters make salacious, disturbing reading, as the profoundly masochistic female writer wallows in her desire for the – ultimately disappointing – appearance of her – ultimately disappointing – lover. Intimate and passionate, they seem to offer a direct line to the woman, the direct line we apparently want so badly.

But there are an awful lot of reasons to view these revelatory, 'Never before Printed', letters with suspicion. First up, if Behn spent, as it seems she did, her final years churning out the work in order to make a living, then surely, if she wrote them, she would have monetised these letters before her death. Secondly, Behn was not known as a letter writer in her lifetime, although she used letters to construct her ground-breaking prose fiction, the novel *Love-Letters Between a Nobleman and His Sister*. This is another way of saying that Behn may have written them but they remain fiction. In any case, there were enough literary models available to an author for Behn not to need to plunder her own emotional experiences. Thirdly, and I think most plausibly, the posthumous publication was opportunistic, someone cashing in on the fashion for printed love letters such as 'The Portuguese Letters' in which, shockingly, a nun writes to a cavalier. The dead Mistress Behn was in no position to bite back.

As Claudine van Hensbergen, who has made a study of the publication, concludes, there is an:

> almost irresistible allure in letters that appear to offer Behn up as the suffering and poorly treated mistress easily recognizable to readers of her poetry, drama, and prose. As a literary text, 'Love-Letters' feeds the temptation to be always in search of Behn the woman rather than Behn the professional and dexterous writer.

Perhaps Behn wrote them (but if so, she was having an off-day as an author); perhaps she did desire Hoyle; perhaps he rejected her as a lover; perhaps she wrote out that rejection in the character of

Angellica Bianca (those initials may be a clue), although then we have to ditch the idea that she was his mistress for ten years after *The Rover*; or perhaps the publication of the 'Letters' was opportunistic fiction exploiting a dead woman's name. What remains certain is that we still want her to have one great love, and for that to have informed her drama.

In the end there is no hard evidence for a relationship. Indeed, the Aphra Behn archival cupboard is startlingly bare.

VI

So we go to the works to find the woman and there we find an Aphra Behn who remains loyal, absurdly so, to the Stuart monarchy and in particular to James, Duke of York. Admittedly, the royals were the patrons of English theatre. For a short while, and once it became crystal clear that Charles II (despite his many and various mistresses and large number of illegitimate offspring) would not bear a legitimate heir and that his Roman Catholic brother, James, would have to succeed him, the Duke of York might have seemed the right political horse to back. Only for a short while, however, and Behn remained committed to James long after it was wise to be so. She dedicated her sequel to *The Rover* (imaginatively titled *The Second Part of the Rover*) to him, claiming that the prince had requested her to write the play while he was in 'voluntary exile' during the Exclusion Crisis. James for a moment becomes Willmore, 'a wanderer too', 'distrest; belov'd, tho unfortunate, and ever constant to Loyalty'. Sycophantic and thoroughly misplaced as this soft-focus fantasy of James as cavalier hero re-enacting the exile of the Royalists in the 1650s was, Behn's loyalty to the Duke of York seemed unshakeable. Todd is forced to explain it by suggesting the 'glamour of privilege', or that the 'simple and transparent manly heroism' of James served to get John Hoyle out of her head.

Behn's allegiance to the Stuarts did not help her much, but it did help to shape the enduring political stereotypes of the future Whig (puritanical, hypocritical, repressed) and Tory (generous, carefree, convivial) parties. As early as *The Rover* in 1677, the political messaging is quite brilliant, with Behn reinventing the rake as 'both libertine and Royalist, at once anti-authoritarian and passionately committed to king, country, and class' (to quote critic Robert Markley) – a move not unfamiliar to the current Prime Minister of the United Kingdom.

Behn's Royalist sympathies are the most stable element in her writings and some think they explain one of the conundrums of her sexual politics. Generally speaking, she is pragmatic, opportunist, professional, giving her audience what they want, and most definitely erring towards the libertine, cynical view of life and love. And yet Behn presents marriage as the goal (and reward) for women, despite all her trenchant critiques of social and sexual convention. This makes sense only if we take on board Behn's belief that government needs to be strong government, not through natural right or even morality, but because it is the best guarantee of stability. Marriage becomes, in this framework, a necessary limit on the potential chaos of the libertine life. There's a whiff of the profoundly mechanistic philosophy of Thomas Hobbes about all this. In order to achieve a stable, peaceful society (and therefore to exercise one's rights to life, liberty and property), men give up their individual power to a sovereign who is able to do everything necessary or everything he considers necessary. Marriage within this framework is a social construction, with entirely subjective terms such as 'love' and 'hate' mere irrelevant window-dressing of the necessary contract. Others go further, Todd arguing that although marriage is presented as a necessary evil based on hypocrisy, it is still better than the libertine alternative, of 'misogyny and lonely pregnancy', where women are 'degraded into a "cunt", as numerous lampoons informed her'. So Hellena marries Willmore.

But, as was glimpsed in the cynicism of *Sir Patient Fancy*, or her cosying up to the King's mistress, Nell Gwyn, Aphra Behn may not have been quite such an advocate of marriage as all that. *The Second*

Part of the Rover shows her to be utterly ruthless. Hellena, attractive, spirited, virgin-wife Hellena, is killed off even before the play has begun, after one short month of marriage to Willmore. If ever proof were needed that it was men that interested Behn more than women (or that she knew that male characters would make her most money), this is it. Elizabeth Barry, she who had played Hellena back in 1677, now played the courtesan in *The Second Part of the Rover*. Did Behn and Barry share a smile, or grimace? What in the end was the difference between the two women in a man's world? *Rover II* is a savage corrective to anyone who might have thought that the marriages at the end of *Rover I* were anything other than lip service to conventional morality.

Far more disturbing is the way in which Behn writes about sexual violence against women. She clearly knew that people (men?) from the King to the commoner enjoyed the frisson of watching potential and actual violence against women. The possibility is ever-present in her plays, with the virginal female body pursued, threatened, desired. She creates, effortlessly, charmless, violent misogynists such as Blunt in *The Rover*, a man who, humiliated by an individual woman, turns his rage against all women:

> a fine Lady-like Whore to Cheat me thus, without affording me a kindness for my Money, a Pox light on her, I shall never be reconcil'd to the Sex more, she has made me as faithless as a Phisitian, as uncharitable as a Church-man, and as ill-natur'd as a Poet, Oh how I'l use all Womenkind hereafter! What wou'd I give to have one of 'em within my reach now! Any Mortal thing in Petticoats, kind Fortune, send me!

Nine of her plays include scenes of rape or attempted rape – this is how women are 'used'. But, as Ann Marie Stewart points out, her heroines 'forgive or dismiss their attackers, marry the men they love, and seem to continue forward relatively unscathed'. Worse still (although for some this step actually redeems Behn), she creates

scenes in which women escape sexual violence by the use of their wits, suggesting that clever women don't get raped.

How can Behn, as a woman, end up in such a place – when her dialogue seems to challenge double standard after double standard? Is she trying to work out a female libertinism? Her pastoral poems demonstrate that it is natural for both men and women to have sexual desires. Her women talk back – speaking shepherdesses? Where will it end? – and women's problems are foregrounded, from becoming pregnant to the indifference of men. In the theatre, it is exciting to see Behn swap gender roles, hear her female characters express desire, show up the double standard whereby society punishes women for actions and feelings that are celebrated in men. But simply to flip the coin, and demonstrate that women can be quite as lustful, powerful and devious as men, does not challenge the existing hierarchies of gendered power. Behn's sole solution is for women to behave like men.

Truth be told, in the cut-throat world of theatre, when you are trying to earn some money, there's not much space for alternative understandings of 'woman'. Especially if you *are* a woman. Behn runs with the male libertines, she shows powerful women working the sexual economy for their own ends, she makes over and again a case that women are equal to men in their capacities whether it be in sex or literature, but in the end, her world reminded her day in, day out, of her essential inequality.

Despite this, she was phenomenally successful. Her strategies worked. The statistics tell their own story. Out of some six hundred plays performed during this period, many were by authors with 'only a single, invariably doomed attempt to their names': 'doctors or critics, actors or impresarios, hacks or aristocrats. Even clergymen tried – and failed', according to David Roberts. Men like poor Silas Taylor. If there were around two hundred playwrights active at this time (although, as noted above, some had a solitary doomed attempt), around thirty are still discussed by academics. Behn's achievement – that we know her name, know at least some of her prose and drama

and poems, that *The Rover* still sells out theatres – starts to become striking. And that's even before recognising, with some awe rather than condescension, that she, unlike those one-play doctors and clergymen, unlike those sons of well-heeled gentry, made her living from the theatre. No mean feat, then or now. And achieved at a time when, from those who controlled the theatre companies (Davenant and Killigrew, Betterton and Harris) to the rulers of England; from those who wrote the plays (Wycherley, Otway and Dryden) to those who wrote about the plays (Pepys and Rochester, to name but two); even to those who wrote the music for the plays, for this was the age of Purcell, the key figures were men. Behn shows us one way of surviving, sometimes even thriving, in a man's world.

VII

Eight years on from *The Second Part of the Rover* (which led to neither royal patronage nor even royal cash), Catholic King James, for all his manly heroism, was out, and Protestant King William and Queen Mary were in. And Aphra Behn was dead, not yet fifty.

She was laid to rest in the same place, Westminster Abbey, where her new monarchs had been crowned just five days earlier. If she had died even five days later, would the new establishment have been as welcoming to the remains of someone so committed to the cause of the ousted Stuart King?

The regime change would hit Behn's reputation hard, but not immediately. Queen Mary could still enjoy a performance of *The Rover* and forgive the play its sins – wicked characters remain not only unpunished but actually rewarded – because the actor playing Willmore was so good in the role, washing off the 'guilt from vice'. The new queen just about stomached *The Rover*, but two other Behn plays received shoddy posthumous performances and hostile reviews, and almost all of her plays would fall out of the repertoire.

Something, however, had shifted. It can be glimpsed in the life and work of Elizabeth Barry. Her 'affair' with Rochester and her baby by him tend to dominate the accounts of her life that relate her to Behn. But move on just three years from the birth of baby Elizabeth, and alcoholic Rochester is dead of venereal disease at the age of thirty-three. Move on some twenty years, and Barry is breaking new ground, working with fellow actress Anne Bracegirdle and Thomas Betterton to form and manage a theatre company, the first time that actresses as well as actors would share the profits. The company premiered up to twenty plays by female playwrights, women like Mary Pix, Catharine Trotter, Susanna Centlivre and Delarivier Manley. What is all the more remarkable about Behn's role in establishing a female tradition in the English theatre is that she had no role models to look to herself, no Bridget of Sweden, no Mary Sidney. The handful of women who had written drama, in the fifty or so years before Behn's birth, wrote their plays to be read. These closet dramas kept public theatre at arm's length for all the usual reasons of immorality, display, professionalism. Women had, of course, been involved in drama over the centuries, from performing in Mystery cycles to providing sex to playgoers, but Behn's career changed everything. She opened a door, Barry kept it open (helped by Thomas Betterton), and women playwrights walked through it.

Admittedly, it did not remain open for long – although long enough for Jane Austen's family to perform a play by Susanna Centlivre at their rectory in Hampshire. When the theatre licence was handed over to the playwrights Sir John Vanbrugh and William Congreve in 1705, it slowly closed. Others made sure it would be locked. Six years on, and Behn's *Rover* is being condemned in the *Spectator* by Richard Steele. He didn't like the fact that Willmore had so many women, that men appeared semi-naked and humiliated on stage, that Behn is explicit about the nature of sexual transactions between men and women. That last point is the important one. Behn, as a woman, should not be writing about sex and that she does so suggests she herself is a loose woman.

It is a slightly different twist on the attacks she fielded while she was alive, when the selling of her words and her body were conflated, whilst her actual writing was quite admired. Now, the very *content* of her work shows her to be no better than she should be. The eighteenth century constructed Behn from her works, and didn't like what it saw. Behn's plays fell out of the repertoire – except *The Rover*, which continued to be performed, fifty-one times before 1800. It really is unstoppable, a theatre company's dream. At the same time, its author became more and more demonised. The nineteenth century was even harder on Behn than the eighteenth. Where are the accounts of children, marriage and family in her work? Where are the helpless feminine victims? Her prostitutes don't even die. How does her work help with the 'great task of enlightening and elevating the whole family of man' (as one Frederic Rowton insisted women's writing – women indeed – should do)? She failed in the first duty of the writing woman, which is to raise the man to her level of moral purity. The trouble was, of course, that Behn had no truck with moral purity either in men or women. Her argument that women, given the chance, could do anything men could do plainly allows her women to sink to the level of men's coarseness. As William Henry Hudson put it in 1897: 'Mrs Behn wrote foully; and this for most of us, and very properly, is an end of the whole discussion.'

Even *The Rover* disappeared from theatres. The one work which kept Behn's literary reputation alive into the twentieth century was *Oroonoko* but it needed to be rebranded, reimagined, as an abolitionist work with its apparently sympathetic portrayal of an enslaved black man. In our own time, critics have pointed out that Behn does not actually question slavery itself and offers a hero who is a 'whitewashed' presentation of a black African. If we are being harsh, she is serving up a dubious racialised fantasy to an English readership hungry for the exotic, like Bradstreet, establishing her authority as woman by ignoring or exploiting those who are different from their European selves. But in the nineteenth and twentieth centuries, *Oroonoko* made the cut, helped by being a work of fiction, with a

love story and sentiment amidst the violence. This was the arena in which women (or should we say ladies) might be allowed to write. Otherwise, if Behn's work was published, it came with a literary health warning: beware obscenity, titillating salaciousness.

Afterword

Enter Virginia Woolf or, to be precise, Woolf and her one-time lover, Vita Sackville-West. The two Bloomsbury women put Behn back on the literary radar, but they did it by damning her with faint praise. To celebrate any author for making money can be a way to denigrate his or her creative achievement. Commercialism has always troubled a certain kind of commentator (usually the ones who don't need to make money from their writing) and there were and are those who think that great art does not belong in a public marketplace. It's a belief that affects men, most notably working-class men, as strongly as it impacts women. Great artists should exist above the commercial fray, motivated purely by the pursuit of truth and beauty. Vita Sackville-West, in her deeply condescending biography, brings gender into the equation. Behn is:

> something more than a mere harlot. The fact that she wrote is much more important than the quality of what she wrote. The importance of Aphra Behn is that she was the first woman in English to earn her living by her pen.

Follow that. Woolf does. She celebrates, kind of, Behn's professionalism, but there's a fair dose of snobbery amidst the praise. She was 'a middle-class woman with all the plebeian virtues of humour, vitality and courage' who was 'forced' by the death of her husband and unfortunate circumstances to write. Behn earned women 'the right to speak their minds', but, echoing Sackville-West,

her contribution to the cause is her ability to earn money, not the words she actually wrote. We should lay flowers on her tomb but – a serious author? No.

Later critics were far more nuanced and generous in their judgements and Behn is now, almost, part of our literary history. But we still need to see her as an inceptionary figure and we still want to, need to, know her story *as woman*. Because of those archival silences, we get pushed into creating stories about her (more or less plausible, as with John Hoyle), the kinds of stories we want to read about women in the past.

In the opening chapter of this book, I sounded some warnings about the fraught business of reading from the text to the life and argued that if we do so, then we should at least show our workings. So, I ask you, reading this, what do *you* make of the fact that Behn's last few poems are addressed to a trans and/or lesbian lover ('To the Fair Clarinda, who Made Love to me, Imagin'd More than Woman'); express a taste for orange flower water; and describe Tunbridge Wells? I would quite like to imagine Aphra Behn in Kent having amazing sex with a trans woman whilst sipping orange flower water, but that probably says more about me than it does about what actually happened in the 1680s.

In the end, whether we can't know Behn in this way because she herself made sure we couldn't or because that is the way in which the archives work, I am absolutely sure of one thing. The particular hook on which Behn is hung, following Woolf and Sackville-West, The First Woman to Earn Her Living as a Professional Playwright, aka the harlot plebeian, is not only inadequate but serves to diminish her as a writer. As with all the authors in this book, her achievement is far greater than merely being first past the post in the women's race. It is also far more problematic and complex.

Just as, for many years, we have wanted Behn to be calling out the racist values of her time, we also want her, as female, to be more sympathetic to women than her male contemporaries. Writing earlier about sexual violence, I was implicitly demanding that Behn, simply

by virtue of living as a woman, offer a challenge to the fetishisation of rape in the drama of the time. She doesn't.

So what? Again, as I said in my opening chapter, why should female authors in the past have to do all the heavy lifting? Why do they need to be good? We don't ask this of our male authors. Behn's gift to us is her complicated wit, her challenging energy. How we respond is up to us. The glorious thing about having her play, *The Rover*, is that in performance, directors, actors and audience make it anew, every time.

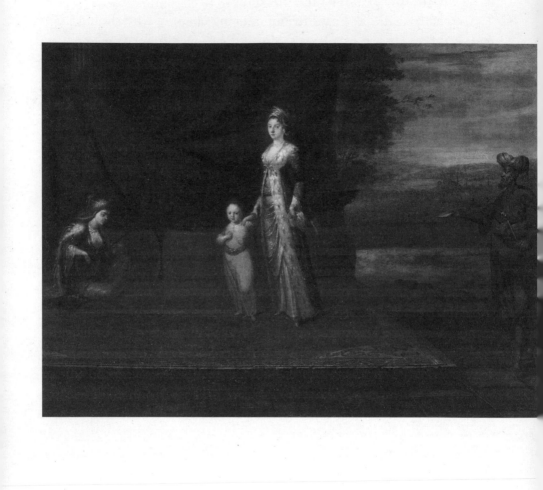

CHAPTER FIVE

Mary Wortley Montagu

'I am now got into a new world…'

S OME SIX WEEKS after Aphra Behn was laid to rest in Westminster Abbey, a baby girl was baptised up the road in Saint Paul's Church, Covent Garden. Twenty-seven years later, in 1716, little Mary Pierrepont (now transformed into Lady Mary Wortley Montagu) would set off on a journey that provided her with the material for one of the most compelling, witty and insightful travel books in English – and now one of its most controversial.

Detested and adored in her lifetime, even those who admired Lady Mary Wortley Montagu weren't quite sure about her: she 'shines like a comet, she is all irregular, and always wandering … born with fine parts enough for twenty men'. The wandering, dazzling Lady Mary would travel overland, in the winter of 1716, through a central and south-eastern Europe ravaged by battles between the forces of (Christian) west and (Muslim) east. Her destination was Constantinople, centre of the Ottoman Empire. Her journey allowed her to find a way of living that made her question everything she knew, and to write the letters and journals which would form the basis of her greatest work and her literary legacy: *The Turkish Embassy Letters*.

At last, in my own journey through an alternative history of literature in English, I can offer something approaching conventional

literary biography. In part this is because of Lady Mary's elite position in society (upper-class people are much more visible in the archive), but it is also because Montagu wrote so many letters, knew so many people who knew people, did so much, so publicly. For all her celebrity in her own lifetime, however, Montagu remains a strange kind of author. She resisted to the last putting her name to any work in print, rejecting the route taken by Lanyer, Bradstreet (however reluctantly) and Behn. Her story therefore speaks to one of the strands of this book: the challenges for any woman, even one as well-connected, well-placed as Montagu, when she engages with public, print culture.

I

Born into the upper echelons of English society in the late seventeenth century – her mother the daughter of an Earl, her father Evelyn Pierrepont becoming first Duke of Kingston-upon-Hull – Lady Mary was handsome, clever and rich. She was also highly capable. She had needed to be. Her mother died when she was three (shortly after the birth of her fourth child), and following a number of years being cared for by her grandmother, little Mary moved between her father's houses where she devoured the contents of his libraries, teaching herself Latin when, as she wrote later, 'everyone thought I was reading nothing but romances'. (She read the romances too, and in French.)

Mary Pierrepont was expected to engage in the intellectual and social world in which her father, an active member of the Kit-Cat Club (a meeting point for literary giants of the time such as William Congreve, Joseph Addison and Thomas Steele), operated. The young girl could and did hold her own. At fourteen, she collected together her juvenile writings: French plays, poetry, verse, prose, an allegory, imitations of Latin poets, and, delightfully for my project since it suggests some baton-passing between the generations of female authors,

a prose-and-verse romance modelled on Aphra Behn's 'Voyage to the Isle of Love'. Young Mary added a note to her collected works:

> I Question not but here is very manny [sic] faults but if any rea-
> sonable Person considers 3 things they wou'd forgive them
> 1 I am a woman
> 2 without any advantage of Education
> 3 all these was writ at the age of 14

Mary self-consciously draws attention to her gender, age and lack of education but there is something slightly (and typically) disingenuous about her half-apology for the 'manny faults'. Her sex ensured she had no formal schooling but, if she were to be honest, her father positively encouraged his daughter's intellectual development whilst the world she lived in gave her easy access to both new literary works and a powerful literary network.

However well-connected, privileged and brilliant Mary might have been, she was also lined up to marry a man of her father's choosing. She had other ideas. One version of events has her conducting a secret correspondence with Edward Wortley Montagu, the brother of one of her close female friends, during her late teens and early twenties, and eventually eloping with him in 1712, which all sounds rather rebellious and romantic until one reads the letters from Mary to Edward (intellectually high-minded but submissive) and his to her (fractious and not exactly adoring) and add to the mix that Lady Mary was in love with someone else. But elope they did, of one mind in their hostility to the financial conventions around marriage – law-yers, portions and custom as Lady Mary puts it in a romance, while Edward sounded off in the *Tatler* – and of one body, as evident by the arrival of a baby boy in 1713. Little Edward, whose worst years were ahead of him (he would later be notorious throughout Europe for his lifestyle choices), flourished, as did his mother.

The death of Queen Anne in 1714 helped the family fortunes, with husband Edward appointed a Lord of the Treasury under

Anne's German successor, George I. The Wortley Montagus moved to London, and Lady Mary thrived at the heart of a sophisticated literary political world. Her writing – for she never stopped writing – found new readers. She was, amongst other endeavours, the sole woman to contribute to the *Spectator* magazine, one of whose founding editors was her father's friend, Joseph Addison. In a characteristic move, Montagu has the confidence to launch a jaw-dropping assault on Addison's satire of a grotesque club of greedy widows led by a Madam President out for a seventh husband. Lady Mary responds by giving the perspective of a young, innocent bride, 'sold' at fourteen to a husband who 'knew to a penny what I was worth':

> this fellow looked upon me as a mere child, he might breed up after his own fancy; if he kissed my chambermaid before my face, I was supposed so ignorant, how could I think there was hurt in it? When he came home roaring drunk at five in the morning, 'twas the custom of all men that live in the world.

Always clear-sighted about marriage, Lady Mary writes with astonishing assurance about sexism, about women, about money. The piece did her no harm at all with Addison. Indeed, Edward, her husband, offered Mary's editorial services to him, and he accepted from her a lengthy critical essay, in which she – as she would – praised his characterisation, savaged his plotting, and suggested a few changes. Addison duly made them, but also asked that Lady Mary's essay should not be made public. Montagu herself chose to retain her anonymity for the piece in the *Spectator*. Some years later, she refused to put her name to an even more impressive piece of journalism, writing for and editing nine issues of an early periodical, *The Nonsense of Common Sense*.

I need to pause for a moment, yet again, to consider the ways in which we still present women's work. Given the fascinating life she led, it is perhaps unsurprising that Montagu the woman compels our attention, as much if not more so than her words. But that fascinating

life is often reduced to her love-life, her family, her domestic arrange-
ments. Consider one esteemed reference work's take on *The Nonsense
of Common Sense*. Over nine issues of the periodical, Montagu writes
about poverty in the wool trade, slams the 'oppressions of the whole
sale monopolisers over the miserable workers', the master trades-
men who 'without mercy grind the faces of the Poor, who are vainly
Industrious, and whose Families suffer more real misery in a free
country than the slaves in Jamaica or Algiers'. She writes about taxa-
tion, industrial wages, interest rates, censorship and press freedom.
She writes anonymously, in the voice of a man, but this is pure and
glorious Montagu. But the *Oxford Dictionary of National Biography*
assures us that 'at this time her life was bitter to Lady Mary'. Life here
is not her writing – it is what's happening to her daughter, her son,
her sister, her female friends, her interest in a young man, Count
Francesco Algarotti, her friendship with Lord Hervey (also inter-
ested in Algarotti). The survey concludes: 'Lady Mary managed her
departure with elaborate deceit: nobody but Hervey knew of either
her motivation or her intentions.' It is, undoubtedly, a good story –
Montagu plotting to leave England, harbouring a fantasy of joining
her Italian lover. But it ignores the sheer authorial achievement of
The Nonsense of Common Sense.

Keeping Lady Mary Wortley Montagu's writing front and centre
is made more difficult by her reluctance to put her name in print.
This stemmed from both her gender and her social class. Within
her coterie, everyone who mattered knew about her writing but her
words stayed within a particular circle. Moving into print would burst
the bubble. Montagu, to a large extent, conformed to the patrician
beliefs of her (very upper) class. She wrote in one letter that 'it was
not the business of a man of quality to turn author': he 'should con-
fine himself to the applause of his friends and by no means venture
on the press'. (Her comment is directed, however, at a specific 'man
of quality' whose writing she considered terrible, so her concern is
literary as much as social.) What was at stake was the God-given
hierarchy itself, the spectre of authors making an impact through,

or taking pride in, their creations rather than their birth. And it was even more dubious if a woman of quality ventured into print, not only because of that by now all too familiar equation of literary with sexual looseness, but because writing for money was, well, plain vulgar. And Lady Mary would never be that.

Montagu felt fear as well as scorn for print. At one point, while she was incapacitated by illness, someone took the opportunity to pass several of her poems to a printer and, in 1716, the year in which she left for Constantinople, the printer Edmund Curll put out three of her 'Town Eclogues' in what was most definitely an unauthorised print edition. One Eclogue was read as an attack on Princess Caroline, wife of the Prince of Wales. It undoubtedly was, but set in the mouth of an ambitious but disappointed Tory Duchess who from being ostentatiously pious has become equally ostentatiously louche ('I've sacrific'd both Modesty, and Ease;/Left Opera's, and went to filthy Plays') solely in order to get in with the Princess and all to no avail. In other words, Montagu is satirising the speaker rather than Princess Caroline but, as with social media today, there was not much room for nuanced irony. No matter also that allies of Lady Mary rounded on Curll – including Alexander Pope, who allegedly gave the printer an emetic in revenge. Suddenly, Lady Mary was not welcome at the Prince of Wales's court. This time the crisis was short-lived, but it all served to reveal the perils of print.

Lady Mary's decision not to print her work, even pseudonymously or anonymously, may however be neither a sign of her frustration nor her repression – or even her fear. It may straightforwardly indicate her privilege, sitting at the heart of an English and European elite. She could share her work, indeed collaborate, with leading authors such as Pope and John Gay. She could enjoy the conversation of visiting intellectuals such as Abbé Antonio Conti. She would move to Twickenham on the Thames outside London to be part of the literary coterie there, taking what was in her view a small house, with just the ten or so bedrooms. No, Lady Mary Wortley Montagu could be an author without taking that step into the commercial mire.

II

During the mid-1710s everything was going rather well for Lady Mary. There was the small matter of her brother-in-law leading a Jacobite rebellion, but the moment – and the rebellion – passed. Even a case of smallpox in the winter of 1715 could not stop her. Most expected her to die. She most certainly did not. By August 1716, Lady Mary is recovered, has a three-year-old son and a politically successful husband, is mixing with the literary great and good (Alexander Pope is particularly keen), and continues to write. A new adventure beckons – four years in Constantinople! Turkey had renewed its threat to Hungary, Austria was preparing for another assault from the east, and Edward was appointed ambassador to the Ottoman Porte and decided to take his family with him.

Off they went. Through the German lands where Whiggish Lady Mary – politically her father's daughter, her husband's wife – is openly critical of absolute rulers. On to Vienna, by water from Ratisbon down the Danube, a journey Lady Mary thoroughly enjoyed. They travelled:

> in one of those little vessels that they very properly call wooden Houses, having in them all the conveniencys of a Palace, stoves in the chambers, Kitchins, etc. They are row'd by 12 men each, and move with an incredible swiftness that in the same day you have the pleasure of a vast variety of Prospects, and within a few Hours space of time one has the different diversion of seeing a Populous City adorn'd with magnificent Palaces, and the most romantic Solitudes which appear distant from the commerce of Mankind, the Banks of the Danube being charmingly diversify'd with woods, rocks, Mountains cover'd with Vines, Fields of Corn, large Citys, and ruins of Ancient Castles. I saw the great Towns of Passaw and Lintz, famous for the retreat of the Imperial Court when Vienna was beseig'd.

That casual mention of the siege of Vienna at the end of this delightful piece of travelogue is a reminder that it was only just over thirty years since the Turkish army had reached the walls of Vienna. The Ottomans had been driven back by the King of Poland's army, but the Emperor and his court had fled the city. It had been close.

That is all in the past. Lady Mary is far more interested in the novelty of travelling by *traineau* ('little machines fix'd upon a sledge' that hold two people) or being offered a 'sub-marriage' – a lover for the time she is in the city. Montagu, she *says*, turns down the kind offer, but she is spurred to reflect on cultural difference: 'Gallantry and good breeding are as different in different Climates as Morality and Religion. Who have the rightest notions of both we shall never know till the Day of Judgment, for which great Day of Éclaircissement I own there is very little impatience.'

Witty and urbane, Lady Mary is quite the eighteenth-century Enlightenment intellectual, entirely able to laugh at notions of the Day of Judgement, cool and dispassionate about matters of faith, leaving it to her reader to decide 'which Divinity is most rational'. Her cultural relativism has limits, however. Her travels through the German lands to Vienna bring out all her very English Protestant eighteenth-century antipathy towards Roman Catholicism. She dislikes what she sees as gross superstition and condemns the monastic life for women. She meets a nun whom she views as 'buried alive'. Tell that to Julian of Norwich. I'd like to think that Montagu is being strategic, wrapping herself in the Protestant English flag in order to protect herself from being attacked for being a woman with opinions.

Six months in, and the Wortley Montagu family faced the toughest part of their journey, overland through Hungary and Serbia to Turkey in January. In Buda, the buildings still stood ruined, unrepaired since the last siege. Lady Mary's letters speak of her fear, and back home her admirers were equally worried. Alexander Pope, in hearing of 'those Mountains of Snow, and Woods laid in ashes you describe', wants to do the journey with her. Instead of Pope, safely in Twickenham, where he can make his romantic offers, the family

were escorted by one hundred foot soldiers, fifty grenadiers and fifty hussars. They needed their guard, for the Wortley Montagus were travelling through a warzone into enemy territory in midwinter.

The Ottoman and Habsburg Empires had been at war for decades. With hindsight, the overall decline of the Ottoman Empire is all too obvious, but Wortley Montagu was posted to Constantinople because, at the time, the Turks were in resurgence. They had triumphed over the Russians, had retaken the Morea from Venice and were eyeing up Hungary, which explains the lack of rush to rebuild.

The tide turned against the Ottomans just weeks into the Wortley Montagus's journey. The Habsburg armies, led by Prince Eugene, defeated the forces of the Grand Vizier, who was killed on the battlefield of Peterwardein. He was just one of the thousands dead on what Montagu calls that 'glorious bloody day'. Lady Mary saw them. The field was 'strew'd with the Skulls and Carcases of unbury'd Men, Horses and Camels'.

She writes of this safely in Belgrade, but the horror has stayed with her. To see 'such numbers of mangled humane bodys' makes her 'refflect on the Injustice of War, that makes murther not only necessary but meritorious'. For Lady Mary, nothing proves better the:

> irrationality of Mankind (whatever fine claims we pretend to Reason) than the rage with which they contest for a small spot of Ground, when such vast parts of fruitfull Earth lye quite uninhabited.

Being Lady Mary, she takes a philosophical turn: 'I am a good deal inclin'd to beleive Mr. Hobbs that the State of Nature is a State of War, but thence I conclude Humane Nature not rational, if the word reason means common sense, as I suppose it does'. Then again, being Lady Mary, she pulls back from anything too serious – after all she doesn't want to bore anyone – and ends with some gentle self-mockery: 'I have a great many admirable arguments to support this refflexion, but I won't trouble you with 'em but return in a plain stile to the History of my travels'.

These kinds of comments are as much a product of her class and literary values as her gender – although the spectre of Eve and the tree of knowledge hovers somewhere nearby. Her delight in conversation, her determination to please, is absolutely of her time in a more general way. Novelist Henry Fielding (her cousin on her mother's side) wrote, for example, that the 'art of good breeding' lies in the 'art of pleasing, or contributing as much as possible to the ease and happiness of those with whom you converse'. This art of pleasing was more than good manners, it was a foundation of a peaceful society in a world with different religions and grievous schisms within those religions. During Montagu's lifetime, values were changing, moving closer to a new social code, in which civilised, civil people keep politics and religion out of conversation, a social code that would de-fang John Milton's political and religious radicalism and turn him into a poet of the sublime.

Montagu's desire to please is also rooted in her sex. It reminds me of Kamala Harris's relentless smiling as she campaigned to become Vice President, a response to the offensive but powerful stereotype of the 'angry black woman' and one presumably learned by Harris over many years of being a woman of colour in public life. Lady Mary's sometimes disconcerting shifts of tone – serious one moment, facetious the next – are also a reflection of a journey which blends terror and delight. She adopts a familiar strategy of the intrepid traveller when dealing with the more dangerous side of her travels. Take the family's reliance on janissaries. These men are exotic and terrifying in equal measure to most, but not to her. The perils are real, but not to her. She's harnessing herself to a strain in travel literature that began with European men journeying in quest of fame and fortune, not to mention a good story. Their women stayed at home. The women of the brave new worlds the men were exploring, discovering, conquering were at best exoticised dusky beauties, at worst hardly acknowledged collateral damage, bodies available for manual labour or sexual release. Now Lady Mary Wortley Montagu gazes on the exotic, dangerous men of her journey and not only draws a political

moral from them (the janissaries' behaviour towards the starving peasants of the Balkans was evidence of 'the natural corruption of a Military Government, their Religion not allowing of this barbarity no more than ours does') but almost relishes the simmering violence of Ottoman life. If a single word should be dropped in a coffee house about a government minister, the place would be razed to the ground and the whole company tortured, for 'they have spys every where'. She recounts that:

> when a Minister here displeases the people, in 3 hours time he is dragg'd even from his Master's arms. They cut off his hands, head and feet, and throw them before the palace Gate with all the respect in the World, while that Sultan (to whom they all profess an unlimited Adoration) sits trembling in his Apartment, and dare neither defend nor revenge his favourite.

Lady Mary is strangely half-hearted in her condemnation of this violence. She compares it with the English world of 'harmless calling names', senseless pamphlets and 'tavern disputes', and suggests that those who think that there is arbitrary government in England should head out to Belgrade and see it for what it is. And it is in this Ottoman world of violent horrors that Lady Mary finds a kindred spirit, the Effendi Achmet Beg (a man who has 'more wit and is more polite than many Christian men of Quality. I am very much entertain'd with him'), in whose garden she sits for hours talking about the differences between Islam and Christianity, sharing poetry and ideas. She writes home to another intellectual kindred spirit, the Abbé Conti, about her 'intimate daily' conversations with Achmet Beg which have given her the 'opertunity of knowing their Religion and morals in a more particular manner than perhaps any Christian ever did'. It's a bold claim, and one she will make again in various guises.

What gave her the edge over those other Christians was her ability with languages. With Achmet Beg, Montagu began to learn Turkish, and as she gained fluency over the coming months she was able to

gain some special, if not unique, insights into and understanding of the Ottoman world. And slowly but surely she fell in love with it.

Montagu's most famous adventure, possible only because she was a woman, took place in Sofia, then, like Belgrade, an Ottoman city. She travels incognito to the baths in a rather splendid coach (wooden lattices, decorations of flowers and poetical mottos, covered with scarlet cloth lined with silk), arriving at about ten of the clock. In she goes, remembering that as a Lady of Quality she is expected to give the portress a tip: Lady Mary rarely forgets her duty to her class. She admires the marble, the fountains, the steam, so hot that "twas impossible to stay there with one's Cloths on".

For Lady Mary – unlike all the other women in the baths – has her 'Cloths on', specifically her:

> travelling Habit, which is a rideing dress, and certainly appear'd very extrodinary to them, yet there was not one of 'em that shew'd the least surprize or impertinent Curiosity, but receiv'd me with all the obliging civillity possible.

The Ottoman women rise to the awkward occasion, showing infinitely superior manners to their Christian, western counterparts: no 'disdainful smiles or satiric whispers', despite the absurdity of Lady Mary arriving in the bathhouse with her clothes on. Instead they 'repeated over and over to me, *Uzelle, pek uzelle*, which is nothing but, charming, very charming'.

At last, the problem of Lady Mary's clothes can no longer be politely ignored.

> The Lady that seem'd the most considerable amongst them entreated me to sit by her and would fain have undress'd me for the bath. I excus'd my selfe with some difficulty, they being all so earnest in perswading me. I was at last forc'd to open my skirt and shew them my stays, which satisfy'd 'em very well, for I saw they beleiv'd I was so lock'd up in that machine that it was not in my

own power to open it, which contrivance they attributed to my Husband.

It's a superbly observed moment of cultural incomprehension. For the Ottoman women, Lady Mary's corsets signify her oppression. And perhaps she *is* oppressed, for not only does she not get naked, but the next day, for all her desire to return to the baths, her husband insists on their leaving the city early.

III

Montagu's constant comparison of east with west, usually to the detriment of her English homeland, takes some more challenging turns for the modern reader. She casually notes slaves sitting behind their mistresses in the bath house ('generally pritty Girls of 17 or 18') or the even younger girls who lie at the feet of one of her hostesses: 'the eldest about 12 year old', both 'lovely as Angels, dress'd perfectly rich and allmost cover'd with Jewells'. She writes of the even younger slaves who attend the Sultana, the:

> eldest not above 7 year old. These were the most beautifull Girls I ever saw, all richly drest; and I observ'd that the Sultana took a great deal of pleasure in these lovely Children, which is a vast Expence, for there is not a handsome Girl of that age to be bought under £100 sterling. They wore little Girlands of Flowers, and their own hair braided, which was all their head dress, but their habits all of Gold stuffs. These serv'd her Coffée kneeling, brought water when she wash'd, etc. Tis a great part of the busyness of the older slaves to take care of these Girls, to learn them to embrodier and serve them as carefully as if they were children of the family.

And she reports, quite the foreign correspondent, that the:

fine slaves that wait upon the great Ladys, or serve the Pleasures of the great Men, are all bought at the age of 8 or 9 year old and educated with great care to accomplish 'em in singing, danceing, Embrodiery, etc. They are commonly Circassians, and their Patron never sells them except it is as a Punishment for some very great fault. If ever they grow weary of 'em, they either present them to a freind or give them their freedoms. Those that are expos'd to sale at the Markets are allways either guilty of some Crime or so entirely worthless that they are of no use at all.

In other words, slavery really is not that bad a thing, after all. And if a slave ends up at the market, well, it's their own fault.

Montagu's acceptance of slaves, and her claim that the way in which they are treated by their Ottoman masters argues for the 'Humanity of the Turks' for their 'creatures' are never 'ill us'd', are part and parcel of her refusal to engage with an easy Islamophobia, and her concomitant critique of European practices. The Ottomans simply manage things better:

> Slavery is in my Opinion no worse than Servitude all over the world. 'Tis true they have no wages, but they give them yearly Cloaths to a higher Value than our Salarys to any ordinary Servant. But You'l object Men buy women with an Eye to Evil. In my opinion they are bought and sold as publickly and more infamously in all our Christian great Citys.

Christians have no right to preach to the Muslim. Montagu is unwilling or unable to take the next, more radical step, to question slavery itself. It exists. Servitude is a given. Better that it is managed with humanity. The result: Montagu takes the eunuchs and pre-teen slave girls for granted, small human cogs in the machine of her enjoyment of Constantinople.

It's easy to miss this because of Lady Mary's infectious enthusiasm for all things Ottoman. Arrived in Constantinople she continues her

love-in with the beautiful young Fatima, which began in Sofia and is now intensified by Montagu's new command of the language. Lady Mary is, however, as much in love with multilingual, multi-ethnic Constantinople as she is with Fatima. In sentences reeking with false modesty, she claims:

> I am in great danger of loseing my English. I find it is not halfe so easy to me to write in it as it was a twelve-month ago. I am forc'd to study for expressions, and must leave off all other Languages and try to learn my Mother tongue.

She has met 'infants of 3 or 4 year old that speak Italian, French, Greek, Turkish, and Russian, which last they learn of their Nurses, who are gennerally of that Country', a phenomenon which casts no very good light on the ladies of England who 'set up for such extraordinary Geniuses upon the credit of some superficial knowledge of French and Italian'.

Again and again, the contrast with her life in England is made, and it is quite clear which she prefers. Her week just outside Constantinople:

> Monday Seting of partridges, Tuesday reading English, Wednesday Studying the Turkish Language (in which, by the way, I am already very learned), Thursday Classical Authors, Friday spent in Writing, Saturday at my Needle, and Sunday admitting of Visits and hearing Musick.

It is so much preferable to 'a perpetual round of hearing the same Scandal and seeing the same follies acted over and over'.

Lady Mary has escaped. She has, or wants to be seen as having, been transformed. In a superb portrait, which prefaces this chapter, she stands, poised, dominant, wearing a blue ermine-edged coat, open over her gold dress. On her head she wears a turban. Her son Edward is painted in a long white dress, and mother and child are

waited on by servants: a woman playing the tambur, a Turkish lute, and a man bringing a letter. They stand on a Turkish carpet, and the city of Constantinople is the backdrop. The artist is Jean-Baptiste Vanmour, already the portrayer of Sultan Ahmed III. Reading, writing and music are everyday delights. London life (which Montagu now rather pities than despises) can no more touch her than it does 'other dead people'.

That enjoyment of life, that dismissal of English society, would not last. In August 1717, Austrian forces defeated the Turks and captured Belgrade. It was another small nail in the coffin of the Ottoman Empire, strengthening the Western powers' bargaining position, and it spelt the end of Edward Wortley Montagu's tenure as ambassador. Although historians point to this battle as crucial to the decision to recall Wortley Montagu, it remains unclear whether it was driven by political in-fighting back home, or a growing sense that Edward had far too much sympathy for the Ottomans. A hawk not a dove was needed, now that the Western powers had the upper hand. Lady Mary had no say in the matter.

She did not want to leave.

> I am now preparing to leave Constantinople, and perhaps you will accuse me of Hipocricy when I tell you 'tis with regret, but I am us'd to the air and have learnt the Language. I am easy here, and as much as I love travelling, I tremble at the inconveniencys attending so great a Journey with a numerous family and a little Infant hanging at the breast. However, I endeavour upon this Occasion to do as I have hitherto done in all the odd turns of my Life, turn 'em, if I can, to my Diversion. In order to do this, I ramble every day, wrap'd up in my ferigé and asmak, about Constantinople and amuse my selfe with seeing all that is curious in it.

The mention of Montagu's 'numerous family' is yet another reminder of her social and political status. For their journey to Constantinople, Sultan Ahmed III had provided them with '30 cover'd Waggons' for

their baggage and '5 Coaches of the Country' just for Lady Mary's 'women'. Her women.

These women were part of the Wortley Montagu 'family'. As Montagu writes elsewhere, there are ten languages 'spoke in my own family. My Grooms are Arabs; my footmen French, English and Germans; my Nurse an Armenian; my Housemaids Russians; halfe a dozen other servants Greeks; my steward an Italian; my Janizarys Turks'.

All the complexities and inconsistencies of her situation, all the charm and arrogance of the woman, appear in her final letters from the city. She's curious, courageous and clever. She is determined to 'amuse' herself, to find 'diversion' – something she has done in 'all the odd turns' of her life. There had already been a few of those, and there would be many more. Her familiarity with the language and customs gives her the confidence to write to Abbé Conti that, although the Turks' magnificence is different in taste from 'ours', it is perhaps 'better'. This is no longer just about amusement. Her love of her life in Constantinople has made her profoundly question her life back home. She is:

> allmost of opinion they have a right notion of Life; while they consume it in Music, Gardens, Wine, and delicate eating, while we are tormenting our brains with some Scheme of Politics or studying some Science to which we can never attain, or if we do, cannot perswade people to set that value upon it we do our selves. I allow you to laugh at me for the sensual declaration that I had rather be a rich Effendi with all his ignorance, than Sir Isaac Newton with all his knowledge. I am, Sir, etc.

It is an astonishing claim from such a learned, intelligent, well-read woman. Is it designed to challenge and delight Conti as much as anything else? (Conti had been the intermediary in the controversy between Newton and Gottfried Leibniz as to which man had discovered calculus first.) The claim does coincide with Montagu's question

about human beings, redolent of Hobbes, that 'considering what short lived, weak animals men are, is there any study so beneficial as the study of present pleasure?' Her defence of sensuality is, of course, yet another indication of her elite status: the life she describes, revels in, is uniquely available to the very wealthy.

And now it was gone – along with many of her beliefs about her own country. She writes that she now almost envies those who can think England a superior place. She knows she must be 'contented with our scanty allowance of Daylight, that I may forget the enlivening Sun of Constantinople'. Such wistfulness. She was not yet thirty.

IV

On 18 October 1718 the *Weekly Journal and Saturday Post* reported that Lady Mary Wortley Montagu had reached England 'richly laden from Turkey'. She was home.

I can't in this short chapter possibly do justice to Lady Mary Wortley Montagu's rich life from this point on. My task here is to leap from 1718 forward some forty-four years, to 1762, from the early years of the reign of German-speaking George I to the early years of his grandson, George III, crowned in 1760, the King who lost Britain's American colonies. No time to explore Montagu's politics (her granddaughter described her as 'Whig to the teeth – Whigissima') or that of her family – her son-in-law would be a Tory Prime Minister. I will give merely the briefest of nods to Lady Mary's spectacular (and spectacularly doomed) passion for a very young, rather brilliant Italian, Count Algarotti, noting that at least Lady Mary showed taste in her mid-life crisis and wisdom in later life by remaining friends with him.[1] A word only about the unconventional but enduring marriage of Mary and Edward – helped in its survival by her remaining away from England for some thirty years – and the string of family crises, from a challenging, some would say criminal, son and heir

to a mentally ill sister, that punctuated Montagu's life. With regret, no time here to explore Montagu's years in Italy and France (two long stints in Venice, where she had a salon and many friends, a less happy four years in Avignon, a bad experience in Brescia where she fell under the control of the emotionally abusive and financially greedy Count Ugolino Palazzi, an upper-class bandit). With some anger, no time to document Montagu's valiant attempt to introduce the 'useful invention' of smallpox inoculation in England. She had witnessed the practice in Turkey; the medical science was sound; Mary had her supporters, even royalty. Her letters tell of Ottoman smallpox parties, her own son's inoculation, her desire to introduce the 'ingrafting' to England, her fear of attack from the medical profession, her determination to have the 'courage to war with 'em' on her return, as she did during the spring smallpox epidemic of 1721. But in the end, the world decided it needed vaccination not inoculation, and to hear about it from a man. Montagu herself was condemned as an unnatural mother. For all this, and much more, I recommend Isobel Grundy's excellent biography, but I will pick up my story again in 1761, with Lady Mary in Italy, now over seventy years old and still writing.

She also has breast cancer. Whether she knew how ill she was is a matter for debate, but when she heard of the death of her husband, Edward, Montagu decided it was time to return to England. Theirs had been an unconventional marriage, but he was her husband – and he had paid her a generous allowance and written letters to her. She repaid him with her own form of loyalty and submission. Did Lady Mary also hear the gossip that he had left £1,350,000? An unlikely figure, but nevertheless, if there was even half that, a quarter of that, then there was going to be trouble – because the Wortley Montagus were of one mind when it came to the necessity of cutting their son, Edward, out of his inheritance and making sure the estate passed to their daughter, Mary, Countess of Bute. Her husband, Lord Bute, was at that moment superbly placed, King George III's right-hand man and recently appointed Prime Minister.

It took until September for Lady Mary to start what was to be her final, belated journey home. Her daughter was not entirely convinced of her mother's wisdom. In her new position, propriety mattered more than ever, and Lady Mary – well, Lady Mary was not, never had been, quite proper. Moreover, it was a gruelling journey for anyone, let alone an old woman debilitated by cancer. But by 11 December 1761, her mother was almost home, waiting in Rotterdam for a boat to bring her across the Channel.

It was in Rotterdam that Lady Mary Wortley Montagu did something remarkable. She handed over two handwritten volumes of papers to a man she barely knew – and a Presbyterian evangelical minister, of all people. She inscribed them. It was her 'will and design' that the minister should dispose of them as he thought proper.

And then she was home. For some weeks and months Montagu was a celebrity. She returned to the social round from which she had been so long exiled, but by July the cancer had taken hold, and she was existing on morphine. Her last short letter, dated 2 July, begins: 'I have been ill a long time, and am now so bad I am little capable of writing'.

Lady Mary died, leaving a guinea to her son, Edward. For all her involvement in the London spring season of 1761, her passing failed to inspire a frenzy of elegies or obituaries. Horace Walpole (occasional friend, more often bitter enemy) wrote, tersely, 'She had parts, and had seen much.' But Walpole, along with literary London, also knew that Montagu had left 'twenty-one large volumes in prose and verse in manuscript'. She was not only a woman of parts who had seen much, she was an author. Her family, however, feared rather than welcomed the possible emergence of Montagu's work. Lady Bute quickly burned Lady Mary's diary, claiming that she was only doing what her mother would have wanted. Then she moved to get hold of some nineteen volumes of writings, and the word on the ground was that they would 'not see the light in haste'.

But what of the other two, the ones Lady Mary 'in her passage gave to somebody in Holland'? Lord Bute worked hard to track them

down 'in terrors' lest they should be published, and was willing to pay good money to recover the manuscripts. Sowden, the evangelical minister, duly gave up the last two volumes of Montagu's literary legacy, pocketing a gift of £200. Or £500. Depending on who you spoke to. Despite Lady Mary Wortley Montagu's (remarkable for her, given a lifetime of avoiding print) desire to have them published, it looked as if the two volumes would go the way of the other nineteen: at best, a dusty family archive; at worst, the fire.

What Lord Bute did not know was that Sowden had loaned out the manuscript to a couple of English travellers for the night. They spent the small hours copying it. One of the travellers was from a family of printers. The rest was easy.

V

Letters of the Right Honourable Lady M—y W—y M—e, written during her travels in Europe, Asia, and Africa, to persons of distinction, men of letters, &c., in different parts of Europe. Which contain, among other curious relations, accounts of the policy and manners of the Turks, drawn from sources that have been inaccessible to other travellers was published on 7 May 1763, just under nine months after Lady Mary's death.

It wasn't the salacious memoir that the family feared and others expected. Indeed, the three small but beautiful volumes of *Letters* were prefaced with a glowing endorsement from a high-minded feminist writer, Mary Astell, written some forty years earlier – and containing her belief that the work should have been published back in 1724. Astell was a passionate advocate of women's education (especially the education of white Protestant upper-class women) and the two Marys became unlikely friends around the time of the death of a fourteen-year-old girl called Eleanor. A precocious poet who lived in Montagu's neighbourhood of Twickenham, she was said to have died

from 'violence of the Bridegroom's embraces' after only eleven weeks of marriage. Astell and Montagu were both horrified, with Astell writing her preface to the letters just four days after young Eleanor's death. What might have been a temporary alignment between the two women (although they remained unlikely friends until Astell's death from breast cancer in 1731) meant that when the work was published, Astell's energetic and openly feminist – women are better than men, as writers and travellers – celebration of Montagu's 'Genius', simplistic though it is, would now be read with the *Letters*.

The volume that Astell read in 1724 was not just a bundle of documents. It was already a literary creation. Montagu made her own copy of each letter sent home from her travels; then, together with an unknown copyist (shades of collaboration, Margery-style), she assembled her literary text into two volumes and had them bound in leather. Even while Lady Mary was writing the letters, she organised them under headings in order to make it easier to bring them together at a future point. These 'heads' are beautiful prose epiphanies all of themselves, capturing so much in so few words: 'I like travelling. Hurryd up and down. Long Journeys, new scenes every day.'[2] On her return to England, she pulled it all together into a whole, re-addressing, editing, repositioning letters, culling some, redacting the name of the addressee in others, carefully structuring her collection – for surely it cannot be a coincidence that there are fifty-two letters, one for each week of the year – and adding dates, not always accurately. Because these are not letters in the service of the historical archive, but of literature. Out of them, Montagu created a 'letter-book', the most appropriate genre to communicate her experiences, her ideas, her personality, her truth.

The *Letters* still have the power to charm but also to provoke and outrage. First the charm. Montagu allows her reader a sense of eavesdropping on a private circle, a fiction of intimacy, of course, but nevertheless enticing. She never lets us forget that the letters themselves are, in and of themselves, exciting and precious. They have been on their own precarious journey through a war-torn Europe;

they are missives from faraway, exotic places. The reader is reminded that letters contain secrets – whether political or emotional. At one point, Lady Mary notes, satirically, that other people's letters ('the pacquet at Prague') were tied to the back of her carriage en route to Dresden: 'the secrets of halfe the country were at my Mercy if I had had any curiosity for 'em'.

Montagu's avowed goal is the entertainment of her reader, both the inscribed reader of each letter, whether sister or poet, royalty or old friends, intellectuals or people she has met along the way, or the much larger body of readers she obviously hoped to reach in print, if posthumously. And entertain she does, from descriptions of god-awful Inns to the Palace of Versailles (irregular – she didn't like it) to a terrible Channel crossing, which is made the more amusing by the description of a foolish woman trying to hide her contraband lace from the customs officers. The letter-book contains a strange but wonderful mix of registers, in part because of the variety of recipients, but primarily because this is quintessential Lady Mary Wortley Montagu. She writes of wolves and fashions, war and pheasants. Trivial social bitching jostles with earnest philosophical analyses.

Yet her stated desire simply to please her readers is something of a blind, with a hint of Behn's ambivalence when she lurches from proclaiming that her sole aim is to pleasure her audience to acknowledging that she also desires fame. Montagu is similar to Behn in her consciousness of her place in the male literary world. So, when she writes she has 'entertaind you with an Account of such a sight as you never saw in your Life and what no book of travells could inform you of. 'Tis no less than Death for a Man to be found in one of these places', she does not just have her eye on entertainment. (Whoever put together the printed volumes recognised a good line when he saw it and ended Volume I with it.) She is setting herself up in explicit competition with the male literary establishment, past and present.

These men and their traditions haunt the *Letters*. Montagu crams her work with allusions, translations, transcriptions of Greek and Latin, echoes of the *Aeneid* and the *Iliad*, the foundation stones of

(male) literary tradition. Lady Mary carries with her, literally and metaphorically, Pope's translation of Homer and, as she travels, she writes of her consciousness that she is passing through the very landscapes described by the classical authors. One of her letters (a long, long letter to Alexander Pope) shows her at work. It contains transcriptions, translations, commentaries, and original verse. Critic Daniel O'Quinn spells out the take-home message for Pope – and for the reader eavesdropping on the correspondence. Montagu offers a decisive, if politely rendered, claim to authority that can be summarised as follows: thanks for your translation of Homer; I can confirm that aspects of your translation are accurate; I enclose my translation of a typical Ottoman poem in the sublime style; you are in no position to question its merits as a translation.

The letter-book as a whole stands as a riposte to the male literary establishment. Not only is Lady Mary Wortley Montagu, a mere woman, able to read and write Latin, but she is now fluent in Turkish. In a world in which translation was the bedrock of literary endeavour, in which Dryden translates Virgil and Juvenal, and Pope famously tackles Homer and Horace, here is Lady Mary doing it, live, and in letter form.

Well aware of a literary culture that has excluded women, Montagu claims – at first sight – that her sex actually gives her an advantage. During that visit to the baths in Sofia, she asserts that her insights are in fact greater than those of iconic male painters and that their art would be improved if they could see what she sees. She is presenting her sex as *enabling*, allowing her to enter spaces denied to men – or rather, to men who had not been castrated like the 'black Eunuchs' who conduct her into audiences with Ottoman dignitaries. By virtue of being female, she can report on the delightfully relaxed Turkish approach to childbirth. Women see 'all Company the day of their Delivery and at the fortnight's end return Visits, set out in their Jewells and new Cloaths'. This she knows because Montagu is herself pregnant, and gives birth in the Turkish manner to her daughter, also Mary, in January 1718. As she writes, she is not 'so fond of any of our

[English] Customs to retain them when they are not necessary'. She is on a knife-edge here: her sex a benefit to give her inside knowledge denied to men, but also pregnancy and birth things to be dismissed with an insouciant cultural observation.

Do the *Letters* succeed in their performance of masculine confidence? Certainly, Montagu works tirelessly to establish her authority as a woman, without being implicated in problems of 'woman'. When it comes to motherhood, for example, Lady Mary plays it cool. She casually mentions that she 'was brought to bed of a daughter five weeks ago', or jokes that since she has 'nothing better to do, I have produced a daughter'. It is all part of her presentation of herself as a leisured, sophisticated, literary woman running with the men, an author who casually drops a baby but then returns to the real business of life – observing the customs and manners of the Ottomans. She is happy to present as 'woman' when it gives her privileged knowledge, especially erotic privileged knowledge. But this is a woman who is not inconvenienced by giving birth.

So much of this is rooted in her desire to, her need to, establish her authority as a female author. Like all the other writers in this book, she has to work very hard at it. She insists, repeatedly, on the veracity of her accounts. Her letters are special because they are derived from her lived experience. She knows that there will be those who don't believe her, recounting her irritation with an unnamed Lady who has accused her of holding back information: 'She is angry that I won't lie like other travellers. I verily beleive she expects I should tell her of the Anthropophagi men whose heads grow below their shoulders.' No, Lady Mary will not make things up, even to please her readers. She is dealing in the plain, unvarnished truth which – by the way, you ignorant English readers – is fascinating and exotic and only accessible to a woman of Lady Mary's abilities (and gender).

Her competitiveness ensures that Lady Mary presents herself as an exceptional traveller and travel writer. In reality, Montagu was if not ordinary then very much of her time, in that more people were travelling, more people were writing about their travel, and travel itself was

increasingly valued as a way for the Elite Enlightened European Male to learn more of the human species. But this is not how Montagu tells it. A letter addressed to the Princess of Wales insists on the perils she has navigated – and only she: 'I have now, Madame, past a Journey that has not been undertaken by any Christian since the Time of the Greek Empereurs'. Montagu is exaggerating of course, since there *were* Christians who had made the journey by land. She can be forgiven because it was a very tough journey – despite or because of the five hundred janissaries who escorted the diplomatic group – but there is no way that Montagu is going to let the reader forget how special she is. Only she can write authentically, authoritatively, about women's lives in the Ottoman Empire.

Montagu has her twin targets – male literary authority, male empirical authority – in her sights in a remarkable letter, dated 16 March 1718, from Pera, Constantinople, but without a named addressee. The author is in quasi-academic mode. She offers her reader a 'Turkish love letter', a *sélam*, a poem made up of objects. The *sélam* was understood by Montagu as a game played by women in the harem, where a message composed of flowers and other objects was sent to a lover and was in turn decoded based on a word that rhymed with the object. Scholars now credit her with introducing the concept to European readers. She sends her unnamed correspondent the items in a 'little box', and provides a literal 'translation' of the objects: 'bits of Charcoal, Scarlet Cloth, Saffron, Ashes' which she warns her reader might look like 'Trash' but are in fact as significant as 'the most passionate Words; but 'tis a Mystical Language that cannot be understood without a Turkish Interpreter'. Fortunately, Lady Mary is up to the task.

Beginning with 'pearl' ('Sensin Uzellerin gingi Ingi' translated as 'Fairest of the young'), Montagu ends with:

Gira	Esking-ilen oldum Ghira
a match	I burn, I burn, my flame consumes me.
Sirma	uzunu benden ayirma

Goldthread	Don't turn away your face.
Satch	Bazmazun tatch
Hair	Crown of my head.
Uzum	Benim iki Guzum
Grape	My eyes.
Tel	uluyorum tez ghel
Gold Wire	I die – come quickly.

Montagu explains the powerful possibilities of the form (a 'million' verses are possible, all emotions can be expressed): 'you may quarrel, reproach, or send letters of passion, friendship, or civility, or even of news, without ever inking your fingers'. Daniel O'Quinn again: Montagu's translation shows 'no equivocation, no vagueness, no sense of idiomatic struggle, only assumed knowledge'. She has suppressed the hard work, the process, she went through to get to this assurance – hard work that is evident in one of her surviving commonplace books.

Montagu has established herself as an expert in a world denied to men. She can interpret communications between the women of the harem and draws her English female reader, the anonymised Lady [---], into this intimate reading experience. Her insider knowledge and her insights work to challenge the validity of male-inspired fantasies of the harem, with their queasy mix of Christian voyeurism and condemnation of the sexualised, veiled woman. Montagu offers a still welcome dose of realism and common sense. The women in the baths in Sofia are just going about their ordinary business.

But there are other, more troubling, ways to read her work.

VI

The *Letters* remain literary Marmite. They certainly sell, with twenty-three editions before 1800 and numerous versions available today.

Publishers knew from the start that Montagu meant money, that this tiny, beautiful book would punch way beyond its weight. But for all the readers impressed with Montagu's authority ('What fire, what ease, what knowledge of Europe and Asia', wrote Edward Gibbon) there are those who have questioned the veracity of the *Letters* to the point of wondering if Montagu even wrote them. Elizabeth, Lady Craven, who made her own journey to Constantinople in 1789, insisted that Montagu's letters were forgeries: 'whoever wrote L. M –'s *Letters* (for she never wrote a line of them) misrepresents things most terribly – I do really believe, in most things they wished to impose upon the credulity of their readers, and laugh at them'. It didn't help that when a second edition, or rather a 'stylish piracy', was rushed out soon after the first, 'new' letters were added. These were indeed forgeries, the result of a bet made 'at a convivial gathering, as to whether Lady Mary's style was or was not inimitable'. When the work came to be reprinted the fake letters stayed, even to this day.

It is not Montagu's veracity or otherwise that troubles readers today but the ways in which she panders to, indeed helps create, a particular kind of orientalism, most notable in her prurient fascination with the harem. Montagu might be celebrated by some for her open enjoyment of women's naked bodies, as when she admires the bathers of Sofia, but her admiration shades into voyeuristic desire for the 'ranks of beautifull young Girls with their Hair finely plaited almost hanging to their Feet, all dress'd in fine light damasks brocaded with silver', young girls she wants to consider more closely but is prevented by 'decency' from doing so. Her fetishisation of 'the East' is invariably in dynamic with her understanding of 'the West', not to mention framed by her profoundly competitive notions of culture: one has to win. Take Montagu's open adoration of the exquisitely, ravishingly beautiful Fatima, who has a 'sweetness full of Majesty that no Court breeding could ever give'. She is smitten to the point where she cannot speak 'being wholly taken up in gazing' – her face, her body, her complexion (no make-up), her smile. 'Her eyes! large and

black with all the soft languishment of the bleu! every turn of her face discovering some new charm!' Even in the recollection of this moment of rapture, Lady Mary cannot resist a challenge to European complacency and arrogance (what madness to call this Ottoman culture 'barbarous'!) and a swipe in the direction of English 'beauties', who would vanish if placed next to Fatima.

As with many of the authors in this book, Montagu gets into the history of English Literature because her journey is viewed as unprecedented and unique. I have seen Lady Mary described as the 'first European woman to travel in many of the places she visited' or the 'first European woman to witness the private lives of Islamic women'. This is to position the *Letters* precisely in the way that Lady Mary Wortley Montagu set them up to be positioned: exceptional.

I wrote about the problems with exceptionalism for the history of women's writing in my opening chapter and when thinking how Anne Bradstreet's family presented her to the world. Exceptionalism enables individual women (or the men who support them) to validate their forays into male-controlled arenas, such as authorship or travelling, but it does not challenge the values that keep those arenas male-controlled.

But there is another way being different, being special, works for Mary Wortley Montagu which is to marginalise or devalue others. Indeed, it relies on doing so. In its crudest form, Lady Mary gains authority by aligning herself with (white, Protestant) Englishness in opposition to a series of demeaned or denigrated others, including white European Catholics, Jews, black Africans and indeed, less special women. At times this is done blatantly, and I won't rehearse her bigoted comments here. But her silences are as powerful as her openly racist or anti-Semitic statements, particularly when it comes to slavery.

Silences are easy to miss. It has taken a long time for us to register, let alone absorb the implications of, the presence of a black boy, dressed in a servant's livery, in a portrait of Montagu. She is in Turkish costume: *anteri*, wide trousers looking at first glance like a

petticoat or skirt, a head-dress (what Montagu calls a *talpoche*), an ermine-lined *kürdiyye* (Montagu's *curdee*, 'a loose robe they throw off, or put on, according to the weather, being of a rich brocade'), broad jewelled belt. Is the boy, asks biographer Grundy, a 'studio prop'? If so, it (he?) is an inauthentic one, since 'child slaves in Turkish households were whites from Circassia and such places; the only black slaves were adult males employed in harems'. Montagu 'knew these things, though other English people might not'. Given Lady Mary's desire to be seen as an authority on matters Ottoman, Grundy is forced to consider that this might be a portrait of Lady Mary's actual slave – or to be precise, the property of her husband, since that's how things worked back then.

Shifting the blame onto Edward Wortley Montagu works up to a point. He was making money out of coal in these years, and sugar-producers in the Caribbean depended on coal-producers in England. The links are there, and this is the period in which the British became the leading slaving power in the world. The Royal African Company had been doing its best (with some 5,000 black Africans transported each year in the 1680s to the West Indies) but more labour was needed in the plantation colonies and therefore the trade was opened up. From 1713, the British could import as many enslaved people as they wished to their colonies in the Caribbean.

But Grundy is forced to acknowledge that 'Lady Mary might have been a slave-holder, for all her enlightenment. Slave-owning was a given in her milieu.' Despite the fact that in theory, slavery did not exist on English soil – it was something that happened far away in the Caribbean and American colonies or indeed in the Ottoman Empire – in practice black people were enslaved in England. And black children were depicted in orientalised portraits at the time, most famously the image of Charles Ignatius Sancho in the portrait of Lady Mary Churchill, Duchess of Montagu, painted just a few years after our Lady Mary's time in Constantinople. (Sancho is identified as 'ye Black of her Grace' and 'her Grace' was good friends with Lady Mary Wortley Montagu.)

It would be unsurprising if Lady Mary had black people in her household, equally unsurprising if they remained somehow invisible to her, enlightened or no. For when she does write about slaves, they become exotic literary fodder for her presentation of her own uniqueness and her arguments for the acceptability of slavery are made in the service of her own self-display. In her letters home, she claims to know that she is shocking her readers with her lack of outrage about it all. Back in England, they will 'imagine me half a Turk when I don't speak of it with the same horror other Christians have done before me'. Lady Mary as ever sets herself up as exceptional, not like 'other Christians'.

Yet, for all her appreciation of women, for all her awareness of her own vulnerability as a woman, for all her infectious delight in travelling in the Ottoman world ('I am now got into a new world ...'), Lady Mary's challenge to her homeland's complacent and inaccurate view of Islam is buttressed and underpinned by her racism, with added doses of anti-Semitism, anti-Catholicism and sheer snobbery thrown in.

Should we be disappointed to discover that Lady Mary fails to embrace what we now call intersectionality? After all, well into the present century, feminism has been dominated by the voices and concerns of white, middle-class, 'Western' women. Only fairly recently has it been pointed out, for example, that the production of white womanhood is achieved through the exclusion of black women. We can say Montagu is of her time. Maybe, as many do, we should ignore her when she's racist.

But marginalised peoples are a strand in this alternative history of English Literature. Montagu believes she needs them to buttress her own authority. Her message is that Ottoman society is (in many ways) superior to the Christian West, certainly not 'barbarous', but both are infinitely superior to the world of Jews and black Africans, the first untrustworthy, greedy, dangerously necessary, the latter grotesque and animal-like. In a British literary world where, simply by virtue of being a woman, she is in the position of weakness, of

being the 'other', what better way to establish her claim to speak by placing herself (a white Christian) above racialised others? A glimpse of what she was up against comes in the editor's note to the readers of the first published edition of the *Letters*. He proclaims that the work is:

> singularly worthy of the curiosity and attention of all *men of taste*, and even of all *women of fashion* [his italics]. As to those female readers, who read for improvement, and think their beauty an insipid thing, if it is not seasoned by intellectual charms, they will find in these Letters what they seek for, and will behold in their author, an ornament and model to their sex.

It's elegantly done, but the double, and by now very familiar, message is clear: women read only so that their physical attractions will be enhanced; the female author remains exceptional – an 'ornament and model' to her sex.

In the end, the slaves, if noticed at all (and it is hard to see the black child in that double portrait for he is in shadow), are either bodies to be gazed upon, perhaps even desired as in the case of the beautiful young girls, or a concept to be discussed in order to bolster Lady Mary's own authority, whether as the corrector of European misconceptions or as fount of classical knowledge.

During an exquisite picnic under fruit trees, Montagu notes casually that the music is provided by slaves. The moment provides an opportunity for reflection, not on slavery, but on the classical poet Theocritus. Her life in the East has shown her that he was far from being 'Romantic' (her word), but instead plainly recording everyday life amongst the peasants of his country. The pastoral poetry she has been immersed in since a girl is coming to life in front of her. Her battle remains with the literary men back home.

VII

Montagu's primary commitment is, above all else, to display her literary command in a world hostile to women in authority. It's a pattern that runs through this book. So many female writers have to expend so much energy defending, however elegantly, their right to write. So many female writers know that their person will be as scrutinised as their work, probably more so. All women are working in a literary world inimical to them, as women.

Montagu fights the only way she knows how. Her life was punctuated with a series of passionate friendships and equally passionate fallings-out with a roll call of eighteenth-century writers, noblemen, politicians and intellectuals. Her relationship with Alexander Pope is the most notorious, but hardly unique. He once warmly admired her. He had her portrait painted, in Turkish dress of course. Perhaps he fell in love with her. When the friendship soured, for reasons unknown although the story goes that Lady Mary laughed at his romantic advances, Pope turned on his one-time friend, writing an obscene riff on Montagu as 'furious Sappho', capable only of doing 'tricks', serving 'cocks'. Only two outcomes are possible if you engage with this writing woman: you will be 'Pox'd by her Love, or libelled by her Hate'.

The creative woman was as dangerous as the pox to men. This kind of casual, vicious sexism was something that Montagu lived with all her life. She was used to being condemned for wearing too much make-up, for being vain, unattractive, dirty. Even those who admired her found her difficult or confusing. Joseph Spence, the man who described her as shining like a comet, also called her 'the most wise, most imprudent; loveliest, disagreeablest; best natured, cruellest woman in the world'. Circulating her writing solely in manuscript did not, could not, protect Lady Mary Wortley Montagu from the attacks on female authors that echo through these chapters.

One of those attacks has a particular resonance for this book. A poet admires Montagu for two delightfully feminine qualities (her

beauty and her wit) but finds her intelligence a little bit more problematic. If Eve and mankind had paid heavily for tasting just one apple of knowledge, what price should Lady Mary pay for having 'robbed the whole tree'? Lurking not very far behind the compliment is a very real anxiety about women usurping men intellectually.

Lady Mary Wortley Montagu cannot escape from her world's, her own, understanding of what it is to be a woman, this fear of an intelligent Eve. That is why she treads carefully.

> My Letter is insensibly grown so long, I am asham'd of it. This is a very bad Symptom. Tis well if I don't degenerate in a downright story teller. It may be our Proverb that knowledge is no burden, may be true as to one's selfe, but knowing too much is very apt to make us troublesome to other people.

She understands only too well that know-it-alls are troublesome, boring even. But she understands even better that a woman with knowledge is as dangerous as Eve.

I'd like to think that this consciousness makes Montagu's one mention of Eve in the *Letters* all the more significant. It happens in those baths, where the ladies of Sofia appear 'in the state of nature, that is, in plain English, stark naked'. The women show no wantonness or immodesty, but move with majestic Grace 'which John Milton describes of our General Mother'. Milton is there, of course, but so too is Eve, our General Mother reclaimed, for a brief moment, for good.

Afterword

Pope's name-calling is ironically a welcome reminder of the other thing that remained constant in the life of this 'furious Sappho' of the eighteenth century, her writing. Dervla Murphy, in her introduction

to an edition of the *Letters*, suggests that Mary Wortley Montagu was plain and simple born too soon. Three hundred years on, she 'might have been a politician, a diplomat, an academic, a scientist, a writer (most probably the last)'. Definitely the last, to my mind, although I bet she would have done some of the other things as well. Montagu lived more lives than most. That ambivalent admirer who wrote that she was 'born with fine parts enough for twenty men' missed the point: she lived the life of twenty women.

At the heart of those lives was writing. Each and every day it seems Lady Mary put pen to paper: so many letters (and so many more destroyed), fascinating, rich, detailed, personal, full of energy; numerous poems, and even more translations; sparkling romances, serious essays, feisty journalism; some twenty-one volumes of memoirs, it was said; and a daily diary.

Yet Montagu was a writer who would inform her daughter by letter that she was writing a history of her own times, but reassure her in the same breath that 'each chapter was destroyed as soon as it was written'. She was a writer who – almost entirely – refused to participate openly in print media until the very end of her life and then took the risk of leaving the two volumes she did want as her literary legacy with a clergyman in Rotterdam. None of this makes the brilliant, frustrating Montagu any less of an author. None of this gives a reason for her neglect.

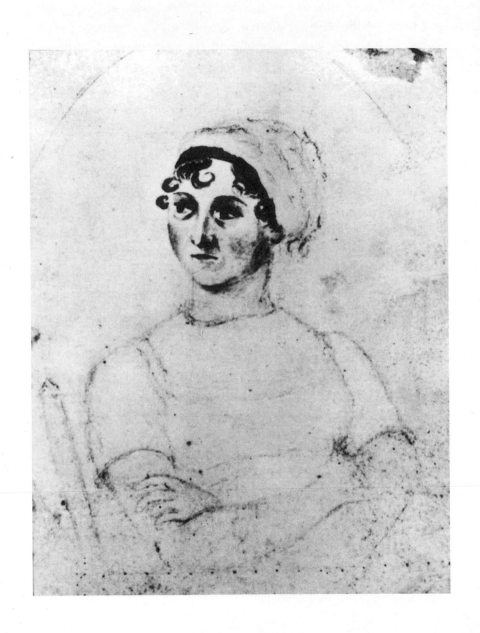

CHAPTER SIX

Jane Austen

'almost screamed'

M Y NEXT AUTHOR is hardly neglected. Jane Austen's six complete novels are now one of the foundation stones of English Literature. The six years between the publication of the first, in 1811, and the posthumous appearance of the last in 1817, are a miracle in microcosm.

Austen is vital to this alternative history not because she is neglected but because her entry into the world of print publication, the three small volumes which comprised the first edition of *Sense and Sensibility*, was so long coming. Whether the clock starts ticking on Austen's writing career with teenage, perhaps pre-teen, Jane's manuscript burlesques (created some twenty years before 1811) or with the completion of the first draft of *Sense and Sensibility* (probably fifteen years prior to the novel's publication), we are looking at a lengthy period of time, as much as two decades out of a life that would end at only forty-one. Austen's long journey to becoming a published (and briefly celebrated) author is as significant to this book's story as the content of *Sense and Sensibility* itself.

I

Go back twenty years from her first publication, to 1791, and Jane Austen was already very much a writer – a bawdy, fanciful, sometimes cruel and often funny writer. As fast as young Jane read books she spat them back out in parody, her writing encouraged and enjoyed by her supportive, literary, play-performing, riddle-writing and 'quite run over with Books' family. It may well be no coincidence that Jane most likely finished her first full-length novel around the time her father gave her a most lovely, and most portable, writing desk. Austen's 'writing-box' survives. When open, it provides a slope on which to rest paper while writing. Its various compartments include a space for an ink pot and a lockable drawer for paper and valuables. It is easy to imagine the young Jane trimming her quill pen, dipping it into her iron gall ink (grey when applied, turning darker, and now, in the Austen archive, brown with age), forming her sentences on paper bought from the local stationers and then gleefully sharing her work with her family. For whether the poetry and prose of established greats like William Cowper and Walter Scott or the burlesques of thirteen-year-old Jane, literature was shared through reading and performance, discussed in person or in letters.

Admittedly, teenage Jane did not have her brothers' formal opportunities: studying at Oxford University (at the same college as their father), taking the Grand Tour, starting up a magazine. But while James and Henry Austen presided over a few editions of *The Loiterer*, a periodical notable only for its tired misogyny, sister Jane back home was writing the longest work of her early teenage years, *Love and Freindship* [sic], a dazzling and thoroughly amoral burlesque of popular sentimental novels.

In Hampshire, Jane had books because circulating libraries supplied them – apparently there was a fierce rivalry between the Chawton Book Society and the Steventon & Manydown Society. These societies were essential given that the concept of the public library and free access to books did not yet exist and

the price of novels had tripled, even quadrupled, due to inflation, the Napoleonic Wars and publishers' greed. Above all, however, Jane had letters. If separated, family members would complete a letter every few days, accumulating 'news' and 'little events', then post it off or perhaps hang on for the chance to respond to any letter received. As Austen wrote, delightfully and delightedly, to her sister Cassandra: 'Your letter is come; it came indeed twelve lines ago, but I could not stop to acknowledge it before.' Jane's letters to, and relationship with, Cassandra were crucial to her development as an author. That the sisters were close is obvious. A somewhat unreliable anecdote has their mother saying that 'if Cassandra's head had been going to be cut off, Jane would have hers cut off too'. The correspondence offers more reliable insights, 'a continuous if unsynchronized conversation' between the two women (to quote Kathryn Sutherland, a superb editor of the letters). Readers now can *hear* Jane's voice loud and clear in these letters, but they also work as a kind of literary apprenticeship in a semi-public, rather than completely private, domain. More often than not, letters were social communications, contrived, curated, designed to be shared with other family members and, if one had an eye to it, with posterity. Austen used letters as the basis of several of her teenage fictions and even when she later abandoned this epistolary form, she remained fascinated by them, making the practicalities and receipt of letters central to her novels.

Austen clearly writes her early work to be shared with family and friends. Yet even in this relaxed coterie, teenage Jane curates, revises and, it seems, self-censors, always with a satiric awareness of the mechanics of the literary world. She writes, for example, thirteen mock-dedicatory prefaces to her *Volume the First*, still more in the succeeding two volumes, her tongue-in-check 'collected works'. That's two more than Aemilia Lanyer. Austen was well aware, and early, of literature as an industry like any other, and specifically she was conscious of the fraught status of the novel within that industry.

When one Mrs Martin was setting up a new subscription library, due to open on 14 January 1798, and looking for subscribers, Austen writes that as:

> an inducement to subscribe, Mrs. Martin tells me that her Collection is not to consist only of Novels, but of every kind of literature, &c. &c. She might have spared this pretension of our family, who are great Novel readers and not ashamed of being so; but it was necessary, I suppose, to the self-consequence of half her Subscribers.

Austen understood that her taste for novels (whether reading them or writing them) was a dubious one in the eyes of those concerned with their own 'self-consequence'. She also recognised that novels were perceived as 'women's work', for in precisely the years in which she came of age as a writer, female authors were making the genre their own. Austen herself mentions nine male as opposed to twenty-one female writers in her own letters. Men most certainly read novels (as Henry Tilney admits in *Northanger Abbey*) but a very familiar gender divide remained in operation: women read women, men read men. Novelists such as Ann Radcliffe, Fanny Burney, Maria Edgeworth, Jane West and Hannah More – some offering titillating romances or gothic page-turners, others offering wholesome moral tales of domestic virtue – created and fed a new market for fiction. All, and more, found their way into Austen family life, enjoyed not just by Jane but by those around her. Her letters, throughout her life, are filled with moments in which books are shared with others: some acquaintances, sometimes out of necessity as when Austen's 'own darling child' (her first copy of *Pride and Prejudice*) arrived from London: 'Miss B. dined with us on the very day of the book's coming, and in the evening we fairly set at it, and read half the first vol. to her.' Other shared readings were more intimate. Writing to her niece, an aspiring novelist, Jane wrote that she had read Anna's chapters 'to your Aunt Cassandra, however, in our own room at night, while we undressed, and with a great deal of pleasure.'

The novel offered a new literary space for women. It was forged from genres which were already characterised as feminine, female, womanly: prose romances, letters, letter-books, epistolary narratives, confessional tales written in the first person. One might think this would be a cause for celebration but, sadly and predictably, female success led not to applause but to the novel becoming devalued as a literary form. Commentators lined up to dismiss it as a feminine genre, what George Eliot (using her male nom de plume) would later call Silly Novels by Lady Novelists. Eliot wrote her attack-essay in the hostile climate of the 1850s, attempting to create a space for 'serious' fiction by women, but the easing of women out of the new literary arena, or the corralling of the female novelist into a space marked 'trash', began in Austen's lifetime. Even the bestselling Fanny Burney, phenomenally successful, almost untouchable in the final quarter of the eighteenth century, was in trouble in the first decades of the nineteenth. The subject matter of her ambitious political novel, *The Wanderer, or, Female Difficulties* was deemed inappropriate for a woman, Burney herself too old – lacking 'vivacity' and 'bloom'.

The novel, as the go-to genre for female authors, was therefore both obvious choice and poisoned chalice for young Jane Austen and it was in this landscape of belief that she began her long journey from being a semi-private writer to a published novelist. The obstacles in her path, some familiar from previous chapters, some new, were many and various, although when two or three Janeites are gathered together, polite arguments arise as to their precise nature and whether they might actually have been opportunities in disguise.

II

Let's go back to the winter of 1795, and assume as did her family that Jane Austen's first full-length novel is safely drafted. Enter Tom Lefroy, visiting a neighbouring rectory, and delighting Jane, celebrating her

twentieth birthday on 16 December. Despite evidence that the two young people are strongly attracted to each other, despite a letter suggesting that Jane has great hopes of Tom, there is no engagement, let alone marriage. Money is the problem. It usually is, in Austen's world.

For some, including one of her best biographers Claire Tomalin, this was a crucial turning point in Austen's life: 'it was not Tom Lefroy, or anyone like him, who became her adventure, but the manuscript upstairs. Not marriage, but art.' But, for Tomalin, this is not without regret. Austen would have exchanged her future as a novelist for being married to Tom Lefroy 'living in an unknown Ireland, with a large family of children to bring up'.

Regret (whether turning to bitterness or creativity or both) is one enduring way of seeing Jane Austen's life, as she sublimates her natural desire for a husband and family and puts her energies into her writing. Some takes on this would be laughable if the ideas underpinning them were not so enduring. Apparently, the ironic ending to *Northanger Abbey* was written by a woman 'on the brink of destruction, in her early twenties, as a result of loneliness, of sexual longing'. The novel shows her 'asking the old question: Where is the man for me?' – John Halperin writing in 1984. Others flip the coin, viewing Austen as having a narrow escape from the literary and legal oblivion of marriage. Add to the mix the one proposal of marriage we know Austen received, from Harris Bigg-Wither in early December 1802. Jane accepted, slept on it, then withdrew her acceptance. More often than not, commentators express some limited sadness that Jane chose to remain single and miss out on the joys of married life, alleviated by relief that by refusing Bigg-Wither, the world gained her novels. Given the actual timing of the proposal/refusal, the episode does not seem to have so much significance: it would be a further eight years before one of Austen's novels would reach the world.

Somewhere between these two is the possibility that if Austen had married, or if her financial situation had improved in some way, her writing might have remained for ever within a semi-private setting, as appropriate to a lady with private income, whether married or no;

another Montagu, if less exalted socially. Even that compromise scenario is tested by a letter written by Jane's clergyman father, George, on 1 November 1797, offering the publishers Cadell & Davies 'a manuscript novel, comprised in three vols about the size of Miss Burney's *Evelina*'. Mr Austen asks about the 'expense of publishing it at the author's risk' but also floats the idea that Cadell & Davies might advance something 'for the property of it, if, on a perusal, it is approved of?'

Mr Austen was probably offering the first version of *Pride and Prejudice*, originally entitled *First Impressions*, which Jane had written over the course of the previous year. The publishers 'declined by Return of Post', failing to answer Mr Austen's query about the cost of what we might call self-publication, ignoring his hints about an advance, and refusing even to read the manuscript. More fool them.

The novel's existence at the end of 1797 and George Austen's attempt to sell it argues that the Tom Lefroy episode did not stop Jane Austen from writing. Nor did it stop her family supporting her ambitions to be a print author. Quite the opposite it seems.

But did the rejection of her Burney-esque novel in 1797 do so? Again, it seems not. Austen continued to carry her writing desk with her wherever life took her. While travelling through Dartford in 1798 she almost lost it, and her savings of seven pounds, when it was accidentally placed in a horse-drawn chaise heading for Dover. When, three years on, George Austen decided to leave the Hampshire village of Steventon and move to Bath, Austen's life became one of constant moving, with many seeing her as unsettled by the experience. Yet still she wrote. More than that, in 1803, she successfully sold a novel, *Susan*, to a publisher, receiving the copyright payment – ten whole pounds – her father had been angling for in 1797. (As with the earlier unsuccessful attempt to sell *First Impressions*, the business was conducted by Jane's male relatives or their representatives.) It was a hollow triumph because Crosby, the publisher, took no steps to publish *Susan*. No matter: Austen began a new novel at the start of 1804. She had just turned twenty-eight in December.

By her next birthday, she had abandoned the work. Jane Austen hung on to the opening chapters to her death but never wrote them out as a fair copy. This was the moment the music could have died. What do the chapters (published long after Austen's death as *The Watsons*) tell us, and why did she put them aside?

If you read them, you might be surprised by their bleakness. The world in which Emma Watson, Austen's watchful, dependent heroine, moves is not terrible, no one is hungry, suicidal or homeless. But it is packed full of bitchy, disappointed and snobbish women living utterly boring lives.

The sheer bitterness of the opening chapters makes it very hard to see how Austen could have engineered the necessary 'romantic' ending of couples united in wedded bliss. Men are presented as so utterly useless, the institution of marriage so utterly bankrupt, that to present either as the goal or reward for a young woman would seem absurd. Austen doesn't even bother to offer more than the haziest glimpse of a male love interest. Instead, all her writerly energies are invested in showing the constriction of Emma Watson's life and (looking on the bright side) the consolation of the companionship of a sister, Elizabeth.

It is almost too easy to map these fictional sisters onto Jane and Cassandra Austen. In a letter written some years later, Austen evokes the claustrophobia of everyday life, the banal social encounters, the dutiful visits, the departure of servants, the arrival of illness. It is escaped in two ways, both mentioned only in passing and with irony. One is the success of 'S & S': *Sense and Sensibility* has reached Ireland. The other is Cassandra: she and Jane are rather gloriously 'the formidables'.

In 1804, Austen allows her impoverished heroine a superb (formidable?) one-liner, adding it in one of her 'patches' or edits. Emma Watson is speaking to the arrogant, detached and wealthy Lord Osborne who has no idea what it is to have little money: 'Female Economy will do a great deal my Lord, but it cannot turn a small income into a large one.'[1] Lord Osborne's response is as significant

as Emma Watson's statement. Emma's 'manner had been neither Sententious nor sarcastic, but there was a something in its mild seriousness, as well as in the words themselves which made his Lordship think'.

Is this exchange just one of the many moments when Austen uses her modest and submissive heroines to challenge patriarchal values? I am not so sure. For all the satire of the marriage market, for all the suggestions – more than suggestions – that women (of a certain class) are trapped by the legal, economic and social structures of their time, Austen nevertheless offers no critique of those structures. Her solution, at least in 1804, is for good women to educate men. Emma Watson's 'mild seriousness' shorn of sententiousness and sarcasm does make Lord Osborne think.

This may be strategic. Perhaps, to reach male readers, Austen has to dial down her judgements on society. Or perhaps driven or conditioned by her political conservatism and her Anglican faith, she is suggesting Emma's kind of approach as the appropriate use of feminine power. The questions remain: can Emma Watson as a character, can she, Jane Austen, as a novelist, morally educate their men? Austen's sense that the answer might be 'no' may lie behind her decision to leave Emma Watson's story unfinished.

I believe but of course cannot prove that Austen knows that what she has written is plain and simple too bleak, her delineation of female dependency too stark. This is a Cinderella story without the prospect of a ball, let alone a prince. Austen knows or believes at this stage in her life that to get published, she needed that romantic plot. *The Watsons* may well be not the tragic victim of patriarchal oppression but rather Austen's dirty little secret, the kind of dispiriting satire that she may have *wanted* to write, but which was incompatible with a more powerful desire: to be a print author. Her next step, when she made a fair copy of one of her most substantial teenage works, the epistolary novella *Lady Susan*, was possibly a fresh attempt at publication, although just as likely to have been motivated by a desire to entertain her family circle. But then, just as her father's unexpected

death in January 1805 left Jane, her sister and her mother completely dependent on the goodwill of their male relatives and more in need than ever of both money and entertainment, Austen was unable to press on. She finally gave up on novel writing.

For the next four years, letters were Austen's only writerly output. Then another turn in the path. One of Austen's brothers, Edward Knight (adopted as a boy by wealthy, childless relatives and duly taking their name) gave Jane, Cassandra and their mother, together with a family friend, Martha Lloyd, a substantial cottage close to one of his manor houses to live in. The years of wandering were over. Jane Austen, at thirty-four, had a home: Chawton.

The house is now something of a pilgrimage site, so connected has it become with Austen's emergence as an author. At Chawton Cottage, she is pictured beyond the quest for a husband, perhaps breathing a sigh of relief at not having to engage in the exhausting and dangerous business of having children. At Chawton, so the story goes, the years of silence ended.

But even before the move, Austen the novelist was stirring. She wrote to the publishers who had bought *Susan* (using the pseudonym of Mrs Ashton Dennis, it has been suggested only for the pleasure of being able to use the initials MAD), saying that she wanted the manuscript back: 'Six years have since passed, & this work of which I avow myself the Authoress, has never to the best of my knowledge appeared in print'. They wrote back to say: pay us what we paid you. Austen dropped *Susan* for the moment, and picked up an epistolary novel, *Elinor and Marianne*, that she had first written some ten years earlier. She revised her prose (no more letters) and revised her approach to publishers.

Back in 1797, George Austen had asked Cadell & Davies how much it would cost him to get his (or rather his daughter's) manuscript published and received no reply. In 1810, Jane Austen asked the same question of the publishers Thomas Egerton and got an answer: £50. That money, to be paid by the author, would cover the book's production and distribution. Any profits would come to the author,

minus a commission taken by the publisher, but so too would any losses. *Sense and Sensibility* was on its way.

It has been calculated that the actual risk for Austen was no more than £30. She had an annual dress allowance of £21 – eighteen months without new clothes would have done it. A further calculation shows that Austen would have broken even once 419 copies were bought, even allowing for Egerton's commission. The somewhat heartbreaking conclusion is that, if Austen had known earlier that even at worst her losses were likely to be manageable, she might have published sooner, perhaps when she inherited £50 in 1807. But so it goes.

In 1810, probably with the support of brother Henry, whether he provided the cash or acted as guarantor, Austen made the deal with Egerton. Through the following spring and summer, *Sense and Sensibility* was always on her mind, as she wrote to Cassandra: 'I am never too busy to think of S&S. I can no more forget it, than a mother can forget her sucking child'.

III

At last, on 30 October 1811, Austen's 'child' appeared to the world. Its mother was not named: *Sense and Sensibility* was 'By a Lady'.

'A Lady' because – as Austen's family reassure us – Aunt Jane did not write for 'fame'. Every chapter of this book has revealed that authorship in and of itself risked accusations of improper femininity, with publication figured as a form of sex work. Now, in the increasingly commercial marketplace of the early nineteenth century, female authors exposed their work, sold themselves, to *anyone* who had money to buy. The main publisher of fashionable fiction, notably silver-fork novels which offered middle-class readers tantalising fictional forays into English high society, Henry Colburn, did well out of his authors between 1810 and 1830. Benjamin Disraeli,

one of those authors, described his publisher as a brothel madam ('Mother Colburn') and referred to himself as a literary prostitute. But somehow this kind of thing doesn't hurt men quite as much. After all, Disraeli still managed to become Prime Minister. All those old, familiar arguments about notoriety and ill fame continued to have currency and therefore many a woman – including Jane Austen – chose to publish anonymously, happy to draw attention to her sex and class, but unhappy to have her private identity known.

Two other words on the title page of *Sense and Sensibility* compromise, however, the gentility and propriety of 'By a Lady'. Readers are offered – 'A Novel'.

It is very hard today to see this is as a bold statement but even Austen's most successful female contemporaries, authors like Maria Edgeworth and Fanny Burney, were reluctant to call their prose fiction novels, rebranding their work as moral tales and memoirs, such was the hostility towards them as female novelists and towards the female readers who enjoyed their work. As ever, the fear of unregulated emotion lies at the heart of many a denunciation. Samuel Taylor Coleridge deplored the mass consumption of novels and their 'mawkish sensibility'. Coleridge's friend and fellow Romantic, William Wordsworth, condemned the 'degrading thirst after outrageous stimulation' to which novels catered. Both men understand the novel as a source of a dangerous contagion of emotion to which women are innately more vulnerable than rational men, exciting the female imagination in inappropriate ways. For these reasons and more, conduct books and other guides to virtuous female behaviour advised young women against reading fiction. The experience might give a 'romantic turn to the mind, which is often productive of great errors in judgement'.

Underlying all this was another powerful and enduring demand made upon women, to modify their own behaviour to control the behaviour of men. Girls, insisted the conduct books, should be restrained and modest. If they were not, they were laying themselves open to seduction, or as we might say, asking for it. Novels,

in contrast, were often built precisely around young women making those errors of (usually erotic) judgement. The go-to plot of Austen's predecessors and contemporaries has a naive, young, under-protected and over-emotional girl in her mid-late teens becoming easy prey for an attractive, often socially superior, libertine man, prey being the key word. For, from around 1740, and thanks in no small measure to the influence of the novelist Sir Walter Scott, sex becomes something that happens *to* a woman whether she is seduced, abandoned and ruined or stands firm and maintains her chastity.

Now, in 1811, despite the stigma attached to novel writing ('a lady would as soon go in for rope-dancing'); despite the warnings against novel reading; and despite her culture's grave questions about the advisability of fiction itself, Jane Austen, daughter of a clergyman, presents A Novel to the world, and that novel will concern itself precisely with those crucial, dangerous late-teen girl years.

Being Jane Austen, her engagement with the 'woman's novel' is witty, entertaining and ground-breaking. After all, this is an author who had been writing burlesques since her early teens and whose novel *Susan* (in its revised version, *Northanger Abbey*) celebrated a distinctly unconventional heroine. Catherine Morland, as she would become, has 'a thin awkward figure, a sallow skin without colour, dark lank hair, and strong features'. She is 'fond of all boys' plays, and greatly preferred cricket' to dolls and dormice. Not just cricket: baseball as well. She even dislikes formal schooling. There's more, because this is still young, exuberant Austen, on a literary roll, just as Susan/Catherine cannot resist rolling down the green slope at the back of the house, nor can Austen resist playing with her genres.

But Austen does not offer an outright rejection of market-leading romantic novels. Instead she responds to and transforms her chosen mode. She casts as much shade on the ideas of proto-feminists as she does on the sentimental hyperbole of most genre fiction. Here is a woman taking on, in the best sense, other women. Here is a woman taking on, in the best sense, a genre which has been deemed 'feminine'.

Is this, then, Austen doing something similar to the Christian evangelical Hannah More, a woman who viewed novels as 'agents of voluptuousness', productive of dangerous fantasies – but then went on to write one anyway? Was Austen harnessing the novel to her own conservative, Anglican values, drawing on the moral, didactic template offered by writers such as More? Certainly the feminine values of prudence, modesty, continence, seriousness and restraint are the values that she extols. Her good girl-women enter society and learn from their mistakes. Her bad girl-women enter society and fall. Austen rewards self-controlled rationality in young women with (happy, we hope) marriage. She punishes selfishness and stupidity in young women who lack emotional discipline with (unhappy, we are told) marriage – or worse. The unwise Lydia Bennets and Maria Bertrams of this world fall. Austen's heroines do not. They learn.

Those contemporaries who noted her work duly admired it precisely because it did *not* incite her readers to 'indulge in feelings, that might tend to render us ill natured, and intolerant in society'. An anonymous commentator, writing in *The British Critic* in 1818, went on to praise Austen herself, whose good sense has 'complete possession over all the other qualities of the mind'. Even 'her want of imagination (which is the principal defect of her writings)' becomes a virtue because it means Austen steers clear of 'all exaggeration'. The alternative – indulging in feeling and the ensuing social disorder – is a far worse prospect than a little dullness.

Admiration was hardly the response to Lady Caroline Lamb's novel *Glenarvon*, her retelling of her disastrous relationship with Lord Byron, revenge fiction in its purest form. When Byron read the book he wrote:

> From furious Sappho scarce a milder fate
> Pox'd by her lover – or libelled by her hate.

If this sounds familiar, it is. These are words with which Alexander Pope attacked Lady Mary Wortley Montagu. Boys will be boys. Byron

had been informed of Lamb's novel by the French author Madame de Staël and wrote, in fury, to his publisher John Murray – Austen's own publisher from 1815. 'A rogue of course', Austen wrote of Murray, while refusing Madame's invitation to meet. In this world, but not of it, it is impossible to imagine Austen writing a letter such as the one to John Murray from Byron. He comments that Lamb, 'the little vicious author', has taken the man's trick of 'kiss and tell' and raised the game to '[fuck] and *publish*'. (The f-word is implied by a dash.) How dare she?

This literary spat reveals, amongst other things, that women, even elite women, could and did publish salacious books. Austen chose not to. She had every reason, as a woman and a novelist, to endorse rationality and restraint, sense over sensibility, and she was rewarded for it. From 1811 on, she would be lauded as a properly feminine writer working for the good of society, producing safely domestic fiction which celebrates civility and self-control – lies and repression by any other name.

IV

And that is precisely the fault line that draws readers back to Jane Austen, over and again. Although there's no doubt in my mind that in 1811 she endorses sense over sensibility, Austen also offers her reader an anatomy of women's repression in all its myriad forms that still has the power to make us question that endorsement.

Austen's language incites us, at many different levels, to probe the apparent moral certainties of her work. Sometimes it happens with a single word. Take a phrase from *Mansfield Park*, the novel Austen started work on while seeing *Sense and Sensibility* through the press. Maria Bertram is expecting a marriage proposal from Henry Crawford but does not receive one. Maria is devastated but has only moments 'to *bury* the tumult of her feelings' before being joined by others (my emphasis).

Austen's heroines have to learn, or have learned, to control, to 'bury' emotion appropriately, and not only in company. Simple silence is not enough. They must learn to speak appropriately. Even Austen's most virtuous and least vivacious heroine, Fanny Price of *Mansfield Park*, a young woman who does not have to learn the hard lessons that Austen makes the headstrong Marianne learn in *Sense and Sensibility*, has to work at this. Contemplating the prospective marriage of the man she loves to the dazzling Mary Crawford, Fanny knows that it 'was a subject which she must learn to speak of, and the weakness that shrunk from it would soon be quite unpardonable'. It is 'quite unpardonable', a sign of 'weakness', to allow her heartbreak to appear. In *Sense and Sensibility* it is a sign of Marianne's new *strength*, her recovery from illness, and her social rehabilitation after (almost) being seduced by Willoughby that at the end of the novel she can claim: 'I *can* talk of it now, I hope, as I ought to do.'

Austen appears adamant that the suppression of emotion (together with its close cousin imagination) is a necessary condition of polite society, but when she spells out what this means in practice, in some justly famous lines from *Sense and Sensibility*, suddenly things seem less certain.

> Marianne was silent; it was impossible for her to say what she did not feel, however trivial the occasion; and upon Elinor therefore the whole task of telling lies when politeness required it, always fell.

Lies? Yes, talking as one 'ought to do' means telling lies.

That word hints at Austen's own struggle with propriety, spoken and written. In a letter, she expresses her desire for 'a few days quiet, & exemption from the Thought & contrivances which any sort of company gives'. Solitude is respite from the demands of 'company'. It was an impossible dream for a woman in Austen's position. She could not work alone. In a sense, of course, no author can, despite the enduring myth of the solitary genius, but Austen more than most needed her father and brothers to support and represent her

professionally; was dependent on her wider family for a home; used her nephews and nieces and, above all, her sister as literary sounding boards. Austen could not live alone, could not absent herself for long from the domestic duties of family life. She saw the toll that these duties took on women, on the mind as much as the body:

> I often wonder how *you* can find time for what you do, in addition to the care of the House; – And how good Mrs West cd have written such Books & collected so many hard words, with all her family cares, is still more a matter of astonishment! Composition seems to me Impossible, with a head full of Joints of Mutton & doses of rhubarb.[2]

There's irony here, of course, because there always is; a slight dig at Jane West (and her 'hard words'); and exaggeration – Austen *did* find it possible to compose despite her household responsibilities, but the truth was that she was all too often in company and sometimes with people whom she could barely tolerate. Her prayers reminded Austen not to 'discomfort' her fellow creatures, not to give 'pain to any human being': how easy it would be to do, how dangerous, how wrong. But her prayers do not ask for forgiveness for the writing of novels.

The suspect status of the sentimental novel, the precarious position of the female author, her own dependent position as an unmarried woman: all three served to ensure that Austen would hardly walk a revolutionary path as a writer. But what she does is take us to the cliff-edge of emotion only to pull back. When Marianne reads a message from Willoughby she 'almost choked', then 'almost screamed'. In a parallel episode, of overwhelming delight this time, when Elinor discovers that Edward is potentially available, she 'almost ran out of the room'. So many almosts. These are women coming close to expressions of emotion, but stopping themselves – at least in company. For 'as soon as the door was closed', Elinor 'burst into tears of joy'. It is Austen's world of public repression and private emotion in action.

One last 'almost': Marianne acknowledges that her 'want of fortitude' in the face of her 'feelings' had 'almost led' her to her grave. But Austen allows Marianne to live, taking her investigation of her novel's title far beyond any simplistic equation: 'sense = good, sensibility = bad, job done'. Marianne's survival is telling. Most conservative moralists and novelists would have killed Marianne off, having made clear that Willoughby had his wicked way with her. Austen does things differently.

First, she displaces the fate that should have been Marianne's onto two other women: a mother (now dead) and daughter (still living but shunned by society) both called Eliza, both seduced in those crucial mid-teens, both fallen women, and both not fully present in the novel, their stories told by the men who loved or seduced them.

Instead of killing Marianne off or banishing her to a life of lonely regret in the provinces, Austen provides her heroine with a sentimental education. Seventeen at the start of the novel, the narrator pronounces at its end that Marianne 'found herself at nineteen, submitting to new attachments, entering on new duties, placed in a new home, a wife, the mistress of a family, the patroness of a village'. It is all remarkably passive: 'found herself', 'submitting', 'placed'.

Teenage Marianne's sentimental education is speedy, final and, for some, thoroughly troubling. But Austen is walking a tightrope here, needing somehow to have a passionate heroine who is not (too) punished for her emotion whilst ensuring that there is a clear distance between Marianne and the two Elizas. To that end, Austen constructs a novel which is surprisingly vague about, and even more surprisingly uncritical of, Marianne's 'errors of judgement'. Her entirely inappropriate trip to Willoughby's house, Allenham, occurs offstage. We are left to imagine what two young people profoundly attracted to each other might do in a carriage ride, let alone having the run of a beautiful house without a chaperone. We are not allowed to see Marianne sin.

At the same time, Austen refuses to take the reader into Marianne's inner life, perhaps because the contagion of her emotion might affect

the reader too powerfully. Instead, we are given free entrance to her wiser sister's mind, one that can look suspiciously like that of her author. In public Elinor is all self-control, civility and lies. In private, that is, in the private world of the novel we are reading, we see her often frustrated with and occasionally disgusted by stupid women.

One of my favourite moments in the novel is when Lady Middleton, not the brightest of women, casts judgement on Elinor. She reads a lot and is therefore judged to be 'satirical; perhaps without exactly knowing what it was to be satirical; but that did not signify. It was censure in common use, and easily given'. The only difference is that Elinor has to bite her tongue, while the narrator can indulge in satirical evisceration. I can't help feeling that these are the moments that Jane Austen, author, lives for.

V

Austen's primary satiric target in *Sense and Sensibility* is, uncomfortably for a romantic fiction, marriage. She is as clear-sighted as to the socio-economic basis of the institution as Lady Mary Wortley Montagu had been almost a hundred years earlier, when she wrote of marriage as the buying and selling of women in 'all our Christian great Cities'.

Most obviously, women have a market price. John Dashwood, repellent though he is, knows full well that Marianne's has dropped because of her serious illness. She will now be lucky to marry a man 'worth more than five or six hundred a-year'. The entire plot of *Sense and Sensibility* is predicated on the grim fact that Mrs Dashwood has only £500 a year with which to bring up and – worse still – dower her *three* daughters. Austen the satirist shows, in practice, how economic life favours men, most famously perhaps in the plot of *Pride and Prejudice* where Elizabeth Bennet (and her sisters) must marry because the family's money has been entailed to a man. Austen's

women as much as her men are invested in this gendered economy, propping it up, competing within it, attracted by its potential rewards. When Willoughby seduces Marianne with talk of spending two hundred pounds to redecorate one room in his Allenham, that is nearly half her own family's yearly income. Every character in *Sense and Sensibility*, including the narrator, is absorbed by money. Every calculation is gone into and Austen was disturbed to find that she had made an error in the first edition. Revising the novel, she changed the phrase 'division of the estate' to 'the succession to the Norland estate' having found that it was not customary to provide for daughters through 'division', double-checking the figures to reassure herself that the 'incomes' could 'remain as they were'.

Austen puts into Marianne's mouth the reason that money matters, when the seventeen-year-old offers up a brutal takedown of marriages of 'convenience', in which women 'submit' to wifedom to buy themselves security.

> 'A woman of seven and twenty', said Marianne, after pausing a moment, 'can never hope to feel or inspire affection again, and if her home be uncomfortable, or her fortune small, I can suppose that she might bring herself to submit to the offices of a nurse, for the sake of the provision and security of a wife.'

This is 'a compact of convenience, and the world would be satisfied'. Austen is mocking Marianne's perception of age (a woman of twenty-seven has one foot in the grave) while the novel as a whole will prove her teenage desire for something more than this submission to be futile, ill-advised, and possibly even dangerous in the sexual economy of Regency England. At the same time, Marianne's acuity about the transactional nature of marriage is hardly disproved by Austen's fiction.

Neither marriage as an institution, nor men as husbands, are particularly enticing. But, as Elinor and the narrator both seem to accept, that is just how things are. Take Mr Palmer. He's not *that* bad,

just another man who has woken up too late to the fact that he is the husband of a 'very silly woman'. He is redeemed by being 'perfectly the gentleman' in his own family, which means being only occasionally rude to his stupid wife and mother-in-law. As the narrator points out, he is what he is, with 'no traits at all unusual in his sex and time of life'. In other words, a (gentle)man husband is tolerable even if he is selfish, lazy, intolerant and rude. And yet, despite all this clear-sightedness, Austen nevertheless has the audacity to offer us weddings as her happy ending to *Sense and Sensibility*.

Do we swallow it? With difficulty, primarily because Austen almost demands that we read sceptically, by drawing explicit attention to the fictional contrivance of her novel's final pages. Austen closes *Sense and Sensibility* with a particularly far-fetched reversal (Lucy Steele marrying Robert Ferrars), but it is a reversal necessary to achieve Elinor's happy ending. She does something even more outrageous in *Northanger Abbey*. Eleanor Tilney is the dependent daughter of a bullying father, who knows 'evils' and 'habitual suffering'. Austen, waving her magic wand as she had done for her other Elinor, saves Miss Tilney from this dismal life by providing her with a husband. And not just any husband, a viscount complete with an 'unexpected accession to title and fortune'. Unexpected? Absolutely, to both the characters and the reader.

The very abruptness of these moments merely draws attention to their status as fiction, as manufactured. Austen is showing us her workings. She is reminding us that, however much we might sympathise and engage with the characters, we are reading a novel, a work of imagination.

Why?

One answer is to see Austen gently pulling us back from the abyss of mapping fiction too closely onto life, and not so gently reminding us of society's values and its ability to enforce them. (There's a rather delicious irony in Austen's use of imaginative fiction to warn against, well, imaginative fiction – an irony that the novelist in my next chapter is also only too well aware of.) There might be

an even tougher message for Austen's readers. She is giving us what we want, those happy endings, those husbands, but insists on these being fantasies rather than real-life solutions to the problems of the dependent woman.

In doing so, *Sense and Sensibility* reveals some of the transactions going on when women read fiction. The two potentially contradictory elements in Austen's fiction – her clear-sighted socio-economic realism and her plots which verge on the fairy tale – are in fact symbiotic. The financial reality of (most) women fuels the desire for fantasy. What Austen shows is that these compensatory fantasies can be thoroughly dangerous for young women even when they do not exist in a romance world of castles, mountains and violent libertine men. The less extravagant fantasies of Austen's very young heroines are still enough to make them vulnerable to sexual predators, although in Austen's world of domestic realism, predation takes more mundane forms.

This is one of the reasons Austen is so concerned with right reading, teaching us, her readers, just how to discern truth from lies, even the necessary lies of 'company'. We have to work out the truth, reading through, past, her trademark, all-pervasive irony. So too Austen's equally well-known free indirect discourse which challenges the reader to work out just how much is a given character's perspective, and how much is the authorial, narrative judgement or summary. Both force the reader to discriminate between two kinds of truth.

Take one of the most well-known opening lines in literature: 'It is a truth universally acknowledged, that a single man in possession of a good fortune, must be in want of a wife.' Opening *Pride and Prejudice* in this way, Austen challenges us to consider whether this is indeed 'truth'. It is, of course, *not* a universal truth, on all sorts of levels, but as a social belief it has a power all of its own, and a currency in Longbourn that will determine the lives of the Bennet sisters. The beauty of irony is that it asks us to consider two 'truths', to understand the validity of them both. It is not a matter of discarding

one interpretation but accepting that – very often – society works by upholding ideas that are touted as truths but are in fact mere social fictions.

Austen sets out our task as interpreters in the earlier *Sense and Sensibility*, using Elinor's voice, here very much aligned (over-aligned for some) with the narrator:

> 'I have frequently detected myself in such kind of mistakes,' said Elinor, 'in a total misapprehension of character in some point or other: fancying people so much more gay or grave, or ingenious or stupid than they really are, and I can hardly tell why or in what the deception originated. Sometimes one is guided by what they say of themselves, and very frequently by what other people say of them, without giving oneself time to deliberate and judge.'

That's the theory anyway. Later in the book, Austen shows theory (quiet deliberation and judgement) coming up against experience. Willoughby, having heard Marianne is near death, arrives in the middle of the night and tells his story to Elinor. He reveals his selective amnesia and his casual hope that his rich wife will die and leave him 'at liberty'. He blames the vulnerable fifteen-year-old Eliza for his impregnation of her – it was the 'violence of her passions, the weakness of her understanding'. And he claims that it is only Marianne's superior mind that means she escaped the same fate, in a chilling echo of Behn's hint that clever women don't get raped. Yet Austen has Elinor feel compassion for him, prompted in no small part by the thoroughly Romantic nature of their encounter.

If even Elinor is deceived at this moment, then Marianne's susceptibility to Willoughby becomes more understandable. But Austen makes clear that Marianne's mistakes are to an extent due to the way in which she consumes literature. She is a responsive, sympathetic, emotional reader who maps fiction onto reality. She actively wants her life to conform to the novels she reads, with Willoughby compared to 'what her fancy had ever drawn for the hero of a favourite

story'. The irony, lost on Marianne, is that she is setting herself up to be the fallen woman of these very novels.

Another early Austen heroine escapes more lightly than Marianne. Catherine Morland was, from fifteen to seventeen, 'in training for a heroine'. Naive, happy-go-lucky, somewhat stolid Catherine has not got the judgement to understand the difference between fiction and real life but she escapes punishment, in part because she is happy to be educated by her future husband, Henry Tilney. But the message remains clear. Austen gives with one hand, offering the compensation of romantic fulfilment in the face of women's actual impotence and inequality, but she takes with the other, insisting that romantic fulfilment can only be achieved within fiction, through fiction, and by knowing it as fiction.

There is, however, one last twist in the tale of *Sense and Sensibility*. Here's the final, long sentence:

> Between Barton and Delaford, there was that constant communication which strong family affection would naturally dictate; and among the merits and the happiness of Elinor and Marianne, let it not be ranked as the least considerable, that though sisters, and living almost within sight of each other, they could live without disagreement between themselves, or producing coolness between their husbands.

Marriage is celebrated not in terms of the loving relationship between man and woman, but the closeness of sister and sister. It's a solution to the problem created by the opening chapters of *The Watsons*. There was no way, even with a narratorial magic wand, even with the addition of lashings of irony, that Austen could see her way to a happy heterosexual ending to a book that begins in the way *The Watsons* does. But in *Sense and Sensibility* the relationship that truly ends the book, and that is (with only very gentle irony) celebrated, is that of the two sisters, Elinor and Marianne. Their husbands fade into the background. Austen has offered us her true happy-ever-after.

VI

In the end, you must choose your Jane Austen.

Did she, with her conservative political and religious views, believe that she needed to save the (silly lady) novelists from themselves, and reform the genre from within? If so, is her irony then a way of underscoring those views or, more problematically, an unconscious reveal of her problems with them? More harshly, is Austen a self-policing woman who takes it upon herself to police other women – even as she allows us a passing regret (in these early novels) for the social pressures which change Catherine Morland from a tomboy to the pliant wife of the admittedly adorable, but equally admittedly patronising, Henry Tilney, or the taming of Marianne? Or, more to our liking these days, is Austen's propriety tactical, with her irony the red flag hinting at a more subversive agenda and a signal that she knows full well that this is the only way 'A Lady' could be published?

The long gap between the manuscript juvenilia and *Sense and Sensibility*, between Jane Austen in 1793 and A Lady in 1811, offers some clues.

The teenage Jane makes political jokes about anal sex and circulates them in manuscript within her family circle, gaining both praise and laughter. The mature Austen writing *Mansfield Park* condemns her anti-heroine Mary Crawford for doing the same (her crude pun on 'rears and vices') and reveals the moral dangers of putting on a play (Elizabeth Inchbald's *Lovers' Vows*) when family theatricals had been a thoroughly enjoyable part of Jane's own youth at Steventon.

What happened?

That question is answered by some in one word: 'print'. Austen transitioned from coterie manuscript circulation, with her work read only by an immediate community of readers, to print author, engaged with the very public territory of publishing – and its proprieties. That Austen took decades to make the move suggests to some that she found it challenging, even unpleasant. Why leave the comfortable world of her quill pen and manuscript on her father's gift desk and

accommodate her art to commerce? It is a favoured trope of those privileged enough *not* to have to consider the market. In the previous century, Lady Mary Wortley Montagu had been quite certain of the negative impact of print publication on the writing of her friend, Sarah (Sally) Fielding. She regretted Fielding's descent into the mire of 'sale work', a woman 'constrain'd by her Circumstances to seek her bread by a method I do not doubt she despises'.

The only thing is, we don't have any proof that Austen was forced to change her novels to make them 'sale work'. *First Impressions* and *Susan* had both been rejected, though in different ways, but that pushed Austen into changing the way she dealt with publishers, rather than changing the way she wrote. She sought publication and continued to seek publication despite setbacks, suggesting strongly that she did not *want* to remain solely in the sphere of private, domestic circulation – the letters or riddles or burlesques of her social and familial circle.

Austen's awareness that what might be acceptable as a family joke would not be acceptable in a published novel 'By a Lady', her ditching of anarchic wit, is for some a taming and to be regretted. Jane Austen the adult novelist becomes a woman at odds with her younger self, perhaps even her true self. The *Juvenilia* – recast, quite rightly, in a modern edition as *Teenage Writings* by Kathryn Sutherland and Freya Johnston – showcase the 'disruptive voices that Austen never completely silenced. Here is the world according to Lydia Bennet.'

But to have the power to evoke (and control) disruptive voices in your writing is one thing. To suggest that Austen retained those voices in order to achieve some form of radical subversion or, if we take the biographical turn, because she was unable to silence them despite her best efforts, is quite another. She could have been far more radical and subversive and still have been published. After all, a bit of public infamy doesn't hurt sales, and publishers like Colburn snapped up controversial books by celebrity authors, such as Lady Caroline Lamb's exposé of her relationship with Lord Byron.

Jane Austen pursued print neither to skewer a former lover nor only because it offered her something more than coterie circulation. She wanted to make money. A triumphant letter of 3 July 1813 to her brother Frank has Jane delighted with her earnings and looking to make more. Austen writes:

> You will be glad to hear that every Copy of S. & S. [Sense and Sensibility] is sold & that it has brought me £140 – besides the Copyright, if that shd ever be of any value. – I have now therefore written myself into £250. – which only makes me long for more.

Austen's £600, earned in five years and from four novels, was not much compared to, say, the £2,100 Maria Edgeworth received for the copyright of a single novel, *Patronage*, in 1814. Priced at £1 8s., it sold 8,000 copies – indeed, sold out – on the first day of the first edition. None of the novels published by John Murray, Austen's publisher from 1815, came anywhere close to this kind of success. Only 252 of the 750 copies of the second edition of *Mansfield Park* sold, whilst *Emma*, sometimes seen as Austen's greatest novel, sold only 1,248 of the 2,000 copies printed and was remaindered in 1821 when only a further 200 or so had been sold. Nevertheless, Austen's earnings, paltry compared to those of the next author in this book, were significant to her, dependent up to this point on financial support from her father then brothers. That she did not expect to make money from *Sense and Sensibility* is suggested by her decision to sell the copyright to *Pride and Prejudice* for £110. She had been hoping for £150, but as she wrote to her sister, Cassandra, it was better to get a deal done quickly since that would 'be a great saving of Trouble to Henry', another glimpse of Austen's sense of dependency on the goodwill of her male family members.

Over the course of her brief few years as a professional author, Austen raised her earnings to between £600 and £700. She spent her money neither on improving her own quality of life nor, more surprisingly, on helping out her wider family. She held on to it. She

invested it. Even when brother Henry's bank failed in 1816, she made no move to liquidate or even draw upon the interest of her investments.

Henry Austen thoroughly misleads us, therefore, when he writes of his sister's lack of interest in 'profit' in his brief account of Austen's life which accompanied the posthumous publication of *Northanger Abbey* and *Persuasion*. What Henry began, Austen's mid-century descendants continued, as they swept Aunt Jane's desire to make money under the Victorian table. They did so with good reason considering the prevailing model of the virtuous female author. Consider Charlotte Yonge, just over a generation later, whose debut novel, *Abbey Church*, shows its female protagonists learning the merits of self-control and the perils of self-conceit. So far, so Austen. But prior to the novel's publication, 'there was a family council held, as to whether she [Yonge] should be allowed to do so. In consenting, there was an understanding that she would not take money for herself for it, but that it would be used for some good work – it being thought unladylike to benefit by one's own writings.'

Henry may have been closer to the mark, but equally of his time, when he presented Austen as uninterested in 'fame'. The anonymity of her early publications confirms that 'in public she turned away from any allusion to the character of an authoress'. This claim is more plausible because of Austen's apparent unwillingness to engage with the world of literary celebrity, evident in her refusal of a meeting with Germaine de Staël and, famously, her reluctance to dedicate *Emma* to the Prince Regent.

Austen's literary world was, on the surface at least, less vicious than, say, that in which Aphra Behn or Lady Mary Wortley Montagu operated, but it was still nasty enough to make keeping a low profile a popular choice. Jane's father and brother, instrumental in her becoming a published author, wanted her work to be read and to be financially rewarded. What they didn't want was for their daughter and sister to be *known*.

Remember even the great Fanny Burney being condemned for lacking 'vivacity' and 'bloom' in a judgemental conflation of woman and work? This is what Austen herself sought to avoid by remaining anonymous, a desire that led to two understandings of self, as evident in a letter to Cassandra. Austen loves the fact that 'I am read & admired in Ireland too': 'I' here is her work. She is less happy with one Mrs Fletcher who 'is all curiosity to know about me – what I am like & so forth – I am not known to her by *name* however'. This 'I' is Jane Austen, the person. Typically the passage ends with Austen satirising the business of literary celebrity, with a mock hope that her portrait will be shown at the Royal Academy ('all white & red, with my Head on one side' in a snipe at Joshua Reynolds) or that she might 'marry young Mr D'arblay' – the eighteen-year-old son of Fanny Burney. Instead, the only record of Austen's appearance is the tiny sketch by her sister which prefaces this chapter. Austen scholar R. W. Chapman called it a 'disappointing scratch' but for many it offers an important and authentic indication as to what Jane was 'like'.

Austen closes her letter with a bathetic reminder of her situation. She thinks she owes brother Henry a 'great deal of Money for Printing & c', a reference to the expense of printing a second edition of *Sense and Sensibility*. This is a woman who does not wish to be known, but a woman who wants her work to be read and who wants to earn money from her novels. It is yet another way, Austen's way, of navigating the terrain of being female and an author.

Austen remained an author almost to the end. In January 1817, her favoured month of the year for starting new projects, she crafted her first writing booklet for a new novel, known to Cassandra as *The Brothers*. It's a funny book, with a cast-list of idiotic, if benign, men and idiotic, and nasty, women. That working title, *The Brothers*, suggests a new confidence in writing about men and the setting, a new-build English south coast seaside resort, is also a departure for Austen.

But Austen had two complete novels in her desk that winter: a new work, *Persuasion*, finished at the end of the previous summer,

and the revised *Susan*, repurchased from the delinquent publisher Crosby and shaped into what we know as *Northanger Abbey*, complete with a feisty authorial note which, amongst other targets, takes aim at Crosby. Austen had published a novel almost every year since 1811, *Persuasion* could or should have appeared in the late spring of 1817, but it seems that Austen did not submit either of her completed novels for publication. Instead, she begins her story of English resort life.

Perhaps her creative confidence had been knocked by the disappointing sales of *Emma*, but she was still able to contemplate starting out again. Perhaps the failure of her brother Henry's bank in March 1816 removed one of her supporters, though with £600 in the bank, Jane was less dependent on her male relatives than when she started out. It might be that Austen did not have the energy to deal with publishers due to her increasing ill health. Others see Austen *choosing* to take a break from print, seeking a period of experimentation without the pressure of publication, but this only makes sense if she was a reluctant print author, a woman conscious that she'd never get a book deal if she wrote what she *really* wanted to write. Even if this were true, and I doubt it, Austen could still have put her completed works out there whilst running wild with her new book.

She was, however, already ill when she began the book, and only seven weeks later, Austen made a note in her diary that she had stopped work on it. At the end of April she wrote her will and a note of the profits she had accrued from her novels. Four months to the day from putting aside the manuscript of what would become *Sanditon*, on 18 July 1817, Jane Austen died in Winchester.

We know, because her family made sure to tell us, that Austen was a good woman to the last. In fact, she was good throughout her life. Biographers, prompted by the family's hagiographies and working within a tradition exemplified by the subtitle to Charlotte Yonge's *The Story of an Uneventful Life*, tell us of Austen's cheerful stoicism fuelled by her Anglican faith. Aunt Jane would lie on three chairs rather than taking the sofa from 'Grandmother' (Jane's mother) when she needed

to lie down after dinner. As Claire Tomalin puts it, this is 'a display of good manners carried to perfection; and proof of a fierce refusal to become an acknowledged invalid'.

Jane Austen died well. But why those completed novels stayed on her desk remains unexplained, just another mystery in this great author's life.

VII

Those silences infuriate modern editors and biographers who have sharp words for Austen's family, bemoaning the curation of her life for the Regency and Victorian public, regretting each letter lovingly destroyed by sister Cassandra. Every chapter of this book suggests the family were quite right to do so. Austen survived the nineteenth century *because* she was smoothed out, gentrified, de-politicised, turned into the 'Lady' of her title pages, concerned only with domestic manners. James Edward Austen-Leigh, the great-nephew who gave *The Watsons* its title and published it in 1871, wrote that the novel was ditched by its author because the subject was 'unfavourable to the refinement of a lady'. Austen had realised 'the evil of having placed her heroine too low, in such a position of poverty and obscurity as, though not necessarily connected with vulgarity, has a sad tendency to degenerate into it'. This would be laughable if it had not been so effective.

Margaret Oliphant (who published as Mrs Oliphant and knew a thing or two about nineteenth-century repression – you will hear more from her in the next chapter in less benign mode) captured something of Austen's quality. She expressed the 'soft and silent disbelief of a spectator who has to look at a great many things without showing any outward discomposure'. One commentator, writing immediately after the First World War, linked Austen's 'beautiful personality' with her ability to write works of 'sheer perfection'. That

crushing link between virtue and ability is a cruel one for creative women. It continues to this day in subtle form.

Jane Austen's survival in the generations after her death was not a foregone conclusion. In 1841, she did not make the cut in a popular collection of 'Standard Novels'. A 'concentration of imaginative genius' according to the blurb, the authors included Edward Bulwer-Lytton, Mary Ward, Captain Frederick Marryat, Theodore Hook and Lady Morgan, but not Jane Austen.

Having survived the nineteenth century, Austen flourished in the twentieth, thanks in no small part to the new professors in the new universities studying the new subject of English Literature. Now her incisive, complex irony helped her into the literary canon, her work ideal for close reading, the preferred practice of the formalist New Critics. At the same time, Austen's irony offered a chance to pathologise her 'regulated hatred' (professor of psychology D. W. Harding's famous formulation), patently a product of her bitterness as a woman without a man. Harding's was a scholarly take on a previous era's gossip around Austen's transformation from the 'prettiest, silliest, most affected husband-hunting butterfly' into the author of *Mansfield Park*, whereby she 'stiffened into the most perpendicular, precise, taciturn piece of "single blessedness" that ever existed', or so reminisced Mary Russell Mitford's mother. Somewhat predictably, the testosterone-driven big guns of American literature despised rather than pathologised this silly-precise spinster, from Ralph Waldo Emerson ('vulgar in tone, sterile in artistic invention, imprisoned in the wretched conventions of English society, without genius, wit, or knowledge of the world') to Ezra Pound: a 'dull, stupid, hemmed-in sort of life'.

Whether pathologised, ridiculed or dismissed (or enjoyed and studied and adapted – Laurence Olivier as Darcy in 1940 promised a glimpse of a world in which 'pretty girls t-e-a-s-e-d men into marriage') Austen was still very much on the radar. Unlike most of the women in this book, she did not need recovery by first-wave feminists. She *did* need unleashing from the Saint Jane of Chawton

narrative. Unleashed she has been, with blushes becoming orgasms; Elinor a dominatrix teaching naughty-girl Marianne a lesson; and 'queer' explorations of sisterhood, literal and figurative. We continue to sex up Austen. Andrew Davies said of his 'more overtly sexual' 2009 adaptation of *Sense and Sensibility* that his version 'gets to grips with the dark underbelly of the book'.

Austen's complacency with regard to slavery is equally under the spotlight, although as with all things Jane, those who wish to keep her on the side of the angels reassure us that she supported abolition. They point to the moment when Fanny Price asks Sir Thomas about the slave trade in *Mansfield Park* and is not answered. This is not Austen ducking an awkward issue, but an author drawing attention to the silences in English society, showing her horror of her country's involvement in the slave trade and slave ownership. As with Bradstreet and Montagu, these are questions we can and should be asking of the past, whether we like the answers or not.

Austen's millions of readers, across the globe, can and will decide for themselves whether they also see subversion in her novels, whether her irony works like acid on all moral certainties. Laura Mooneyham White, whose phrase that is, thinks not, because of her understanding of Austen as a faithful Anglican. I confess I change my mind each time I read the novels but I do keep coming back to the remarkable passage in *Persuasion* in which Austen considers men's control of history – indeed of narrative itself – and women's powerlessness against that control.

Captain Harville claims the authority of books to prove women's inconstancy, but has the decency to predict Anne Elliot's response: 'But perhaps you will say, these were all written by men.'

'Perhaps I shall. – Yes, yes, if you please, no reference to examples in books. Men have had every advantage of us in telling their own story. Education has been theirs in so much higher a degree; the pen has been in their hands. I will not allow books to prove any thing.'

These words underpin the book you are reading now: the pen has indeed been in men's hands. But Anne backs off from the argument and makes peace with Harville by allowing that one can never 'expect to prove any thing upon such a point. It is a difference of opinion which does not admit of proof.' This is quintessential Austen, a moment when with one breath she reveals a systemic problem (here the structural 'advantage' of men when it comes to narrative) and with the next pulls away from spelling out the implications.

Afterword

When he considers his little sister's brilliance after her death, Henry singles out Austen's ability in letter-writing ('familiar correspond-ence') to exemplify and characterise her achievement as a writer.

> Every thing came finished from her pen; for on all subjects she had ideas as clear as her expressions were well chosen. It is not hazarding too much to say that she never dispatched a note or letter unworthy of publication.

Jane Austen's sheer hard work, determination and professionalism are well and truly camouflaged here. The truth is that we know (because of those patches on *The Watsons*, because an alternative ending to *Persuasion* survives, because *Sense and Sensibility* and *Northanger Abbey* – and probably *Pride and Prejudice* – were transformed from earlier work) that Austen was an assiduous reviser of her own work. Her novels did not drop 'finished' from her pen. She worked damn hard to perfect her writing, worked damn hard to earn her place in literary history.

Following in the footsteps of Henry, Austen's great-nephew James Edward Austen-Leigh used the physical evidence of his great-aunt's letters to prove the proper femininity of her writing practice ('her

clear strong handwriting', her 'art in folding and sealing') to, in the words of Kathryn Sutherland in a superb essay on Austen's life and letters, 'deflect enquiry from anything as potentially countersocial and selfishly absorbing as creative writing'. James Edward wrote that whilst 'some people's letters always looked loose and untidy', Austen's 'paper was sure to take the right folds, and her sealing-wax to drop into the right place'. This is an absurd substitution for genius, as Sutherland so rightly points out.

Austen is, indisputably, a genius. I like to think she knew it. This is the woman who wrote: 'I must keep to my own style & go on in my own Way.' Those self-consciously contrived endings, revelling in the author's omniscience – coming on the back of the subtle use of irony and free indirect discourse within the body of her novels – allow her to remind us of two vital things. I have written about one of them, that we are reading fiction and what that might mean for women. The other is that she is in charge. She is A Lady who has written A Novel. She *needs* to establish that authority because of the whiff, indeed the stench, of impropriety surrounding her fictions, the need to redeem novels from the taint of her own sex. But establish it she does, and how.

Women's creative work takes many forms. Jane helped her mother and sister make a most beautiful quilt or coverlet, that quintessentially female, feminine art form. You can see it on display at Chawton Cottage. She cut out, folded and sewed paper covers for the manuscripts of *The Watsons, Sanditon, Persuasion* – and surely many more of her writings. The nature of her life ensured that she had to explore her genius while attending to the sugar, tea and wine stores, the mutton and the rhubarb; while coping with rejections from publishers; while living as an economic and social dependent; while suffering the encroachments of serious illness. And all the while remaining ladylike. No *outward* discomposure.

Jane Austen did, quietly, what Aphra Behn did, loudly. She earned her living as a professional writer. That her family chose not to dwell on this aspect of her life when remembering Austen says more about

their values than it does about Austen's, but their choice helped to protect her from being labelled a 'mere harlot' by the Bloomsbury set. Her life remained a predominantly private one, conforming conveniently to what her social world, and our literary histories, want from a lady author, but this is precisely what helped her to square the circle of being both a woman and an author. When Austen died, her local newspaper honoured Austen as a daughter *and* an authoress. It took a while, but eventually Winchester Cathedral, Austen's burial place, caught up. At first her memorial praised the woman for her 'charity, devotion, faith and purity'.[3] Then someone added an important further six words: 'known to many by her writings'. Daughter *and* authoress, quilt-maker and letter-writer, good Christian and 'known to many', a woman and a writer of genius. It could be done. It can be done. We can honour and remember our female authors.

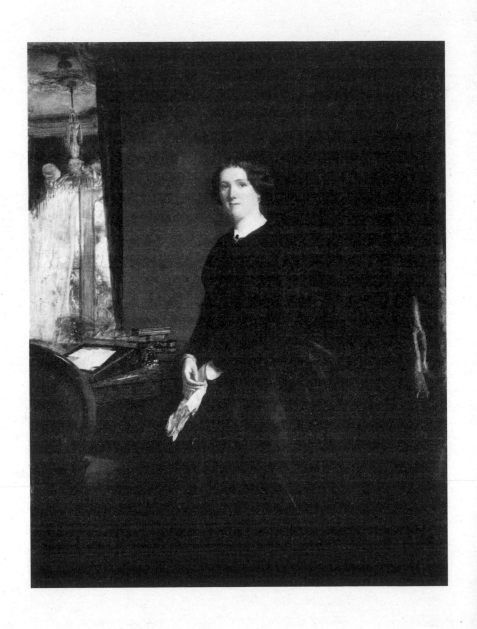

CHAPTER SEVEN

Mary Elizabeth Braddon

'She has the cunning of madness, with the prudence
of intelligence. I will tell you what she is, Mr Audley.
She is dangerous!'

I T'S 1859 and Mary Seyton's acting career is, to be frank, not going very well. Seven years in, and long gone are the days when she played young female leads. Seyton was Cinderella once. Now, at twenty-two she's given the parts of middle-aged women. Best forgotten is her London debut. She moves from theatre to theatre on the provincial touring circuit, two shows a night, constantly changing repertoire. Mary's mother, Fanny, who left her father when she was four, travels with her as her protector and friend. It is not a bad life: she has made good friends and some money in the theatre.

But Seyton wants to be an author. This is her story.

I

Between rehearsals and runs, Mary makes the time to write poetry, plays, reviews, short stories, anything. She courts, when she can, powerful literary figures, men such as the bestselling novelist Sir Edward Bulwer-Lytton, fifty when he sees teenage Seyton act. The

two begin a literary correspondence. She is used to failure, her heart falling at the postman's knock, since it heralds the sound of another 'rejected MS dropping through the open letter-box onto the floor of the hall'. Her acting friends know where her heart lies (she is 'writing a novel', her theatrical work a 'secondary consideration') and they believe in her. They cheer her on when one of her plays is selected for London performance: 'So now fortune smiles upon you – go in and win.' They console her after yet another setback: 'surely perseverance like yours shall somewhere gain its true light. To me you must ever remain a living marvel.'

Perseverance – with a dose of patronage – paid off. In February 1860, Mary Seyton gave her benefit performance with the Brighton theatre company with whom she had been happiest. The local paper reported that Miss Seyton 'of literary rather than histrionic fame' would be returning to Beverley, Yorkshire, to concentrate on her writing. To Yorkshire, because that was the home of wealthy, elderly John Gilby to whom Seyton had been sending her short stories since the previous November. Gilby decided that this young woman would, through his largesse, become a poet. She would leave the stage. She would write a long narrative poem about Garibaldi's contribution to Italian Unification and Gilby would pay for its publication. She need not worry about money. A similar arrangement had been made in the same year down in London whereby another young actress – Ellen Ternan, far more successful than Seyton – left the stage under the protection of a wealthy man, one Charles Dickens. Gilby, it seems, unlike Dickens, hoped for a wife not a mistress but in the coming months he did little to enhance his prospects, instead becoming more and more controlling. He made Mary promise to consult him about any commissions and to 'take none without my permission'. His protégée would not write for the theatre; she would live in Yorkshire, not London; she would write according to his notion of good literature, not hers.

Mary Seyton had other ideas. Or rather, Mary Elizabeth Braddon – to give our author her real name and while we are at it, her real

age, twenty-four – had other ideas. By the end of 1859, she had ditched her stage name (the manuscript of her London play has 'Miss Braddon' as the playwright) and when *Garibaldi and Other Poems* was eventually published, it appeared as the work of the gender-neutral M. E. Braddon. It was M. E. Braddon who, in the final weeks of her life as Mary Seyton, was offered fifty shillings up front for a weekly fiction serial by a provincial publisher. The first instalment of *Three Times Dead; or, the Secret of the Heath* appeared in the same month in which her benefit show took place. Mary's friends made sure of a good review in the local *Brighton Herald*, which looked forward to the completion of the serial then its appearance as a stand-alone volume, 'a Railway book'. This was the turning point, not Gilby.

Three Times Dead did not make its author much money (of the ten pounds she was promised by the publisher, Braddon received not a penny) but writing fiction, even pulp fiction, perhaps especially pulp fiction, was exhilarating and far better than dependence on Gilby.[1] Changes in the publishing industry since Austen's time, specifically the lowering or removal of tax on print, had created the market in which Braddon would flourish, allowing for the production and sale of cheap fiction. She was in her element, later recalling she 'dashed headlong at my work … and set my puppets moving', taking raw pleasure in the imaginative freedom available to her. Above all, writing fiction allowed Braddon to deal in what she called the 'angels and monsters' created by her own brain.

It was all in sharp contrast to the agony of producing the ghastly Garibaldi poem for the judgemental Gilby. Braddon hated swotting up on history, classical allusions, Spenserian metres, all in the cause of breathing a little life into a 'dry as dust record of heroic endeavour'. By the time *Garibaldi and Other Poems* appeared in early February 1861, a year on from her benefit performance in Brighton, it was clear that neither narrative poetry nor John Gilby nor even Yorkshire were going to play a part in Braddon's future. The volume was not even dedicated to Gilby.

When Braddon looked back on the summer of 1860 she remembered finishing her first novel, 'knocking Garibaldi on the head with a closing rhapsody', enjoying the York races (Gilby was a racing man) then leaving Yorkshire 'almost broken-heartedly on a dull grey October morning to travel Londonwards through a landscape that was mostly under water'. Broken-heartedly? If so, it was a heart soon mended. A couple of months later, Braddon was already close with the London based, Irish-born publishing entrepreneur John Maxwell who was using his influence to get favourable reviews for the Garibaldi volume.

On 28 February 1861, the two men coincidentally put pen to paper to write to Mary Elizabeth Braddon. John Gilby was vicious. He had plucked her from the stage and now she demonstrated neither gratitude nor honour. She had deceived him utterly being 'such an actress that you cannot speak without acting'.

> I have worked as hard and done as much for you as it was possible for a gentleman to do for a woman in your position. I can only feel pity for you not unmingled with contempt, and wonder if you have one redeeming trait in your character.

John Maxwell, in contrast, was charming. Addressing his 'dear Polly' (the name by which Mary was known to her acting colleagues), he is both smitten – her absence has created a void – and ironically self-deprecating about his feelings. He's writing because he really must tell her that one of his authors, Anna Hall, has admired her work as 'brimful of unconscious and almost wholly undeveloped power!' Already, there's a hint that 'Max' is having a private joke with Polly here, at Hall's expense. They both know that Braddon was already a relatively experienced professional woman, but it is helpful to her cause to have people like Anna Hall see her as an innocent, unformed girl.

By March, Maxwell was helping to edit, then to republish Braddon's serial *Three Times Dead*, now with a new title, *The Trail of the Serpent*.

Sarah Waters, in her insightful preface to the work's first modern edition, sees the change as a canny marketing ploy signalling the novel as one of the first, perhaps *the* first, British detective novel. Rebranded, it sold a thousand copies in seven days. By June, Maxwell had appointed Braddon as chief serial writer for a new ultra-cheap magazine for working-class readers, the *Halfpenny Journal*, with her mother, Fanny, as editor.

The next part of the story is the stuff of legend. John Maxwell, as he was wont to do, launched yet another magazine, this time a two-penny weekly, *Robin Goodfellow*. For some reason, the writer of the lead serial failed to deliver just before the first copies were due to appear. Maxwell considered delaying, but then 'Miss Braddon heard of the difficulty'. It was pointed out to her that there was 'no time'.

> 'How long could you give me?' asked the aspiring authoress.
> 'Until tomorrow morning.'
> 'At what time tomorrow morning?'
> 'If the first instalment were on my breakfast table tomorrow morning' he replied, indicating by his tone and manner the utter impossibility of the thing, 'it would be in time.'

The next morning the publisher found upon his breakfast table the opening chapters of *Lady Audley's Secret*. It is a great story, and – given Braddon's phenomenal productivity – it might even be true.

And so it came to pass that, in July 1861, the first instalment of *Lady Audley's Secret* appeared, produced overnight by its prodigious author and ending with the requisite cliff-hanger.

Somewhat bathetically, the serial came to an abrupt close at the end of September not because Lady Audley's story had been told but because *Robin Goodfellow* folded. Maxwell's magazines had a tendency to do this. Undeterred, Braddon started work on a new novel, *Aurora Floyd*, whilst continuing to produce her pulp fiction serials. But such was the interest in *Lady Audley's Secret* that Braddon was begged to complete it. She was happy to do so (what was one more

novel on top of the three or four on her desk?) and *Lady Audley* rode again from February 1862, now in the *Sixpenny Magazine*.

By the time the final instalment of *Lady Audley's Secret* appeared on the first day of 1863, Braddon's career was soaring. In the early months, she had been directly up against Charles Dickens, with instalments of *Great Expectations* appearing in *All the Year Round*. She should probably have sunk without trace against that kind of competition. But instead, and in response to demands by readers who wished her to continue publication, Braddon reinitiated serialisation in Maxwell's *Sixpenny Magazine* on a monthly basis in January 1862. A few months later, she made a lucrative deal with a new, young publishing company (Edward and William Tinsley) which would bring out *Lady Audley* in an expensive three-volume edition. The two major circulating libraries, Mudie's and the Library Company, fought to get hold of copies to feed reader demand. Braddon signed for a 'New and Cheaper Edition' complete 'with a Photographic Scene of the Lime-tree Walk at Audley Court' to be sold at six shillings – a day's wages for a skilled workman. Reprints of her other novels were rushed out in even cheaper editions, with both *The Lady Lisle* and *Captain of the Vulture* published in the Shilling Volume Library. And *Lady Audley* ran again in serial form, also with illustrations.

Meanwhile, Braddon continued her 'halfpenny bloods' and 'penny dreadfuls' (*The White Phantom*, *The Black Band* – under the pseudonym Lady Caroline Lascelles – and *The Octoroon*, starring Cora, an Englishwoman and a slave) and, as if that was not enough, on top of the pulp fiction, she completed *Aurora Floyd* for one of Maxwell's more upmarket new magazines.[2] The novel made its way to the London stage, joining *The Black Band* and *The Octoroon*, live every night in Whitechapel, and the three West End productions of *Lady Audley* already running. When the Tinsley brothers launched an aggressive marketing campaign, spending several hundred pounds advertising both *Lady Audley* and its author, they need hardly have bothered. Braddon's work was everywhere.

II

The novelist George Moore remembered reading the novel. He was eleven, travelling with his parents, and they were discussing a new book that 'the world is reading'. The boy was intrigued by the talk of a slender, pale, fairy-like heroine, although not enough to prevent him being distracted by the 'delight of tearing down fruit trees and killing a cat'. Young George then remembered Lady Audley, stole the novel, and read it 'eagerly, passionately, vehemently'. Everything about this reading experience was deplorable, quite apart from the theft itself. Novel authors and novel readers were, critics thundered, consumed by 'nervous fancy', stimulated by fiction to uncontrollable, unnatural and dangerous bodily sensations, which 'carry the whole nervous system by steam'.[3] It was a new take on the anxieties surrounding the novel in Austen's time, a modern set of fears for a modern genre: sensation fiction.

Braddon was its reigning queen. For a reader in the early 1860s, *Lady Audley's Secret* is on almost every page startlingly, disturbingly, modern. Her very words are new ('hypersensitive', 'amateurish' and 'tight-lipped' amongst her first usages). Alicia Audley finds her cousin Robert as unresponsive as a 'peripatetic, patent refrigerator'. Lady Audley doesn't merely play the piano, she plays Mendelssohn. Her portrait is painted by one of the 'pre-Raphaelite brotherhood'. Braddon writes of new-build estates in London emerging from 'the chaos of brick and rising mortar around them', of newspapers, railway journeys and telegrams. Austen's pre-suburban, railway-less England is not in fact that far away in time – it just feels as if it is. It is disorientating to read that in 1845, when Cassandra Austen died of a stroke, her brother Henry came to the funeral at Chawton and left on the night mail for Leamington. Fifteen years after Cassandra's death, railways, along with all the other forms of industrialisation and technological advancement, were part of everyday English life.

Braddon's novel revealed to its eager readers just how easy it was to transform one's identity in this rapidly changing world. The old

certainties of Austen's England, where Darcy arrives in the neigh-
bourhood and people know exactly who he is and what he is worth
(or in which John Dashwood can calculate the precise value of his
half-sister Marianne), are gone.

> *Plot spoiler alert! If you have not (yet) read* Lady
> Audley's Secret, *you might wish to skip to the end
> of this chapter and then return here having fully
> enjoyed the twists and turns of Braddon's novel.*

Within this world transformed, Braddon's plots do not unfold in
leisurely style, they hurtle forwards. Consider this crisis (there are
so many it is hard to keep count) between Robert Audley and Lady
Audley. The exchange begins:

> 'Lady Audley, did you ever study the theory of circumstantial
> evidence?'
> 'How can you ask a poor little woman about such horrid things?'
> exclaimed my lady.

Robert moves inexorably to a climactic denunciation, demonstrating
how small pieces of circumstantial evidence are coming together as
'links of steel in the wonderful chain forged by the science of the
detective office' until, eventually, 'the penalty of crime is paid'.
It's strong stuff. Lady Audley promptly and somewhat conven-
iently faints. Most authors would draw breath, but Braddon immedi-
ately gives Robert a great speech of denunciation and judgement: his
opponent is a 'demoniac incarnation of some evil principle'. Audley
ends with an ultimatum:

> you will no longer pollute this place by your presence. Unless you
> will confess what you are, and who you are, in the presence of the

man you have deceived so long; and accept from him and from me such mercy as we may be inclined to extend to you; I will gather together […] witnesses [… and] bring upon you the punishment for your crime.

Stop there? No. One more twist. Lady Audley rises 'suddenly and stood before him erect and resolute; with her hair dashed away from her face and her eyes glittering'. She pronounces that Robert Audley has achieved a hollow victory: 'You have conquered – a MADWOMAN!'

No wonder *Lady Audley's Secret* sold. No wonder, also, that contemporaries expressed concerns about and hostility towards both novel and author, offering a new, high-Victorian take on age-old anxieties about women and literature.

First, the protagonist. *Lady Audley's Secret* has a powerful female cast list: the unscrupulous servant and the poor governess, the straight-talking country woman happiest on a horse and the beautiful moral guide for wayward men. This was entirely conscious on the part of Braddon, who thought she knew better than her main literary rival: 'Wilkie Collins is on the wrong track, isn't he? […] Three numbers & no female interest – surely a mistake so far as Mr Mudie's constituency' is concerned. (Mudie controlled the circulating libraries of Britain, making and breaking novelists.)

Others begged to disagree with Braddon's allegiance to 'female interest'. Author Eneas Sweetland Dallas, in *The Gay Science* of 1866, argued that all novelists necessarily find it challenging to involve females of the species in exciting action because, if a woman is 'put forward to lead the action of a plot, they must be urged into a false position'. The novelist has to 'give up his heroine to bigamy, to murder, to child-bearing by stealth in the Tyrol, and to all sorts of adventures which can only signify her fall'. In other words, the only way to give a female character agency is to make her criminal and damned. A female protagonist is by definition a fallen woman. And then the twist of the knife. The female novelist struggles even more because

as *women* they 'naturally give the first place to the heroine' but as *writers* they understand that 'passive and quite angelic, or insipid' heroines do not make good fiction. There's that divide again, creating a chasm between a woman and authorship.

What to do? Braddon's protagonist, Lady Audley, both challenges and stokes Dallas's concerns. She is an apparently docile woman who *looks* angelic but is actually nothing of the kind. She is worryingly active. If Gothic fiction presented women as the passive victims of male villains – those libertine rakes – sensation fiction, at least in the hands of Braddon, showed women fighting back. Compelling? Certainly. Immoral? Definitely. No wonder then that Lady Audley was described by one contemporary critic, William Fraser Rae, as 'at once the heroine and the monstrosity of the novel', with Braddon accused of attempting to 'portray a female Mephistopheles'. Of course, she can only fail, because 'a woman cannot fill such a part'. Braddon has, however, created a 'Lady Macbeth who is half unsexed', a protagonist whose 'timid, gentle, innocent' veneer conceals her depravity. The critic concludes that this 'is very exciting; but it is also very unnatural. The artistic faults of this novel are as grave as the ethical ones. Combined, they render it one of the most noxious books of modern times.' And that is that: an unnatural heroine and an unethical novelist.

Except for readers it was not that simple, primarily because Braddon does not represent Lady Audley as an unsexed monstrosity. Robert Audley (her self-appointed judge, jury and in effect executioner) can still see his aunt as a 'wretched creature', 'forlorn and friendless' in her 'womanhood and her helplessness'. Very few readers can feel *no* sympathy for her, the daughter of an alcoholic; an abandoned wife; a woman haunted by a fear of inheriting her mother's madness; a woman who knows, first hand, the horrors of poverty and exclusion. Braddon's protagonist moves through a series of identities: born Helen Maldon, she marries and becomes Mrs George Talboys; after her husband's departure for Australia, she transforms to governess Lucy Graham and thence to Lady Audley;

her life ends as Mrs Taylor. At each stage, Braddon shows us how and why these identities accumulate. An actress, yes, but made so 'by the awful necessity of her life'.

Braddon's achievement, however, goes beyond risking sympathy for a monstrosity. She reveals what lies behind her heroine's behaviour, not simply pointing to the faults of others (the disastrous father, the absentee husband) or indeed to the sins of the woman, but to an entire system built on ideas about female behaviour. We come to understand femininity as a construction by seeing its workings. Here's her description of governess Lucy Graham (the heroine's third incarnation).

> Wherever she went she seemed to take joy and brightness with her. In the cottages of the poor her fair face shone like a sunbeam … everybody, high and low, united in declaring that Lucy Graham was the sweetest girl that ever lived.

Everyone loves Lucy, from Sir Michael Audley who makes her his wife to her nephew, Robert Audley, who worries he is falling for his aunt. None can resist 'the tender fascination of those soft and melting blue eyes; the graceful beauty of that slender throat and drooping head'. Braddon contrasts Lucy's obvious attractions with the more dubious appeal of Alicia, Sir Michael's daughter. Alicia's penchant for hunting has taught her to go 'through the world as she goes across country, straight ahead, and over everything', a determination and directness that kills all desire in Robert.

Robert eventually comes to realise that Lady Audley's façade of angelic domesticity is a 'diabolical delusion' but does this realisation condemn the woman born as Helen Maldon or the society which has told her that precisely this, domesticity, is the way to succeed as a woman? The question goes to the heart of one of the most disturbing aspects of Braddon's novel. She pretty much has to end *Lady Audley's Secret* with the good people coupled up, just as Austen did, a half-century earlier, or Behn, nearly two centuries

before. Unlike Austen and Behn, Braddon is also writing a detective fiction and therefore needs to reveal whodunnit – or in this case, howdunnit or was it ever even dunn. By the closing page, the conventions – of society and novel – have been observed. Crime has been punished (privately), and the good name of the Audley family has been preserved (discreetly). The triumphant detective is rewarded with a moral and beautiful wife and a suburban villa by the Thames between Teddington and Hampton Bridge. It's hardly Pemberley or Donwell Abbey, nor even a vicarage and a private income, but it's an upper-middle-class dream of domestic security nonetheless.

As with Austen, however, en route to this happy point, Braddon makes us question whether a diagnosis of madness is engineered only to keep the family's name out of the newspapers; challenges us to tell the difference between real and faked femininity; and asks us to sift proper marriages from improper ones. It is not as easy as it looks because Braddon's heroine was, according to the values of her time, entirely right to seek to marry since the alternative was worse. The 'quite abnormal' number of unmarried women, some 2.5 million useless, *surplus* women, were 'indicative of an unwholesome social state', 'both productive and prognostic of much wretchedness and wrong', or so wrote W. R. Greg in an influential article of 1862. The concern about abnormal spinsters piled the pressure on 'normal' women to marry and reproduce. Very, very few people challenged the view that marriage and baby-making were the 'great and paramount duties' of women. Ideally, marriage should be for love rather than interest, wealth or position, but in the end, pretty much everyone insisted that any marriage was better than none at all.

Helen Maldon seeks marriage. Wonderful. What is slightly less wonderful is her use of marriage solely to escape from her alcoholic spendthrift father. What is utter anathema to the mid-Victorians is her exploitation of her beauty to gain interest, wealth and position. She coolly and rationally monetises her femininity. 'My ultimate fate

in life,' she explains, 'depended upon my marriage, and I concluded that if I was indeed prettier than my schoolfellows, I ought to marry better.'

In Austen's novels, if a woman makes what has been described, elegantly, by Tabitha Sparks as an 'architecturally triumphant' marriage she is to be applauded. Hurrah for Lizzie Bennet, mistress of Pemberley. Moreover, if a woman seeks to escape a life of dependency or paid employment, she is not only permitted to escape but is rewarded. Jane Fairfax in *Emma* speaks out against the 'governess-trade', one which involves 'the sale, not quite of human flesh, but of human intellect' and Austen gives her a wealthy husband. Not so Lucy Graham who actually becomes a governess and also speaks out against the 'dull slavery' of the life. This is partly a reflection of Braddon's era in which calculating women who sought to 'marry better' were condemned with 'an intensity spurred by industrialism's changes to class hierarchies', to quote Sparks again. The poor but honest woman, the wife who puts up and shuts up, becomes the ideal. No matter that George Talboys is an abysmal, profligate husband who abandons his wife and new-born baby in the middle of the night without a word of explanation. Helen should have stayed. Instead, she makes another mercenary, loveless marriage – and this time, it is an illegal one.

The legal and decent marriages at the end of *Lady Audley's Secret* are not exactly convincing. Braddon makes a very late decision to marry off Alicia to a man she rejected in no uncertain terms many chapters earlier, Harry Towers. He's not the brightest of chaps ('I haven't got much brains myself I know') and he doesn't want a 'strong-minded woman, who writes books and wears green spectacles; but, hang it! I like a girl who knows what she's talking about!' Harry, in his way, does love Alicia. Whether Alicia loves Harry remains entirely unclear, but what's love got to do with it?

III

Elaine Showalter, in a hugely influential reading, regards Braddon as always focused and strategic. She understands Lady Audley's eventual diagnosis of madness as a 'get out of jail' card for both the author and her readers, saving 'Braddon the unpleasant necessity of having to execute an attractive heroine with whom she identifies in many ways'. The woman reader is moreover spared 'the guilt of identifying with a coldblooded killer'. I am not so sure. Not only is the diagnosis of madness deliciously ambiguous (now you see it, now you don't) but it seems a simplification of both author and character to argue that Braddon identifies with the ultra-feminine Lady Audley.

I see Braddon offering something more powerful and more literary. Powerful, because the novel provides an anatomy of how and why Helen Maldon uses her ultra-femininity to achieve her goals, which all goes to make us think, hard, about ultra-femininity and women's proscribed purpose in life. Literary, because Braddon foregrounds stories – who tells them, who controls them, who listens to them – as in this confrontation between Robert and Lady Audley, played out in front of Sir Michael, when Robert tells his aunt the 'story' as he understands it. Lady Audley in turn tells her 'story' to try to soften her husband who:

> sat silent and immovable. What was this story that he was listening to? Whose was it, and to what was it to lead? It could not be his wife's …

Sir Michael plainly cannot compute what he is hearing. He cannot let go of the previous story he has been told of governess Lucy Graham's childhood – the orphanage and so on. Braddon is astute about what we do and do not hear, and what we choose not to hear. When Robert Audley is telling Lady Audley his account of his dear friend George's return to England he says that 'the thought which was uppermost in his mind was the thought of his wife'. Lady Audley interrupts:

"'Whom he had deserted," said my lady quickly.' On a plot level, this is a slip. Lady Audley should not know that George deserted his wife but she cannot help herself. This is her truth and she blurts it out. She moves quickly to cover up her mistake, but she need not have bothered. Robert Audley was not listening. But we, the readers, are.

However strategic and calculated Lady Audley's story of her childhood might be, it is also deeply moving. She talks of her fears about visiting her mother in the asylum, how she imagined the horror of the situation, her nightmares in which her mother grabbed her by the throat. But when young Helen finally meets her mother, she sees a 'golden-haired, blue-eyed, girlish creature' skipping towards them, with her 'gay, ceaseless chatter'. To me, the next five words are heartbreaking: 'But she didn't know us.'

I am still uncertain as to how many of the ambiguities present at the end of the novel, and the questions it asks throughout about love, marriage, femininity and society – about Lady Audley herself – are primarily a product of Braddon's writing at speed, something she insists upon again and again when explaining the nature of her fiction. There was clearly no steadying editorial hand at work. Elsewhere, however, Braddon knows very well how to provide moral closure, as in the closing paragraph of one of her pulp fictions, *The Black Band*, in which the narrator assures the reader that 'the won-drous balance of good and evil will infallibly adjust itself in the end', with 'the Power which rules this marvellous universe' meting out 'vengeance' on those who 'laugh to scorn the just and merciful laws of an All-Wise Providence'. There's nothing quite this blatant in *Lady Audley's Secret*, but Braddon does ensure that Robert Audley is not only more manly and more married, but also more religious by the end of the novel:

> The one purpose which had slowly grown up in his careless nature until it had become powerful enough to work a change in that very nature, made him what he had never been before – a Christian.

Similarly, Braddon presents Lady Audley as fallen. She could not find happiness in her valuable possessions because she was 'no longer innocent; and the pleasure we take in art and loveliness being an innocent pleasure, had passed beyond her reach'.

It is the manly Christian Robert Audley who makes the familiar leap from the particular (Lady Audley) to the general (all women). When she threatens him with the madhouse,

> a shiver of horror, something akin to fear, chilled him to the heart as he remembered the horrible things that have been done by women since that day upon which Eve was created to be Adam's companion and help-meet in the garden of Eden. What if woman's hellish power of dissimulation should be stronger than the truth, and crush him?

Lady Audley may have been condemned as a failed attempt by Braddon to create a thoroughly modern Mephistopheles (a devil who uses telegrams and trains to work her evil) but within the novel she is understood by Robert Audley as a thoroughly modern and thoroughly terrifying Eve.

And yet, and yet, I can't help think that Braddon leaves an opening for the reader to feel compassion for a woman who has lost her innocence or, rather, had it taken away from her in her childhood. Equally provocatively, Braddon has established Robert Audley as a man who lazily parrots tired, sexist formulae about women: 'They want freedom of opinion, variety of occupation, do they? Let them have it. Let them be lawyers, doctors, preachers, teachers, soldiers, legislators – anything they like – but let them be quiet – if they can.' In this context, does Robert's misogyny, his conflation of his aunt and Eve, become just another story of woman created by man?

Braddon has forced us to look at the system that produces a Lady Audley, that falls for her, both in the sense of desiring her and being duped by her. She is a false, deceiving Eve – a manipulative, beautiful 'fiend' in the words of Robert Audley – but we can understand, for a moment, why she is such.

IV

That wonderful story of the breakfast table appearance of the opening chapters of *Lady Audley's Secret* sits comfortably with Braddon's self-presentation as a fast, prolific writer, writing the second half of the novel in 'a fortnight' with the 'printer at me all the time'. Decades later, she recalled that she wrote the book wherever she happened to be, 'in Essex, in Brighton, in Rouen, in Paris, at Windsor, and in London', suggesting a much longer, and it turns out more honest, time-frame for the novel.

The truth was that from June 1861, Mary Elizabeth Braddon, with her mother Fanny, was living in John Maxwell's house at 26 Mecklenburgh Square, London. The breakfast table was in her own home. Those trips, whether to Brighton or Paris, were with Maxwell; the two of them stayed in Essex at Ingatestone Hall, a source for the novel, as man and wife; to her friends, she was now Mary Maxwell; and in March 1862, Mary gave birth to Gerald, the couple's first child.

The truth also was that Mary Braddon was not Mrs Maxwell and that Gerald was illegitimate. John Maxwell was already married to Mary Anne Crowley and the couple had five children.[4] This was not new territory for the author of *Lady Audley's Secret*. Mary Elizabeth Braddon was no stranger to scandal, or rather no stranger to others passing judgement upon her. Since childhood, her life had offered a vocally moral Victorian (and there were many vocally moral Victorians) cause for concern. Her mother, Fanny, had left her outwardly respectable solicitor father when Mary was four, exhausted by his disastrous financial management, sexual infidelities and all-round uselessness. (Henry Braddon's adultery alone was not, according to the law of the time, sufficient grounds for Fanny to divorce him.) Then there was the acting career. Things had not moved on *that* much since the time of Aphra Behn. Charles Dickens, for one, was horrified by the way drunken male audiences treated actresses, but instead of condemning the men, he argued that women should not go on the stage because men are incapable of controlling themselves. Braddon

laughed this kind of thing off, writing that going into theatre was 'a thing to be spoken of with bated breath, the lapse of a lost soul, the fall from Porchester Terrace to the bottomless pit', but she knew what people thought. Then there was John Gilby who had sought to save Mary Elizabeth's lapsed soul from the bottomless pit. People talked. And now, in 1862, here was Braddon earning her living by means of her pen, a profession slightly more respectable than the stage, and in turn, slightly more respectable than sex work but, as every chapter of this book demonstrates, the three can get very entangled, whether conceptually or in practice. Twenty-six-year-old Mary Elizabeth Braddon, installed in Mecklenburgh Square, bearing her lover's illegitimate child (and raising his legitimate children), was no stranger to society's judgements. This might be one of the reasons she didn't break stride. She was used to it.

Putting aside the morality of their domestic arrangement, Braddon was taking something of a financial risk allying herself with Maxwell, who had a tendency to fail fast and fail often. *Robin Goodfellow*, the magazine which folded shortly after *Lady Audley* began its run, was already the rebranded *Welcome Guest* on which Maxwell had lost £2,000 the previous year. In October 1862 he had to mortgage all his magazines to a Mr Norris. In contrast, M. E. Braddon was raking it in. Crucially, however, it was as 'Spinster and Author' of Mecklenburgh Square that Braddon signed her next book contract, with Maxwell as witness. If she *had* been married to him, then her income would have been seized to pay his debts. Living in sin, the spinster and author kept control of her money or, as Willmore might have put it, got all the honey of marriage without the sting.

Looking from the outside, commentators and colleagues condemned Maxwell's exploitation of Braddon: a cartoon showed him as circus ring master forcing her to write. If the price to be paid for both to get what they wanted, in Braddon's case to carry on writing, was a public perception that she was a 'self-denying' victim, then so be it. Behind the scenes, both Max and Polly were clear-sighted, unsentimental realists, as evident in Braddon's explanation of the

choice of title of her husband's new magazine for which she would be editor: '*Belgravia* is the best bait for the shillings of Brixton and Bow'. Her description of the gap between the complex, nuanced, profound book that authors feel they *should* be writing and the actual words appearing on the page in front of them is a piece of comic genius. She senses that within her is the great work (what she calls 'the Archetype'). The trouble is that the 'Archetype is a perfect eel in the matter of slipperiness.'

> There he goes gliding through the turbid waters of the brain, such a beautiful shining rainbow-hued creature. You try to grasp him, and Lo he is gone. He has a rooted antipathy to pen & ink. Out walking in the dismal London streets, sitting in a railway carriage, reading other people's books, playing the piano, lying in bed, there he is always, my perpetual companion. I sit down to my desk, & hey presto, the creature is gone, not so much as a quarter of an inch of his silvery tail remains.

In an equally entertaining letter to one of Maxwell's magazine editors, Braddon lists her 'right-down sensational' devices, from 'bank-notes and title-deeds under the carpet' to a 'part of the body putrefying in the coal-scuttle', before moving into a slightly crazed riff on what a writer could do with the idea of missing parts of a corpse, dividing the story into 'bits' rather than 'books': 'BIT THE FIRST: The leg in the gray stocking found at Deptford.' 'BIT THE SECOND: The white hand … found in an Alpine crevasse!' She's laughing at her rival novelist Wilkie Collins here, but moves swiftly, and characteristically, to professional business, the need for a 'sensational fiction to commence in January'. She'll do it, 'workmanship careful, delivery prompt'. Honest, amusing, full of *joie de vivre*, this is M. E. Braddon, author, at work. Almost everything about this letter, from her acknowledgement of the way she works (fast) to what she writes (sensational fiction) to her pride in her 'workmanship' (literature as craft, not art), challenges the literary pieties of her era.

The wave of cheap fiction, written by people like Braddon, published by people like Maxwell, designed to be consumed quickly rather than for moral growth and above all to be enjoyed ('excitement, and excitement alone, seems to be the great end at which they aim'), troubled deeply those seeking to protect Literature with a capital L.[5] The morally upright W. H. Smith and his son worked to transform the somewhat tawdry offerings at station bookstalls into something much more wholesome. Charles Mudie, the intensely religious owner of the largest, most powerful circulating library, tried to ensure that no general infamy would get into his 'Select Library', particularly when it came to novels. His 1860 catalogue made this point not once but twice. The higher class of fiction would be tolerated but 'Novels of objectionable character or inferior ability are almost invariably excluded'. Cheap print was evidence of 'a widespread corruption' in society, with writers figured as drug dealers, offering the literary crack cocaine of a railway novel to supply the 'cravings of a diseased appetite'. The most vulnerable were the working classes, the young (think of little George Moore) and, of course, women.

Each century finds its own way to say the same thing: do not read this, ladies. In the mid-nineteenth, John Ruskin begged parents to 'keep the modern magazine and novel out of your girl's way' and poets exhorted women to 'Calm the wild tumult, probe the vain desire/And – more than all – don't set the bed on fire.' Kate Flint, expert on women's reading practices, cites this verse as a vivid example of:

> some of the most frequently expressed anxieties concerning the Victorian woman reader: that her imagination, even her expectations, may be stimulated in a way that is totally incompatible with her daily life; that she will become so distracted as to ignore the perils of her immediate environment (or, in other contexts, her duties); and – although I am not sure how far [the poet] intended the implication – that she will be dangerously sexually stimulated by the print she consumes.

Braddon is alert to all of this and addresses it in her remarkable novel of 1864, *The Doctor's Wife*, her Englishing of Flaubert's *Madame Bovary*. (The novel led not only to charges that Braddon was importing immoral French literature across the Channel but that she was a mere plagiarist. As ever, Braddon fought fire with fire: 'By the bye about Thackeray, don't you think it was from Balzac he got that habit of looking down on his characters? Becky Sharp is only Valérie Marneffe in an English dress', referring to a character in *La Cousine Bette*.) In *The Doctor's Wife*, Braddon shows her heroine, the sappy Isabel, failing to gain straightforward pleasure from reading novels, and instead allowing books to make 'the dull course of common life so dismally unendurable'. Isabel:

> wanted her life to be like her books; she wanted to be a heroine, – unhappy perhaps, and dying early. She had an especial desire to die early, by consumption, with a hectic flush and an unnatural lustre in her eyes.

But unlike the moralists, Braddon insists, using one of her most memorable characters, the sensationalist novelist Sigismund Smith, that novels in themselves are not evil. They are 'only dangerous for those poor foolish girls who read nothing else, and think that their lives are to be paraphrases of their favourite books'. Smith knows better.

> Sigismund wrote romantic fictions by wholesale, and yet was as unromantic as the prosiest butcher who ever entered a cattle-market. He sold his imagination, and Isabel lived upon hers. To him romance was something which must be woven into the form most likely to suit the popular demand. He slapped his heroes into marketable shape as coolly as a butterman slaps a pat of butter into the semblance of a swan or a crown, in accordance with the requirements of his customers.

And so does Braddon, the author who offers 'workmanship careful, delivery prompt'.

V

Braddon's protestations that she simply does not have the time for Art or Literature (or even editing and fact-checking) are part and parcel of her claim, made throughout the early years of her professional life as actress and author, that she has to work in this way in order to earn money to support her mother and herself. It was the perfect sop to those moralists who believed that unless absolutely pushed into it, a woman should not take up any form of profession, but that if she was forced by circumstance to earn money from her pen, that pen should be used for moral good.

In this climate, it is hardly surprising that Braddon drew a clear line between her domestic and her professional selves, although I sometimes wonder how she did it given the arrival of a baby boy, Francis Ernest, born just ten months after Gerald, in January 1863 and then a daughter, Fanny Margaret, at the end of the same year. That's three children under two by the end of 1863 whilst also acting as stepmother to Maxwell's five older children. But Braddon as mother, let alone unmarried mother, is invisible when she writes to Bulwer-Lytton. At eight months pregnant with a ten-month-old baby, she may mention that she goes nowhere that requires 'fine dress' and that she 'can't drink wine' but she keeps very quiet as to why that might be. She may write about making money, but she does so to support herself and her mother – no mention of Maxwell, let alone dependants. If she suggests a meeting after a certain date it is because she is going 'into the country', not (you can almost hear the covering cough) because she is having yet another baby. Braddon claims she does not wish to 'bore' Bulwer-Lytton about her life since she plagues him enough with her 'doubts and difficulties about

literary matters'. This is why she keeps her 'domestic personality in the background'. A few years later, when she does at last sign herself as Mary Maxwell to Bulwer-Lytton (acknowledging that she is 'now the head of a grown-up family – who I think love me almost as well as if I were indeed their mother'), she tells him that there had been 'very powerful commercial reasons' against using that name 'in any public manner'.

Braddon's professional success meant that her strategy of domestic discretion could not be sustained. To her distress ('It is all Mr Tinsley's fault for advertising me as "Mary Elizabeth"'), she was exposed as a woman. Worse, it became publicly known that she was living with, and bearing the children of, the already-married John Maxwell.

Margaret Oliphant, who so admired Jane Austen's detachment, launched one of the first and most vicious attacks on Braddon for, if people were anxious about women as consumers of novels, then they saved a special circle of hell for the women who wrote sensation fiction. Oliphant blamed her fellow female authors for threatening the 'sanity, wholesomeness and cleanness' of English fiction.

> Nasty thoughts, ugly suggestions, an imagination which prefers the unclean, is almost more appalling than the facts of the actual depravity … it is a shame to women so to write … a woman has one duty of invaluable importance to her country and her race which cannot be over-estimated – and that is the duty of being pure. There is perhaps nothing of such vital consequence to a nation.

Oliphant's especial target is Braddon, a woman who has suggested that an 'eagerness for physical sensation' is a 'natural sentiment of English girls'. Miss Braddon (hardly 'pure') did not know 'how young women of good blood and good training feel'. What was hinted at in Britain was shouted in America. In 1866, the *New York Times* ran the headline 'Miss Braddon as Bigamist', strictly speaking untrue, but what a gift of a story!

The irony was, and remains, that a good number of Braddon's novelist contemporaries had, shall we say, complicated private lives. William Makepeace Thackeray was in love with Jane Brookfield. They were married, but not to each other. Thackeray's wife was in an asylum and could do little, but Jane's husband eventually put an end to the relationship, which we are assured was 'intense' but 'almost certainly not sexual (there may have been a chaste embrace or two during the course of a joint stay at Clevedon Court … late in 1848)' according to one biographer's note on Brookfield. Wilkie Collins, Braddon's co-progenitor of sensation fiction, had a long-term relationship with Caroline Graves, but did not marry her, although he was free to do so. He made no great secret of his domestic arrangements because he quite liked to be seen as a rebel. But only up to a point. Collins did not introduce the lower-class Caroline to the wives of his male friends. Later, he had a relationship with Martha Rudd, a Norfolk shepherd's daughter and a servant, who kindly bore the increasingly ill Collins three children. Wilkie ended up with both women, which is some sort of result I suppose. Then there's John Ruskin's pursuit of a child, Rose La Touche, who, at eighteen and able to decide for herself, briefly considered a celibate marriage with him but decided against. Rose died a year after Mary Anne Maxwell in 1875, in an asylum in Dublin. She was twenty-seven. Last but not least, the celebrated artist William Powell Frith who painted, in 1864, the portrait of Mary Elizabeth Braddon you can see at the start of this chapter, had two households, one with his wife, Isabella Baker (who bore him twelve children), and one with his mistress, Mary Alford (seven children). Nobody was that bothered, least of all Braddon, with whom Frith got on extremely well, as recorded in their entertaining correspondence and his memoirs.

Sometimes, the heat got turned up, as when Charles Dickens's relationship with Ellen Ternan precipitated the departure of his wife, Catherine, from their two homes and separated her from all but one of her children. Dickens duly went into cover-up mode, putting statements in *The Times* and his own magazine *Household Words* about

'some domestic trouble of mine' of 'a sacredly private nature' although 'within the knowledge of my children' which has been misrepresented by his enemies 'most grossly false, most monstrous, and most cruel'. 'Sacredly private' it was, and 'sacredly private' it was – pretty much – allowed to remain.[6] Dickens nevertheless trod carefully in public with regard to the relationship with Ternan, not risking a joint trip to America where press exposure was far more likely. On this side of the Atlantic, people covered each other's backs. Everyone knew everyone else's business and – usually – kept that business quiet. So it went, and so it goes, with the English establishment.

Almost all of her male contemporaries, and even some of her female ones, received a free pass with regard to their often deeply unconventional personal lives. Not Braddon, despite her attempts to retain her privacy as far as she could. She refused to be photographed, for example, giving as justification that it was 'such a comfort in moving about the world to be unrecognised', in contrast to some fellow novelists who actively courted celebrity. When William Powell Frith (he of the irregular living arrangements) paints Braddon, approaching thirty, she is dressed in stern black with the tools of her trade. As such she was exhibited in the Royal Academy in 1865, fifty years or so after Jane Austen laughed at the idea that her portrait would appear there as a simpering society lady, all red and white. Andrew Maunder, in his edition of recollections of Braddon, writes that she 'did not apparently unburden herself to anyone – women or men' and Braddon herself, in an unfinished memoir, says, 'I was always silent about things that interested me profoundly – silent even with my mother.' The reticence, the discretion, the attempts to keep the camera at bay, the severe black: none of it worked.

Braddon's sins were against both gender and class. One hundred years on from the publication of her first novel, the prosecuting counsel, seeking to ban D. H. Lawrence's *Lady Chatterley's Lover*, asked a famous question: 'Is it a book that you would even wish your wife or your servants to read?' In the 1860s, Braddon had unleashed

a similar horror. It was not merely that she wrote material that fascinated 'ill-regulated minds' – that had always happened. But in the past, those minds belonged to the 'lowest in the social scale, as well as in mental capacity'. All had changed.

> To Miss Braddon belongs the credit of having penned similar stories in easy correct English, and published them in three volumes in place of issuing them in penny numbers. She may boast … of having temporarily succeeded in making the literature of the Kitchen the favourite reading of the Drawing Room.

In the previous generation, silver-fork novelists including Bulwer-Lytton had served up tales of aristocratic life for readers much lower down the social scale. Now sensational fiction mixed melodrama with a new ingredient: realism.

The violence in sensation novels happens in ordinary places to ordinary people (as well as in extraordinary places and to extraordinary people) in homes like yours. And it is happening now. Indeed, I have to admit that I was shocked when reading *The Trail of the Serpent* by a particularly cold-blooded murder which comes out of nowhere and early: chapter 3. As in *Lady Audley's Secret*, it is not so much the actual violence, but the banality of it that is disconcerting. Henry James viewed Braddon's fiction as an offspring of the Gothic novels so popular at the start of the century, and so satirised by Austen. She reveals the 'most mysterious of mysteries which are at our own doors … instead of the terrors of Udolpho, we are treated to the terrors of the cheerful country house; or the London lodgings. And there is no doubt that these were infinitely more terrible.' Violence is brought close to home.

That a woman could do this touched on some even deeper fears, ones fed by profound beliefs about women and knowledge. W. R. Greg, in his 1859 article 'False Morality of Lady Moralists', could insist that the 'truths' of 'sexual affection', particularly the 'saddest and deepest' truths, are, thank the Lord, hidden from women.

Many of the saddest and deepest truths in the strange science of sexual affection are to her [woman] mysteriously and mercifully veiled and can only be purchased at such a fearful cost that we cannot wish it otherwise.

Greg is relieved that women are ignorant of sexual matters, that the dark places 'are never trodden by her feet, and scarcely dreamed of by her fancy'. But there's a strong hint of not all women. There are women who *do* know about these things, and they purchase that knowledge at a terrible price. (His allusion to the 'science of sexual affection' appeals to the older meaning of the word as knowledge – the one used by Milton when he has his fallen Eve in *Paradise Lost* address the Tree of Knowledge as the Mother of Science.)

Greg is preoccupied with 'sexual affection'. So too was Dallas, whom you will remember as the author of *The Gay Science*. Warming to his theme of what makes good fiction, and taking as gospel that female characters are only interesting when engaging with the opposite sex, he argues that authors are forced, purely on the grounds of keeping the reader's attention, into tackling a 'theme' from which they used 'to shrink'. Readers get descriptions of 'the most hidden feelings of the fair sex which would have made our fathers and grandfathers stare'.

This is precisely what Braddon does in *Lady Audley's Secret*. Within the novel's fictional world, Robert Audley achieves a successful cover-up. To the reader, Braddon reveals the hidden sexual history of Helen Maldon, Mrs George Talboys, Lucy Graham, Lady Audley and Mrs Taylor. And Margaret Oliphant is quite sure why Mary Elizabeth Braddon is capable of this. The fascination with bigamy plots 'could only have been possible to an Englishwoman *knowing* the attractions of impropriety and yet loving the shelter of the law' (my italics). Indeed, it was not just sex about which Braddon knew too much. It was horse racing and the theatre, the life of the working classes, drinking and fighting and crime and Paris. She knew too much about men, showing as much 'intimate knowledge of easy

male society' as she did of women's matters, with the latter meaning gussets, seams and dresses and the former theatricals, horses and dogs 'and little Paris dinners' and we all know what happens at little Paris dinners. Even the relatively sympathetic Henry James is snide, writing of Braddon's 'intimate acquaintance with that disorderly half of society which becomes every day a greater object of interest to the orderly half'. As James writes, almost choking on what he calls 'an irresistible vulgarism', 'Miss Braddon "has been there".

All of this goes way beyond the straightforward implication that the only way that Braddon can create a character like Helen Maldon is because she has 'been there' which, by the by, sounds uncomfortably close to those feminist analyses which talk of Braddon 'identifying' with Lady Audley thereby reducing the novelist's achievement to a confession of self. No, this goes deep. It represents yet another powerful proscription upon women as to what they can or cannot have authority to speak or write about, what they can or cannot or, if we are being honest, *should* not know.

VI

The attacks kept coming and they hurt. Braddon's 'half cynical acquiescence in immorality' was deplored, her vulgarity condemned, and even her 'cleverness' was that 'of a clever barmaid'. The clever barmaid wrote to Bulwer-Lytton in October 1867 that:

> I am made the target for every scribbler's venomous [*sic*] shaft …
> It is quite as much as I can do to struggle against the disgust and
> depression occasioned by little carping criticisms which *teach* me
> nothing, & indeed seem intended only to wound & annoy.

Wounded and annoyed, certainly, but I am less sure that Braddon channelled the 'pain' of her situation as an almost-bigamist into her

writing, as argued by her first biographer, Robert Wolff. The pain she experienced was not from her actual situation (the evidence suggests that she and Maxwell were happy together, professionally and personally) but from the actions of those who sought to hurt her.

Braddon fought back by defending her literary, rather than her lifestyle, choices. In her privileged and rare role as (female) editor of *Belgravia* magazine, she could commission writers to argue for sensationalist fiction and they duly did so, with comparisons to Shakespeare, nods to Dickens (actually a sensationalist), and a vigorous defence of the realism of the novels. Prudery and 'cant' were temporary fads, adults were being treated as children. In the real world, real men and women don't want baby-food: 'We want meat: and this is a strong age, and we can digest it.'

If her enemies wanted Braddon to hang up her pen, then they had misjudged the woman. As her husband (legally so by the time he wrote these words) put it, 'It is as natural for her to write as it is for a mountain torrent to flow.' Braddon herself was aware that her experience of life was an asset to her fiction, if not to her reputation. Reflecting on her extremely close relationship with her mother, constant companions and confidantes from the time Fanny left Mary's father, Braddon writes that her mother 'told me much that is not generally told to a girl'. There is no sense that this was wrong, too much too young. There is not even condemnation of her father's role in ensuring that mother and daughter had to fend for themselves. It is a straightforward explanation of the novelist's precocious knowledge of the world.

I suspect that Braddon continued to produce her meaty fiction to prove her critics wrong, but I know that she continued to write because she loved and needed to create. She knew she was driven: 'I write every day … tormented by all kinds of petty cares – & always impressed by the ever present idea that I ought to write so many pages before I dine, or I have lost a day.' She knew she used writing to escape: 'Writing novels has become now a sort of second nature to me. I live for little else, & try to shut away all thought of trouble

by plunging into pen & ink.' Trouble included the death of her child, Francis, in 1866, the year during which Braddon took on the editorship of *Belgravia* and, battling depression, produced just one novel. Within months, she was back on track, the title page of the June 1867 edition of *Belgravia* promising inside *Birds of Prey*, a novel by the author of Lady Audley, etc., etc., and *Circe* by Babington White – aka Mary Elizabeth Braddon. The next edition, in October, launched yet another serial from 'the author of Lady Audley, etc.'. I feel exhausted just looking at the contents pages. But Braddon needed the deadlines and pressure, from within and without – because without them the words would not come.

As time went on, as the money poured in, as the big houses were bought (in Richmond-upon-Thames and then the New Forest), Braddon did not need to write, and she certainly did not need to write as many books as she did. So what motivated her? There's a typical honesty in one of her answers to the question. She has 'a noble desire to attain something like excellence' but that is trumped by 'a very ignoble wish to earn plenty of money'. Braddon's letters and diaries show that those big houses were often filled with family (those ten children) and friends (many, many friends, some who stayed for long periods), none of which comes cheap.

Braddon's unfinished memoir offers meagre pickings when it comes to motivation, not least because although it runs for 185 typewritten pages, we only reach Mary Elizabeth, age eight or nine. The title 'Before the Knowledge of Evil' suggests a Freudian angle to Braddon's biographer Wolff, a woman preoccupied by her sinful father's intrusion into her happy relationship with her mother. Or perhaps Braddon viewed her adult life (actress, author, and mistress of Maxwell) as 'evil' and would only write about the beforetime. When I look at a letter written in the aftermath of Maxwell's death in which she admits she had hoped for a little longer with him but a 'three days' illness, influenza, ended that hope' and praises him for being the 'best and most unselfish of husbands', a man who 'never shirked a domestic duty, however difficult and painful', I see a widow

grieving for the man with whom she had apparently been very happy for over forty years, rather than some hidden angst regarding the author's father's 'shirking' of his domestic duty – the view of Wolff again, looking for Mary Elizabeth's demons.

There are absolutely no other indications that Braddon believed her acting, writing or relationships were sinful, whatever the views of her society. Instead, as an adult, Braddon learns about evil but she is neither defeated nor silenced by that knowledge. She uses it, she writes it, she owns it, she can even make us laugh about it. It is her way of surviving in the world. It makes her the writer she is.

Braddon as memoirist may have turned to her childhood because she had already written about herself as an adult in her novel, *The Doctor's Wife*. Not as a mistress, wife or mother, but as an author. Sigismund Smith (Sam by birth and to his friends, but Sigismund works so much better don't you think?) is very much a self-portrait of the female artist as a young man. Braddon pokes fun mercilessly at her own literary practice. Plagiarism? Well, 'when you're doing four great stories a week for a public that must have a continuous flow of incident, you can't be quite as original as a strict sense of honour might prompt you to be'. Pretension? 'I call my Jeannie "Aureola"; rather a fine name, isn't it? and entirely my own invention'. And most delightfully, Smith's plan to re-write Oliver Goldsmith's charming, gentle novel of manners, *The Vicar of Wakefield*, in the 'detective pre-Raphaelite style'. Braddon brings her alter ego back in *The Lady's Mile*, but now he has abandoned the penny public to court the favour of circulating library subscribers, and duly 'sublimated the vulgar Smith into the aristocratic Smythe'. Everything about this glorious character (as unromantic as the prosiest butcher) suggests that Braddon not only knew exactly what she was doing as an author but that she thoroughly enjoyed doing it too.

There's a particularly revealing moment when the newly minted Smythe talks of people's disappointment when they meet him. He is now a celebrated novelist and his fans expect him to be dark, swarthy and diabolical – a very Mephistopheles. Instead, they sidle away,

disappointed by quite how ordinary he is. Surely this is Braddon writing of herself.

Her own early fiction was sentimental, modelled primarily on *Jane Eyre*: 'Stories of gentle hearts that loved in vain, always ending in renunciation'. As Henry James recognised, Braddon grew up. Her novels were 'brilliant, lively, ingenious and destitute of a ray of sentiment'. Mature Braddon was sceptical: 'I think the faculty of writing a love story must die out with the first death of love. We cease to believe in the God when we find that he is not immortal.' So much for love. In another truly remarkable letter, she goes further to explore what it is to write as a woman, and a woman who has begun to question 'romance', who sells rather than lives through her imagination.

> I have begun to question the expediency of very deep emotion, & I think when one does that one must have pretty well passed beyond the power of feeling it. It is this feeling, or rather this incapacity for any strong feeling, that, I believe, causes the flippancy of tone which jars upon your sense of the dignity of art. I can't help looking down upon my heroes when they suffer, because I always have in my mind the memory of wasted suffering of my own.

Braddon is, at first sight, not only justifying her impressive comic abilities but also defending herself against an implicit charge of unfeminine coldness. She goes on, however, to do something astonishing, a re-write of *Othello*. Shakespeare's play recounts the domestic tragedy whereby a husband kills his wife because he believes, wrongly, that she has been unfaithful to him. When Othello realises his mistake, he kills himself. Yes, writes Braddon, Othello suffered, but he could have avoided all that grief by 'packing his portmanteau & writing a few lines to Desdemona to the effect that he had reason to believe her a very wicked woman', before leaving Cyprus and sorting out an adequate income for her to live on 'through the hands of his solicitor &c'. Above all Othello 'might have avoided all the bolster & pillow & subsequent dagger business & lived down his sorrow; lived

perhaps to wonder what he had ever seen in Brabantio's whey-faced daughter'.

Braddon's irreverence towards the Bard ('flippancy of tone') masks but does not conceal a profound message about 'very deep emotion'. It is not merely futile, 'wasted suffering', but it is dangerous and particularly dangerous to women. Suddenly it is not women's emotional imbalance that threatens society, it is men's. Braddon is challenging Victorian gender pieties on at least two levels. She refocuses attention on Othello's instability, ignoring Desdemona's selfless attempt to acquit her 'kind lord' husband of her own murder in a final gasped lie. Braddon's target is Othello. He could and should have been a bit more sensible. He would have moved on. Men do. He would have found someone else. Above all, Othello did not need to kill his wife – 'all the bolster & pillow' business. Desdemona did not need to die.

VII

Mary Elizabeth Braddon died on 4 February 1915, a few weeks after the first Zeppelin air raid on Britain, a few months after the death of 54,000 men at Ypres. She was, unsurprisingly, 'downhearted' about the war. Did she take comfort from her son Will's assurance in November 1914 that it would 'be over before his Battalion is ready to go to France'? She undoubtedly took comfort from her career. In what was perhaps another false start to a memoir, she wrote that 'The history of my life is for the most part the history of the books I have written'. Those books by 1915 constituted eighty novels, with *Lady Audley's Secret* still in print. Let's not even count the plays, poems, journalism – and screenplays. Braddon's brand of fiction was a perfect fit for the early film industry, precisely because it lacked dialogue and interiority, and offered plentiful melodrama and horror. I was delighted to find that, into her seventies, Braddon purchased a motorcar, watched 'an aeroplane in full flight, descending, and

stationary' and went to see – and sent her staff to see – *Aurora Floyd* at the cinema. Her books had a truly global reach. Robert Louis Stevenson wrote to her from his adopted home, Samoa, in 1894 to say that she was 'out and away greater than Scott, Shakespeare, Homer, in the South Seas'. An 1895 poll had Braddon as 'the most popular of our lady novelists'.

And then she was not only forgotten, but discarded. It is as if in a hundred years' time, no one would read Harry Potter or have heard of J. K. Rowling.

Afterword

It seems that selling a lot of books was not enough. Being big in Samoa was not enough. Being a national treasure in your seventies, an old woman of 'sweet soul and a well-stored mind' who reminds the British of their better, past selves, was not enough. Did she do charity work? Of course. Mrs Maxwell's Holiday Fund provides vacations for underprivileged children. Had she lived down her scandalous past? Yes, for in 1876, she acts in a charity performance and no one connects Mrs John Maxwell with Mary Seyton. Has she given carefully chosen celebrity interviews? Absolutely. Here's 'Miss Braddon at Home', a self-avowed 'Tory by birth and instincts – I love old things, old habits, old houses, old customs, old trees, old halls, old costumes.'

> My idea of a perfect and pleasant day is to devote the whole of it to writing and reading; when I say the whole of it, I mean from breakfast at ten, say until dinner at seven, with intervals of strong tea, and sometimes a little luncheon. I can do this four days during the week and enjoy it, and get through a lot of work, if I have the other two for riding, and more especially for hunting.

You would think that a loving husband and brother who keep your manuscripts, and bind them, beautifully, permitting your descendants to present the volumes to the State Library of Tasmania, would help to keep your name alive. You would hope that the memoir written by your son in 1937, and which creates you as a model of perfect Victorian femininity with not a whiff of scandal, a woman with a 'naturally … happy disposition', modest through and through ('Just as she never talked about herself, she very rarely thought about her self'), the 'true source of 'happiness in the house', its 'gentle unselfish mistress', would satisfy the gender police. No. Still not enough.

Intellectual snobbery as much as sexism lies behind Braddon's forgetting, although the two have been known to go hand in hand. She herself was only too well aware that she was only and ever a 'popular' writer. She gives her fictional double, Sigismund Smith, a speech about the remarkably prolific playwright Guilbert de Pixérécourt (more than a hundred plays in the first third of the nineteenth century) who was 'never a great man; he was only popular'. But as Smith says, 'isn't it something to have his name in big letters in the playbills in the Boulevard?' and, as important: 'He did what was in him honestly and he had his reward.'

During her lifetime, Braddon did what was in her honestly, had her reward, and more serious authors lined up to condemn her. In 1866, George Eliot complained to her publisher John Blackwood that she sickens with:

> despondency under the sense that the most carefully written books lie, both outside and inside people's minds, deep undermost in a heap of trash. I suppose the reason my 6/ [shilling] editions are never on the railway stalls is partly of the same kind that hinders the free distribution of Felix. They are not so attractive to the majority as 'The Trail of the Serpent'.

Braddon is 'trash', but goodness she does sell.

Fast forward nearly thirty years. M. E. Braddon has written some more serious novels, even some campaigning novels. She is now married to John Maxwell, legitimising their domestic arrangements if not their five surviving children. But still the novelist George Gissing satirises the couple in his *New Grub Street*'s Mr and Mrs Jedwood, the latter a lady novelist who goes by the name Miss Wilkes. Gissing snidely comments on 'Miss Wilkes's profits', and the way a nonentity like Mr Jedwood can rise by the 'stroke of fortune which had wedded him to a popular novelist'. It's all a bit harsh, given that by 1892, John Maxwell was an invalid and Braddon's novel of that year, *Like and Unlike*, focused on the contrasting lives of a sex worker and a society hostess, showing that 'Miss Wilkes' was as interested in gritty social realism as Gissing. But like Eliot, Gissing is really stung by Braddon's selling power, writing bitterly that one of his novels was rejected because it was 'too painful to please the ordinary novel reader and treats of scenes that can never attract the subscribers to Mr. Mudie's Library'. Gissing and Eliot, despite their undoubted radicalism and literary skill, were dismissive of the 'majority', the 'ordinary', reader, and – in Gissing's case – thoroughly disturbed by the spectre of a professionally and economically successful woman who supports her man.

Things started to change once the feminists got hold of Braddon. Her late arrival at the literary history ball was thanks primarily to their sterling work, including their (entirely correct) claim that she was one of the progenitors of sensation fiction. Braddon is now also acknowledged as one of the earliest writers of British detective fiction. Her sleuth in *Lady Audley's Secret* may not be quite as groundbreaking as Peters in her 1860 *The Trail of the Serpent* (as a deaf man, he is a rarity in the genre) but to be in at the birth of two genres – and all within eighteen months – is quite an achievement for any author. But the celebration of Braddon's skill sits alongside frustration with her caution. She offers fantasies of escape, perhaps even protest, but fails to offer any solutions to the problems she exposes in her fiction. Again, we place a heavy burden on the female author. Women

are asked to do the feminist work, to offer solutions to structural inequalities and injustices, while Dickens is allowed to conclude his survey of the horrors of working-class industrial life with Stephen Blackpool's 'it's aw a muddle, lass. It's aw a muddle.'

Each generation creates Jane Austen (and Charles Dickens and William Shakespeare) in its own image. One of the truisms of literary criticism is that great writers create great work that enables us to do so, to transform, say, the apparently conventionally misogynist *Measure for Measure* into a feminist statement by highlighting a moment of silence at the play's end. But this subversive interpretation was only made possible because Shakespeare's plays live on – and how. Braddon's words disappeared. We should have been arguing about the end of *Lady Audley's Secret* and the end of Lady Audley for the last 150 years. That we have not been doing so is one of the sadnesses driving this book.

In the End

A STRAND in feminist literary philosophy insists that any and all women's access to language, to the Word, is determined by the cultural constructions of patriarchal power. Authentic women's writing is therefore impossible because men control language. All that is left to those born female is a form of imitation of male discourse. A text might be self-reflexive, sophisticated or even subversive, but it remains mimicry in a patriarchal literary economy. It is impossible to change the script. We cannot redeem Eve, however many times we re-write her.

Scholars of the New Testament have their own perspective on this, developed as they explore how and why women have been excluded from the narrative of Christ's crucifixion and resurrection. Jane Schaberg, for example, is convinced that Mary Magdalene was the first person to see the risen Christ but Mary's historical witness:

> is seen as romantic, emotional, crazed; her influence regarded as inessential, insignificant, minor. Even some modern historical research seems to be tainted with the subliminal thought: O so it depends on the word of a whore? Anything to avoid it all depending on her word, the word of a looney …

The response to this erasure is to reimagine Mary, transforming the Magdalene from a penitent prostitute to the 'apostle of apostles' and/or Jesus's wife, mother of his child, perhaps even the feminine divine. Look, here's (the new, improved) Mary Magdalene.

Anna Fisk, whose work I mentioned in my opening chapter, has thought hard about what's going on here. She reminds us that this salvational Mary is a thoroughly precarious, almost desperate, construction, pieced together from very little – almost as little as the conventional reading of the Magdalene as 'whore' which is based on five words: 'woman who was a sinner'. Even Schaberg, so keen to bring her Mary forward, acknowledges that Mary's memory stands 'as a warning: there is nothing in Christianity for women and there never was'.

The rest can only be silence.

II

All eight authors in this book would have recognised this debate, although conducted in different terms. They write in the shadow of the Fall, of the Tree of Knowledge, of Eve. They write in worlds in which words and the Word belong to men, as does social, economic and political power. They write with and against the myths they inherit – and not only those concerning sex and gender. They negotiate with, retell, re-write foundational texts, whether the Bible, fairy tales or Shakespeare. They write knowing that silence is the safer path but it is not the one they take.

The women in this book know they will need to collaborate with men, indeed are dependent on men, whether within the family or beyond, and that if they earn money, let alone good money, someone will dust down the age-old link between sex work and literary work and use it against them. From Julian of Norwich to Mary Elizabeth Braddon, they write knowing that it is never simply a matter of getting the works written, tough though that can be. They will then find

it harder than their male contemporaries to reach readers, whether in their own time or beyond. No wonder they often long to take their gender out of the equation, despair at how what we now call identity politics are weaponised against them. Because above all, each and every author writes knowing that their selves as much as their literary works will be scrutinised.

I would not have written this book unless I believed that attending to women's lives matters as much as attending to their words. Mary Elizabeth Braddon spent her life being told what she was, most obviously and notoriously as Maxwell's mistress. Not much of it was kind. All of the women in this book articulate similar experiences, at one point or another, in one form or another, bearing witness to the effect upon them – sometimes spurring them to action, sometimes stopping them in their tracks. I want to pause, in these final pages, on just one of those moments, which comes in a letter of Braddon's, written in 1866, when she had recently been appointed editor of *Belgravia*.

She writes of the 'wonder' of seeing her name 'emblazoned anon on hoardings & railway stations'. There's a hint of modesty, of discomfort with publicity, but also something deeper, which she reveals in her next sentence: 'I think that it is not me – but some bolder and busier spirit which worketh *for* me – and which I would at times fain lull to temporary rest'. This does not suggest to me that Braddon is tyrannised by her professional, creative self, that all she wants to do is stay home and bake cookies. Indeed, as with Anne Bradstreet, over two hundred years earlier ('But if I rest, the more distressed my mind'), Braddon did not like to stop. Like Montagu and Austen – and I'd like to think the other authors in this book – Braddon, from early childhood on, simply loved the business of writing. She was the little girl who saw a performance of *Cinderella*, then read over and over again the 'book of the words', the schoolgirl with a 'stolid method of composition, plodding on undisturbed by the voices and occupations of the older girls around me'. Braddon at about thirty years old merely wants a temporary break from pressure, not a cessation of all creative work.

The next line, which concludes her contemplation of the billboard, is what strikes me most: 'I find there is nothing more difficult than to live one's own life.' I hear an echo of Jane Austen's letter in which *she* (metonymically her books) enjoys being known in Ireland but *she* (physically the spinster of Chawton, living with her mother, sister and friend Martha) does not wish to be known by the inquisitive world: two Janes. I hear a hint of the very last of Lady Mary Wortley Montagu's *Letters* when she addresses, obliquely, what it is always to be written. She is offering a burlesque poem to her correspondent and admirer, Alexander Pope, in which she makes fun of his effort on the same subject, the death of a rustic couple, John Hughes and Sarah Drew. Montagu is thoroughly, almost shockingly, flippant:

> Here lies John Hughes and Sarah Drew;
> Perhaps you'll say, What's that to you?
> Believe me, friend, much may be said
> On that poor couple that are dead.

And on she goes, suggesting that their death might well have been a lucky escape:

> Who knows if 'twas not kindly done?
> For had they seen the next year's sun,
> A beaten wife and cuckold swain
> Had jointly curs'd the marriage chain:
> Now they are happy in their doom,
> FOR POPE HAS WROTE UPON THEIR TOMB.

The specific context for this exchange was Pope's demand for an emotional, sentimental response to the dead lovers, to his poem, and above all to him as man. It was a response that Mary Wortley Montagu was entirely unwilling to provide. Pope wrote that he sought a 'Tear from the finest eyes in the world. I know you have Tenderness;

you must have it…'. Does he? Must she? Montagu is having none of it. She laughs at herself, at marriage, at sentimentality, but crucially she also mocks Pope's power to confer significance on the dead lovers – and on her, in life or death. She prefers to 'continue to be your stupid *living* humble servant' rather than 'be *celebrated* by all the pens in Europe'. She will live, not die. She will write, not be written.

Returning to Braddon's weary acknowledgement that 'there is nothing more difficult than to live one's own life', fifty years on from her billboard moment, the novelist set out to *write* her own life. Remember this is a woman who asserts that the 'history of my life is for the most part the history of the books I have written'. It should have been straightforward, but Braddon – no quitter – laid down her pen. Did she recognise the truth hinted at in Austen's letter? In her case, not the two Janes, but Polly and M. E. Braddon. It was not that there was 'nothing more difficult' than to write one's own adult life, but that it really wasn't worth the trouble. I would suggest Braddon knew, as woman, she had already been written.

Eve is not biting back, she just wants a break from being Eve. Braddon and Austen want their work to be read, not their lives. Cassandra Austen understood. She was protecting the second Jane from the world when she burned her letters. The families of Anne Bradstreet and Lady Mary Wortley Montagu did the same. Mary Elizabeth Braddon did it herself, writing in her diary, nine months after the death of her husband, John Maxwell: 'Burning M's letters afternoon.' These women (and their supporters) are seeking to hide the life, hoping that the work will be the more clearly seen, in the same way that some feminists now warn against the biographical turn because it will lead only to sexism.

It's a risk I am willing to take, as I try to hold the life and the work in the same frame. For me, it remains the most powerful way to appreciate these women's achievements as authors and to understand why, still today, they and their work constitute an alternative history of literature in English.

III

Doctor Who, experiencing being female for the first time in 2018, puts it well: 'Honestly, if I were still a bloke, I could get on with the job and not have to waste time defending myself!'[1] To 'get on with the job' as a woman means of necessity wasting time and energy engaging with society's beliefs about what women can and cannot do, what women *are*, but still managing to get the words down, whether on vellum or hot-pressed paper, with quill or fountain pen.

Even then, there were no guarantees that those words would reach the future, reach us. Back in 1611, Aemilia Lanyer offered her poetry to a noble woman with the humble hope that 'When I am dead thy name in this may live'. I hear contained within those monosyllables an unspoken, greater hope, that the author's name and words might live too. Somehow, and with little or no thanks to the gatekeepers of literary patriarchy, the words of the authors in this book have reached us – loud and clear in some cases (Jane Austen and Julian of Norwich, for example), mere whispers in others. My own hope is that these chapters amplify the voices that have been too long muted and encourage a reassessment of those voices that we think we already know. Or, to echo Lanyer, that these authors' names and their words 'in this may live'.

Acknowledgements

I am fortunate in having been able to continue to research (virtually) and write (at home) during these Covid times with the added blessing of the ghostly company of eight inspiring female authors of genius and resilience. But the moments when I could sit in a library – masked, sanitised and distanced – were very precious, and I am deeply appreciative of all the efforts made by the librarians here in Oxford to make those moments possible. Thank you also to everyone at Oneworld Publications for keeping the show on the road but especially my astute, generous editor, Sam Carter, who has made this a better book. Any errors and infelicities that remain are entirely my responsibility.

My agent Kirsty McLachlan's encouragement to think big provided the germ for *Eve Bites Back*. Conversations with my teachers and students over many years are woven into every chapter. But without the kindness of friends this book would simply not have been completed. Thank you especially (and in strict alphabetical order) to Kathryn Basson, Antonia Bruce, Dave Crossley, Katrina Crossley, Jane Draycott, Karen Elliott, Richard Gipps, Madeleine Katkov, Martha Maguire, Jayne Marshall and Paul Schwartfeger.

Those closest to me (most notably the rather wonderful Hugh Weldon) have witnessed most starkly the sometimes messy realities of a writer's life. My daughters, Rebecca and Elise, facing their own battles, continue to astound me with their wisdom, courage and spirit. Every page of this book owes something to them. I do so hope all shall be well.

Notes

1. Julian of Norwich and Margery Kempe

1 British Library, Add. MS 37790, https://www.bl.uk/collection-items/the-short-text-of-julian-of-norwichs-revelations-of-divine-love, f. 97r.
2 British Library, Add. MS 61823, https://www.bl.uk/collection-items/the-book-of-margery-kempe.
3 Anke Bernau provides a survey of medieval misogyny in her chapter, 'Medieval Antifeminism', in *The History of British Women's Writing, 700–1500*.

3. Anne Bradstreet

1 Gog represents the heathen in Hebrew and Christian Scripture.
2 A good starting place is 'Historical Foundations of Race', National Museum of African American History and Culture, available at: https://nmaahc.si.edu/learn/talking-about-race/topics/historical-foundations-race.
3 See the marvellous Heather Wolfe's work on this and so much more.

4. Aphra Behn

1 Roberts, *Restoration Plays and Players*, chapter 2.
2 Biographer Janet Todd offers an Eaffrey Johnson, born on 14 December 1640 near Canterbury, daughter of Bartholomew Johnson from Bishopsbourne, who, amongst other jobs, was a barber in Canterbury, and his wife Elizabeth Denham from a trading family in Smeeth. Even if this is not our Aphra/Eaffrey, then almost every biographer agrees that she was born and bred in Kent.
3 See Hopkins, 'Aphra Behn and John Hoyle'.

5. Mary Wortley Montagu

1 There's quite a lot of nonsense written about this relationship. Lady Mary did not elope to Italy with Algarotti nor was her passion for the man a sign of the complete breakdown of her marriage to Edward. Algarotti was bisexual, with Lady Mary's chief competitor being Lord Hervey, also bisexual and the recipient of similar levels of bile as Montagu. Romantic rivals they may have been, but Hervey and Montagu joined forces as writers to fight back against, amongst others, Alexander Pope. Nobody was very nice. Hervey wrote about the hunchbacked Pope that the only reason his 'wretched little carcass' remained 'unkick'd' and 'unslain' was because people pitied his ugly body. Conspiracy theorists, then and now, suggest that Pope made sure this attack was published partly to gain sympathy for himself, partly to justify his sinking to new lows in his own reply.

2 Here's the 'head' to a letter to Madame Kielmannsegge, half-sister to the King and sometimes, incorrectly, referred to as his mistress. '1. I won't tell how oft I have writ, I will think she remembers me. 2 Balm of Mecca. Potargo. 3 Greek no Slaves. Magnificence and dress of Turks. Bagnio Civillity. French Ambassadresse. Ceremony. Pomp. Court to me. Fine weather. One letter to serve for many. Nothing to recompence. My picture.'

6. Jane Austen

1 Austen's manuscript (New York Morgan Library & Museum MS. MA 1034), in which you can see the author's revisions and insertions, is reproduced in Kathryn Sutherland (ed.), *Jane Austen's Fiction Manuscripts*, vol. 4.

2 Austen is referring to the conservative novelist Jane West whose 1796 novel *A Gossip's Story* is seen by some as an influence on *Sense and Sensibility*.

3 'In Memory of JANE AUSTEN youngest daughter of the late Revd GEORGE AUSTEN formerly Rector of Steventon in this County She departed this Life on the 18th of July 1817, aged 41, after a long illness supported with the patience and the hopes of a Christian. The benevolence of her heart, the sweetness of her temper, and the extraordinary endowments of her mind obtained the regard of all who knew her and the warmest love of her intimate connections. Their grief is in proportion to their affection, they know their loss to be irreparable, but in their deepest affliction they are consoled by a firm though humble hope that her charity, devotion,

faith and purity have rendered her soul acceptable in the sight of her REDEEMER.'

7. Mary Elizabeth Braddon

1 Braddon later described Gilby as her 'Mæcenas in Beverley', 'a learned gentleman who volunteered to foster my love of the Muses by buying the copyright of a volume of poems and publishing the same at his own expense – which he did, poor man, without stint, and by which noble patronage of Poet's Corner verse, he must have lost money. He had, however, the privilege of dictating the subject of the principal poem, which was to sing – however feebly – Garibaldi's Sicilian campaign.' There's a flavour of 'more fool him' to all this. Others were less reticent. Someone who knew both parties believed that Gilby wished to be 'father, lover and friend' to Mary but was completely out of his depth.

2 A far-from-everyday tale of a passionate, raven-haired woman who loves her horses – and her groom – and is handy with a horsewhip, *Aurora Floyd* is often more critically admired than Braddon's other so-called 'bigamy' novel, *Lady Audley's Secret*.

3 Mansel, 'Sensation Novels', quoted in Tomaiuolo, *In Lady Audley's Shadow*.

4 Maxwell married Mary Anne Crowley (according to her aggrieved brother-in-law, the only source of information for her life) on 7 March 1848 in Saint Aloysius's Chapel, Somers Town, London – built as part of the Catholic Revival in England. She was twenty-two. After the birth of the couple's youngest child 'a separation took place between the parents, and Mrs Maxwell resided thenceforth with her family in the neighbourhood of Dublin.' It's still repeated that Mary Anne was incarcerated in an asylum in Dublin, with dark hints that her husband had placed her there when she became inconvenient to him, her insanity (puerperal) provoked by childbirth. No one familiar with the Victorian era's treatment of difficult women would discount this story, but in this case, there was probably no asylum. Less melodramatic, but equally sad, it appears that Mary Anne ('broken in mind and body') went home to her parents, and her children remained with their father or at school. An admittedly hostile witness, the same Anna Hall who had admired Braddon's work back in 1860, and perhaps felt duped as to the young novelist's innocence, recorded a conversation with Maxwell about Mary Anne. He told her, 'coolly', that she was 'defunct'. Was she dead? (Hall knew she was not.) He merely repeated, with emphasis: 'she is *de*-funct'. The original Mrs Maxwell would live

until 1874. Her brother-in-law remained reticent on the cause of death, mentioning only 'a long and severe illness'.

5 Mansel, 'Sensation Novels', quoted in Tomaiuolo, *In Lady Audley's Shadow*.

6 Maxwell's own attempt to use print media to diffuse the scandal of his living arrangements failed spectacularly. In hindsight, the notice ('Miss Braddon, the novelist, was recently married to Mr Maxwell, the publisher') seems utterly misguided, given that his wife was alive if not well in Dublin, something her brother-in-law, Richard Brinsley Knowles, pointed out in an acid, if vague, rebuttal: Mary Anne 'who has borne her husband a large family, is still living.' When Mary Anne Maxwell did finally die, in 1874, it was Brinsley Knowles's turn to weaponise print media, when he published deeply insensitive telegrams sent by John Maxwell at the time of his wife's death.

In the End

1 Joy Wilkinson, 'The Witch-Finders', *Doctor Who*, Series 11, Episode 8, aired 25 November 2018.

Works Cited

Harriet Andreadis, 'The Sappho Tradition', in *The Cambridge History of Gay and Lesbian Literature*, ed. E. L. McCallum and Mikko Tuhkanen, 2014, pp. 15–33

Anon., *The British Critic*, 9, March 1818, pp. 293–301

Jane Austen, *Teenage Writings*, ed. Kathryn Sutherland and Freya Johnston, 2017

Juliet Barker, *The Brontës*, 1995

Leeds Barroll, 'Looking for Patrons', in *Aemilia Lanyer: Gender, Genre, and the Canon*, ed. Marshall Grossman, 1998, pp. 29–48

Christine Battersby, *Gender and Genius: Towards a Feminist Aesthetics*, 1989

Anke Bernau, 'Medieval Antifeminism', in *The History of British Women's Writing, 700–1500*, vol. 1, ed. Liz Herbert McAvoy and Diane Watt, 2012, pp. 72–82

Mary Blume, 'Elisabeth Lutyens', *International Herald Tribune*, 9–10 January 1982

Anne Bradstreet, *The Works of Anne Bradstreet*, ed. Jeannine Hensley with a foreword by Adrienne Rich, 1967

Kathleen J. Bragdon, *Native People of Southern New England 1650–1775*, 2009

Daniel Brayton, 'Bradstreet, Anne', in *The Oxford Encyclopedia of American Literature*, 2004

Martin Butler, 'Jonson's Folio and the Politics of Patronage', *Criticism*, 35, 3 (1993), pp. 377–390

Caroline Walker Bynum, *Holy Feast and Holy Fast: The Religious Significance of Food to Medieval Women*, 1987

Gordon Campbell, *Bible: The Story of the King James Version 1611–2011*, 2010

R. W. Chapman, *Jane Austen: Facts and Problems, The Clark Lectures, Trinity College, Cambridge*, 1948

Julie A. Chappell, *Perilous Passages: The Book of Margery Kempe, 1534–1934*, 2013

Eneas Sweetland Dallas, *The Gay Science*, 1866

Theresa M. DiPasquale, *Refiguring the Sacred Feminine: The Poems of John Donne, Aemilia Lanyer, and John Milton*, 2008

Margaret J. M. Ezell, *Social Authorship and the Advent of Print*, 1999

Anna Fisk, 'Stood Weeping Outside the Tomb: Dis(re)membering Mary Magdalene', in *The Bible and Feminism: Remapping the Field*, ed. Y. Sherwood, 2017, pp. 150–169

Kate Flint, 'The Victorian Novel and Its Readers', in *The Cambridge Companion to the Victorian Novel*, ed. Deirdre David, 2000, pp. 17–36

Charlotte Gordon, *Mistress Bradstreet: The Untold Life of America's First Poet*, 2005

T. Gould and C. Battersby, 'Genius', in *Encyclopedia of Aesthetics*, 2014

W. R. Greg, 'False Morality of Lady Novelists', *National Review*, 8 (January 1859), pp. 144–167

W. R. Greg, 'Why Are Women Redundant?', *National Review*, 14 (April 1862), pp. 434–460

Isobel Grundy, *Lady Mary Wortley Montagu: Comet of the Enlightenment*, 2001

Isobel Grundy, 'Montagu, Lady Mary Wortley [née Lady Mary Pierrepont] (bap. 1689, d. 1762), writer', *Oxford Dictionary of National Biography*, 2004

G. S. Haight (ed.), *The George Eliot Letters, 1869–1873*, 1954

John Halperin, *The Life of Jane Austen*, 1984

Madeline E. Heilman and Tyler G. Okimoto, 'Why Are Women Penalized for Success at Male Tasks?', *Journal of Applied Psychology*, 92, 1 (2007), pp. 81–92

Claudine van Hensbergen; '"Why I Write Them, I Can Give No Account": Aphra Behn and "Love-Letters to a Gentleman" (1696)', *Eighteenth-Century Life*, 35, 1 (2011), pp. 65–82

P. A. Hopkins, 'Aphra Behn and John Hoyle: a Contemporary Mention, and Sir Charles Sedley's Poem on his Death', *Notes and Queries*, 41, 2 (June 1994), pp. 176–185

William Henry Hudson, *Idle Hours in a Library*, 1897

Henry James, 'Miss Braddon', *The Nation*, 9 November 1865

Honorée Fanonne Jeffers, online discussion, Cultural Office of the US Embassy in London, 22 March 2020

Sarah Rees Jones, '"A peler of the Holy Cherch": Margery Kempe and the Bishops', in *Medieval Women: Texts and Contexts in Late Medieval Britain*, ed. Jocelyn Wogan-Browne et al., 2000, pp. 377–391

Rebecca Krug, *Margery Kempe and the Lonely Reader*, 2017

Christina Luckyj, 'Not Sparing Kings: Aemilia Lanyer and the Religious Politics of Female Alliance', in *The Politics of Female Alliance in Early Modern England*, ed. Christina Luckyj and Niamh J. O'Leary, 2017, pp. 165–182

Rev. Henry Longueville Mansel, 'Sensation Novels', *Quarterly Review*, 113 (April 1863), pp. 481–514

Robert Markley, 'The Canon and Its Critics', in *The Cambridge Companion to English Restoration Theatre*, ed. Deborah Payne Fisk, 2000, pp. 226–242

Andrew Maunder (ed.), *Lives of Victorian Figures V: Mary Elizabeth Braddon*, 2007

Dervla Murphy, Introduction to *Embassy to Constantinople: The Travels of Lady Mary Wortley Montagu*, ed. Christopher Pick, 1988

Margaret Ellen Newell, *Brethren by Nature: New England Indians, Colonists, and the Origins of American Slavery*, 2015

Marcy L. North, 'Women, the Material Book and Early Printing', in *The Cambridge Companion to Early Modern Women's Writing*, ed. Laura Lunger Knoppers, 2009, pp. 68–82

Daniel O'Quinn, *Engaging the Ottoman Empire: Vexed Mediations, 1690–1815*, 2018

Margaret Oliphant, 'Novels', *Blackwood's Edinburgh Magazine*, 102 (September 1867), pp. 257–280

Margaret Oliphant, *The Selected Works of Margaret Oliphant*, ed. Joanne Shattock and Elisabeth Jay, 2011

William Fraser Rae, 'Sensation Novelists: Miss Braddon', *North British Review*, 43 (1865), pp. 180–205

Janina Ramirez, *Julian of Norwich: A Very Brief History*, 2016

Adrienne Rich, 'When We Dead Awaken: Writing as Re-Vision', *College English*, 34 (1972), pp. 18–30

David Roberts, *Restoration Plays and Players: An Introduction*, 2014

Margaret W. Rossiter, 'The Matthew Matilda Effect in Science', *Social Studies of Science*, 23, 1993, pp. 325–341

A. L. Rowse, *The Poems of Shakespeare's Dark Lady*, 1978

Frederic Rowton, *The Female Poets of Great Britain, Chronologically Arranged*, 1849

Lara Rutherford-Morrison, '9 Times Men Were Given Credit for Women's Work' (2017), www.bustle.com/p/9-times-men-were-given-credit-for-womens-historic-accomplishments-41120

Vita Sackville-West, *Aphra Behn: The Incomparable Astrea*, 1927

Jane Schaberg, *The Resurrection of Mary Magdalene: Legends, Apocrypha, and the Christian Testament*, 2002

Elaine Showalter, *A Literature of their Own: British Women Novelists from Brontë to Lessing*, 1999

Tabitha Sparks, 'To the Mad-House Born: The Ethics of Exteriority in *Lady Audley's Secret*', in *New Perspectives on Mary Elizabeth Braddon*, ed. Jessica Cox, 2012, pp. 19–36

Lynn Staley, *Margery Kempe's Dissenting Fictions*, 1994

Ann Marie Stewart, *The Ravishing Restoration: Aphra Behn, Violence, and Comedy*, 2010

Kathryn Sutherland, 'Jane Austen's Life and Letters', in *A Companion to Jane Austen*, ed. Claudia L. Johnson and Clara Tuite, 2009, pp. 13–30

Kathryn Sutherland, 'Making Books: How Jane Austen Wrote', in *Jane Austen: Writer in the World*, ed. Kathryn Sutherland, 2017, pp. 119–143

Kathryn Sutherland (ed.), *Jane Austen's Fiction Manuscripts*, vol. 4, 2018 (print), 2019 (online)

D. J. Taylor, 'Brookfield [née Elton], Jane Octavia (1821–1896), literary hostess and writer', *Oxford Dictionary of National Biography*, 2012

Janet Todd, *Aphra Behn: A Secret Life*, 2017

Saverio Tomaiuolo, *In Lady Audley's Shadow: Mary Elizabeth Braddon and Victorian Literary Genres*, 2010

Claire Tomalin, *Jane Austen: A Life*, 1997

Frances Trollope, *Domestic Manners of the Americans*, 1832

Laura Mooneyham White, *Jane Austen's Anglicanism*, 2011

Joy Wilkinson, 'The Witch-Finders', *Doctor Who*, Series 11, Episode 8, aired 25 November 2018

Susan Wiseman, *Aphra Behn*, 2007

Heather Wolfe, 'Was Early Modern Writing Paper Expensive?', *The Collation*, 2018, https://collation.folger.edu/2018/02/writing-paper-expensive/

Robert Wolff, *Sensational Victorian: The Life and Fiction of Mary Elizabeth Braddon*, 1979

Susanne Woods, *Lanyer: A Renaissance Woman Poet*, 1999

Virginia Woolf, *A Room of One's Own*, 1929

Gillian Wright, *Producing Women's Poetry, 1600–1730: Text and Paratext, Manuscript and Print*, 2013

Further Reading

Primary Texts

Julian of Norwich, *Revelations of Divine Love*, ed. A. C. Spearing and Elizabeth Spearing, 1998

Margery Kempe, *The Book of Margery Kempe*, trans. Anthony Bale, 2015

Aemilia Lanyer, *Salve Deus Rex Judaeorum*, in *Isabella Whitney, Mary Sidney and Aemelia Lanyer: Renaissance Women Poets*, ed. Danielle Clarke, 2000

Anne Bradstreet, *Poems and Meditations*, ed. Margaret Olofson Thickstun, 2019

The Rover, *The Turkish Embassy Letters*, *Sense and Sensibility* and *Lady Audley's Secret* are all readily available in modern editions.

Lives

Putting together these suggestions has vividly revealed the varied literary historical fortunes of the women in this book. Biographical takes on Jane Austen constitute a publishing sub-industry all of

their own. Spoilt for choice, I ended up plumping for an old familiar favourite. When it comes to most of the other authors the biography cupboard is much less well stocked. What there is, however, can be exceptionally good. I recommend in particular Anthony Bale's new and exemplary study of Kempe and Isobel Grundy's superb life of Montagu.

Janina Ramirez, *Julian of Norwich*, 2016

Anthony Bale, *Margery Kempe: A Mixed Life*, 2021

Susanne Woods, *Lanyer: A Renaissance Woman Poet*, 1999

Charlotte Gordon, *Mistress Bradstreet: The Untold Life of America's First Poet*, 2005

Janet Todd, *Aphra Behn: A Secret Life*, 2017

Isobel Grundy, *Lady Mary Wortley Montagu: Comet of the Enlightenment*, 2001

Claire Tomalin, *Jane Austen: A Life*, 1997

Jennifer Carnell, *The Literary Lives of M. E. Braddon*, 2000

Index